The AVA Guide to **Travel Photography**

Keith Wilson

ava | Essentials

AVA Publishing SA
Switzerland

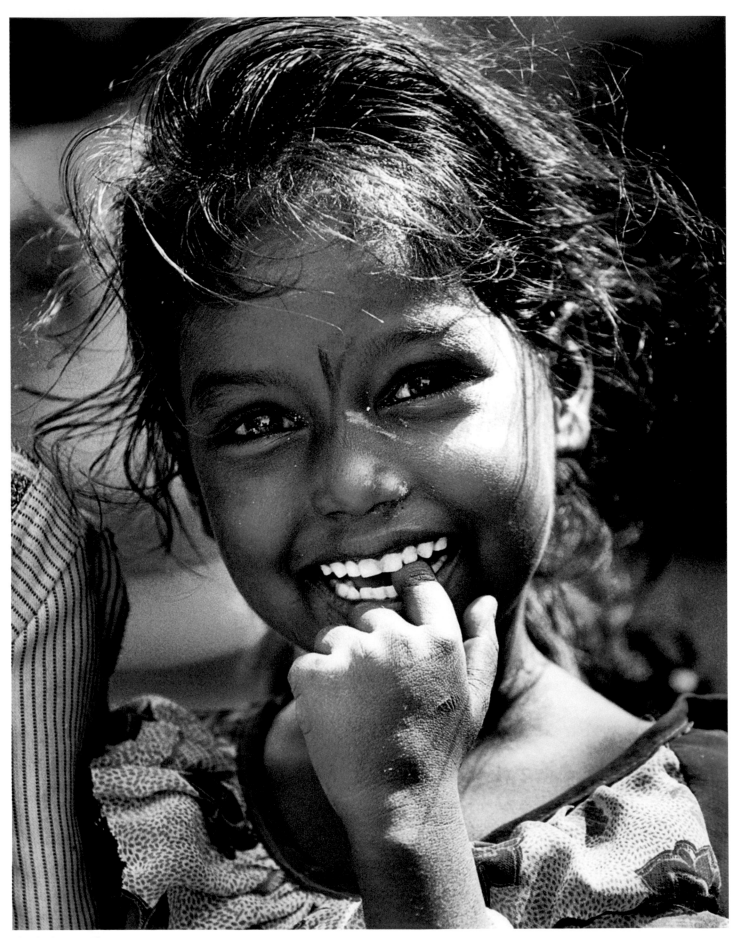

Alan Chan (see page 53)

[]

The AVA Guide to **Travel Photography**

Keith Wilson

Published by AVA Publishing SA

Chemin de la Joliette 2

Case postale 96

1000 Lausanne 6

Switzerland

Tel: +41 786 005 109

Email: enquiries@avabooks.ch

Distributed by Thames and Hudson (ex-North America)

181a High Holborn

London WC1V 7QX

United Kingdom

Tel: +44 20 7845 5000

Fax: +44 20 7845 5050

Email: sales@thameshudson.co.uk

www.thamesandhudson.com

Distributed by Sterling Publishing Co., Inc.

in USA

387 Park Avenue South

New York, NY 10016-8810

Tel: +1 212 532 7160

Fax: +1 212 213 2495

www.sterlingpub.com

in Canada

Sterling Publishing

c/o Canadian Manda Group

One Atlantic Avenue, Suite 105

Toronto, Ontario M6K 3E7

English Language Support Office

AVA Publishing (UK) Ltd.

Tel: +44 1903 204 455

Email: enquiries@avabooks.co.uk

ISBN 2-88479-054-3

Design by Gavin Ambrose

Production and separations by AVA Book Production Pte. Ltd., Singapore

Tel: +65 6334 8173

Fax: +65 6334 0752

Email: production@avabooks.com.sg

Louis Greene (see page 118)

The 'complete traveller' always carries a camera — and enough film to last the journey.

Contents

Introduction

Travel and photography are one of life's great couplings. Since the mid-19th century the increasing popularity of photography has shadowed the growth in travel as the first Victorian 'grand tours' of Europe and the settlement of the American West were documented by this new technological feat.

A century and a half later and it's almost impossible to find anyone who doesn't take pictures while on holiday. Indeed, the 'complete traveller' always carries a camera – and enough film to last the journey. While a passport, tickets and currency are essential to your capability to travel, a camera ensures you have the means to preserve the memories you bring back home.

But how do you get the best out of that camera and what type of camera should you take? And what about lenses, filters, film? Or should you just do it all digitally? These are some of the typical questions that you can find answered in this book, along with chapters on how to photograph a variety of landscapes, candid portraits, landmarks, festivals, night scenes and events.

Of course, photography isn't just about the equipment you have. True success depends on how you use it and how well you prepare for the journey ahead. That doesn't mean to say that great images can't result from some serendipitous moment while plodding along the Inca Trail, or riding the Manly Ferry across Sydney Harbour.

That's the magic of travel photography; so often the best pictures are unplanned, unexpected and unforgettable.

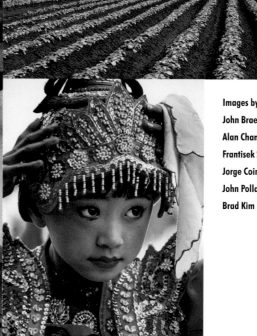

Images by (clockwise from top right):

John Braeckmans

Alan Chan

Frantisek Staud

Jorge Coimbra

John Pollack

Brad Kim

So often the best pictures are unplanned, unexpected and quite unforgettable.

How to get the most out of this book

Navigation

Each spread is labelled clearly so you can instantly know what is on that page.

Types of camera

Digital compact

Since the late 1990s, digital compact cameras have grown rapidly in popularity with a specification and resolution to match the very best of 35mm compact cameras and at a comparative price. They are now the number one choice in the point-and-shoot camera market because of the additional benefits digital can offer. Users immediately grasp the versatility of the colour monitor for playing back images and as an alternative to the main viewfinder. Then there is the ease with which images can be uploaded to computers and websites or emailed. Users are also attracted to the savings they can make by not having to buy film or having to wait hours or days to see their results. Instead of film, a digital camera uses an image sensor covered in millions of photo diodes known as pixels, which capture the image and then record it on a removable memory card. These cards have different capacities and the number of images that can be stored also depends on the type and size of image file used. These files are usually JPEG, TIFF or RAW (most digital compacts feature more than one type). In terms of controls and handling digital compacts are very similar to their film camera equivalents with identical exposure mode and metering options, shutter speed and ISO ranges. However, digital compacts drain batteries at a faster rate than film cameras, so extra batteries should always be carried. Fortunately, digital compacts are sold with power packs, some styled as docking stations built around an AC mains adapter that recharges the camera's batteries.

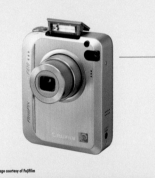

Image courtesy of Fujifilm

Fujifilm FinePix F610 Zoom – megapixel zoom compact

Specification includes:

3x optical zoom (equivalent to 35–105mm in 35mm)	Manual exposure mode
2 LCD screens (including 1.8in LCD monitor)	2 focusing modes (single shot AF & continuous AF)
6.3 million pixel effective resolution	2 film advance modes (single frame & continuous up to 5fps)
ISO 160–1600 image sensitivity range	Built-in pop-up flash
5 programmed exposure modes	
2 automatic exposure modes (Av) (Tv)	

PROS: Stylish design; easy handling; good colour reproduction.

CONS: LCD monitor difficult to read in bright light; small optical viewfinder.

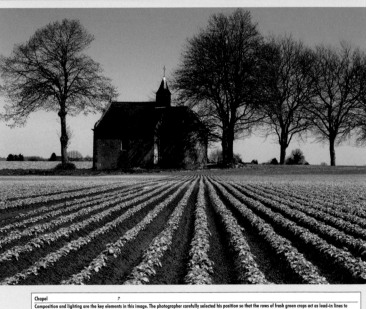

Chapel

Composition and lighting are the key elements in this image. The photographer carefully selected his position so that the rows of fresh green crops act as lead-in lines to the old chapel. He then waited for the sun to drop to the right of the frame, resulting in an angled lighting that creates more relief and texture in the field.

Photographer: John Broeckmans	Time: Early afternoon	Lens: Built-in zoom	Exposure: 1/125sec at f/8
Location: Flanders, Belgium	Camera: Olympus C-5050Z	File type: JPEG	Tripod: No

Information

Each page features inspirational text which clearly explains how to achieve the results you desire.

Detailed descriptions

Each image is accompanied by an explanation of what the photographer did and why. This section also features quotations from the photographer.

Flash & time exposures

Flash is extremely useful for providing additional lighting at times when there isn't enough or any available light or it is in the wrong place for your subject. The most useful flash technique for the travel photographer is 'fill-in' – the use of a small amount of flash by day to illuminate areas of the subject that are in shadow. Fill-in flash can be used with any flashgun, including the smallest built-in unit on a point and shoot camera. Indeed, when photographing someone against the light, you should use flash in order to prevent your subject from being thrown into silhouette.

It is important to know the limitations of your flash unit, namely the nominal flash to subject distance and the angle of coverage. The workable flash range on a typical built-in unit is around 3m (10ft) at ISO 100. Using a faster film or ISO number will extend this range, but if you need more power, you will have to use a separate flashgun. With a separate flashgun you can control the flash output to 1/2, 1/4, 1/8, even 1/16 power. It's also possible with some models to place the flash off-camera and fire it remotely.

Slow sync flash is a popular technique with moving subjects. It entails setting a slow shutter speed to record any movement or areas lit by ambient light while the subject illuminated by the flash is 'frozen' by the faster flash sync speed. This looks most effective when photographing a car, cyclist, dancers or other fast moving subject at night when trails of ambient lights streak across the background.

Many flashguns have a facility known as second curtain sync whereby the flash fires as the camera's second shutter curtain begins to travel across the film plane or image sensor. As a result any ambient streaks are recorded before the flash fires, thereby appearing behind the flash frozen image and helping to emphasise the direction of movement.

Some night scenes are better photographed without flash; all they need is a long exposure of many seconds, even minutes, sometimes longer. These are called time exposures and the camera has to be mounted on a tripod or firmly supported by other means. Typical subjects for a time exposure include: a floodlit landmark or building, fireworks, the lanes of car lights from traffic passing over a bridge, arcs of star trails or the Northern Lights in the night sky. Time exposures are fun because how long you leave the shutter open is down to guesswork and experience, but the results are often surprising.

Inverse square law

Whichever flash you use it pays to remember the inverse square law. This stipulates that as you double the subject distance from the flash, the amount of light reaching the subject reduces by a quarter. If you were to double the distance again, the light would only be 1/16 of the intensity at source. This law reminds us that flash is ineffective with long range subjects.

Star trails over cactus →
To photograph star trails in the night sky requires a long exposure, with the camera firmly mounted on a tripod. Desert skies are very dark because there is no light pollution, commonplace in towns and suburbs with lots of floodlighting and streetlights, so the stars are more visible. For this stunning image the photographer, Leping Zha, aimed his camera directly at the Polar Star and repeatedly fired a Nikon SB28 flashgun manually at the cactus. He also used a flashlight to 'paint' the cactus for around ten minutes. The four hour exposure time was necessary to record a long and bright trail of stars, seemingly revolving in concentric circles around the Polar Star .

Photographer: Leping Zha	**Lens:** Pentax SMC 45mm f/4
Location: Pipe Organ National Monument, Arizona, USA	**Film:** Fuji Velvia 50
Time: A night in March	**Exposure:** Four hours at f/5.6
Camera: Pentax 67II	**Tripod:** Yes

Chain Bridge, Budapest Overleaf
City architecture takes on a totally different appearance at night. Carefully placed floodlights illuminate the form and shape of the structure in a more graphic way than is possible by day. The Chain Bridge in Budapest is a classic example, although making this image was a dangerous undertaking as the photographer had to set up his tripod at a traffic circle, which meant cars were whizzing past on three sides. The 12sec exposure is too long to freeze any of the fast moving cars in the image. Instead, their lights have left a ghostly wash of light on the road.

Photographer: John Orr	**Lens:** Nikkor 17–35mm AF-S ED zoom
Location: Budapest, Hungary	**Film:** Fuji Reala 100
Time: 8pm	**Exposure:** Approx 12sec at f/16
Camera: Nikon F100	**Tripod:** Yes

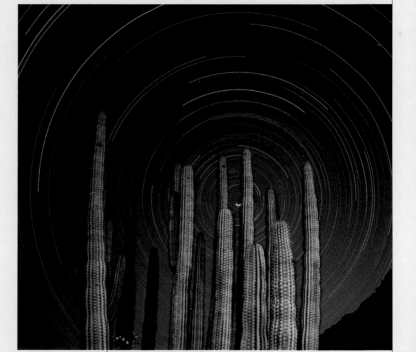

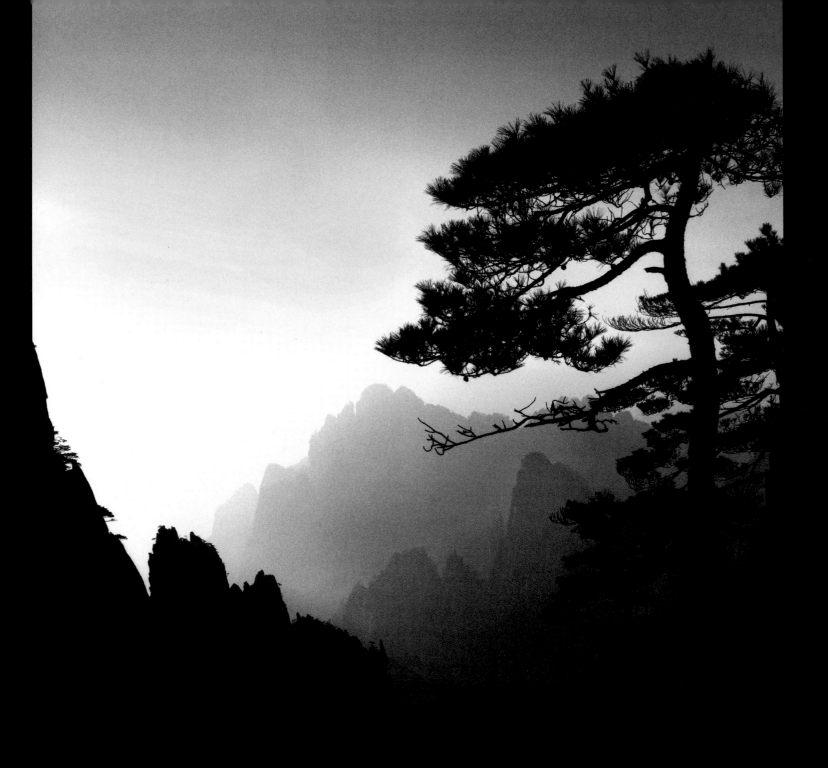

Leping Zha (see page 35)

Whatever your destination, every journey begins at home. With your suitcase open on the bed and with what must seem like the entire contents of your wardrobe spread out in disarray, wondering what photographic equipment to take can seem like an impossible task. However, the decisions you make at this point will play a huge part in determining the level of success you attain from your travels.

Types of camera

Aside from your choice of camera, lenses, film or memory cards there are other essentials to pack as well as a host of accessories to consider. The trick is to pack only what you and your photography need. Excess baggage doesn't just hit your pocket at the airport check-in, it also weighs you down, creating both a mental and physical obstacle to making better pictures.

Your choice of equipment will depend on where you're going and the type of subject matter you will encounter. It's worth then looking at the type of equipment that's available to today's travel photographer and examining those cameras, lenses and accessories that are most suitable for your needs.

35mm autofocus SLR

For many years, travel pictures have been made through the viewfinder of a 35mm camera, in particular a SLR (single lens reflex). This has been the camera of choice for many travel photographers for decades. Viewing the scene through the camera's actual lens makes composition a more accurate exercise than with a compact camera that uses a separate viewfinder window.

Popular makes of SLR from Canon, Minolta, Nikon and Pentax are supported by a large range of interchangeable lenses, from fisheye to super telephoto, macro to zooms. It is this range of lenses that gives the 35mm SLR such an advantage over other camera systems.

Today's cameras are much lighter as manufacturers use more plastics in construction and lighter metal alloys. The prevalence of automatic features also makes the SLR quick and easy to use, although some all-manual models continue to be made. Even the most basic model of 35mm SLR has a wide range of automatic exposure and metering modes, as well as automatic film advance and rewind, automatic film speed selection and a built-in flash.

The only disadvantage about the 35mm SLR for some photographers is the size of the film frame – at 24x36mm, its dimensions are no bigger than a thumbprint. This is an important factor when considering enlargement for future reproduction of your images, but as we shall see later, your choice of film, camera support and some other technologies can readily compensate for this.

Canon EOS 3000V – a typical low-cost 35mm SLR

Specification includes:

2 automatic exposure modes (Av & Tv)	2 film advance modes (single frame &
7 programmed exposure modes	continuous 1.5fps)
1 depth of field exposure mode	Built-in pop-up flash
Manual exposure mode	Automatic exposure bracketing
3 metering modes (partial, 35 zone	Exposure compensation +-3 stops
evaluative, centre-weighted)	Exposure lock
30–1/2,000sec shutter speed range plus B	Depth of field preview
4 focusing modes (single shot AF, predictive	10sec delay self-timer
AF, AI focus AF, manual focus)	Optional electronic remote release
2 film speed setting modes (manual: ISO	Hotshoe for dedicated external flash
6–6400; DX coded: ISO 25–5000)	Weight: 365g (body only)

PROS: Easy to use; lightweight; good autofocus and metering; bright viewfinder; extensive lens range.

CONS: Is it robust enough for hard travelling? Is the 35mm format big enough for you?

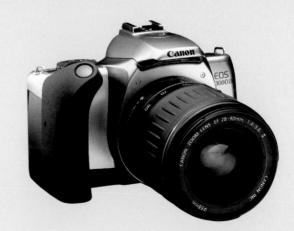

Image courtesy of Canon Inc.

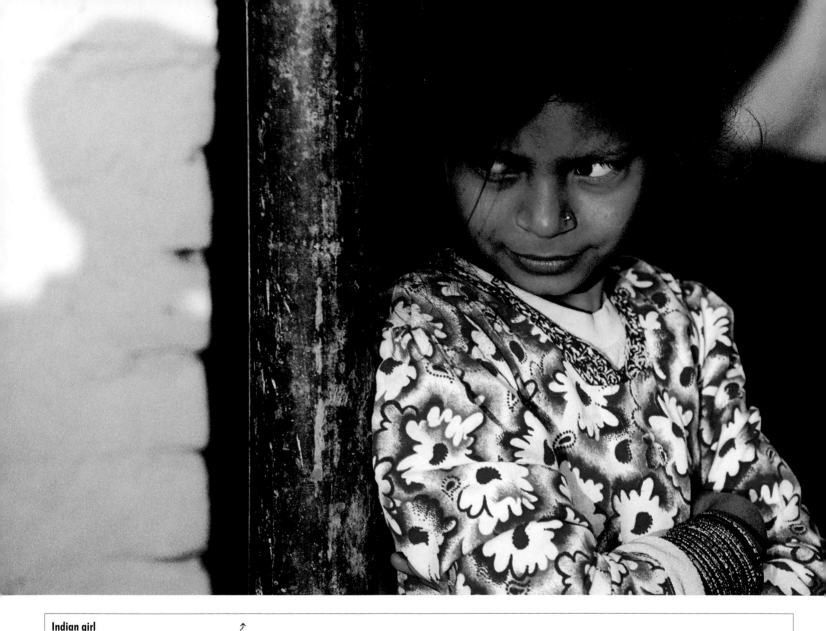

Indian girl ↗

This girl was among a group playing on the seashore where lots of fishermen were working. Using the long end of a telephoto zoom the photographer managed to isolate her from the group to frame this portrait. The mixture of bright low light and shadow on her face has been accurately exposed using the camera's automatic metering system. Modern SLRs all feature sophisticated metering systems that can be relied upon for high-contrast situations like this.

Photographer: Alan Chan

Location: Southern India

Time: Morning

Camera: Canon EOS 1

Lens: Canon 70–200mm f/2.8 L at 200mm setting

Film: Kodak Gold 100

Exposure: 1/250sec at f/4

Tripod: No

Types of camera

Digital SLR

In terms of design and handling many makes of digital SLR are based on older 35mm SLR cameras of the same make. They also use the same lens mount, allowing the camera make's range of lenses to be freely interchanged between a digital and 35mm SLR body. Press and sports photographers were the first to switch to digital because of the speed which images could be seen and then sent to picture desks and agencies by email, just minutes after exposure. This speed of delivery plus the time saved by not having to process and edit means still pictures make it into print far quicker than in the days of film.

At the heart of the digital SLR is the electronic image sensor. There are several different types but they all work in a similar way, registering light through the lens on an array of pixels on the sensor then storing the resulting image on a removable memory card. Like film, there are different types and sizes of memory card, but it is the size and sensitivity of the camera's sensor that plays the greatest part in determining the quality of the image. Generally speaking, the greater the number of pixels, the better the image resolution.

Another key difference between 35mm and digital SLR cameras is the colour LCD monitor. Not only does this allow you to view images stored on your memory card, but it also doubles up as an electronic viewfinder. Also, the ability to view an image on the monitor immediately after exposure means photographers can see if they got the picture, edit images they don't need, or make exposure adjustments if necessary.

Digital cameras are more versatile in changeable or low light, because ISO values and white balance can be adjusted for each frame to boost exposure. By contrast, altering the ISO rating on a film camera means having to stick with the new rating until the end of the film. After that, an appropriate adjustment needs to be made to the developing time in order to compensate for any deviation from the film's nominal rating.

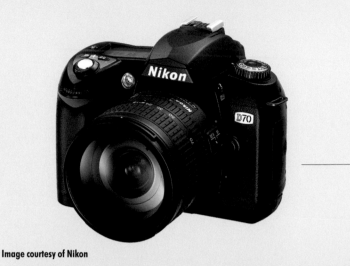

Image courtesy of Nikon

Nikon D70 – for quality, affordable digital SLR photography

Specification includes:

23.7x15.6mm CCD image sensor	AF, continuous AF, manual focus)
6.1 million effective pixels	2 film advance modes (single frame &
3 image file sizes (large, medium, small)	continuous 3fps)
2 image storage formats (RAW & JPEG)	Built-in pop-up flash
1.8in LCD monitor	Automatic exposure bracketing
6 manual white balance modes + Auto	Exposure compensation +-5 stops
ISO 200–1600 image sensitivity range	Exposure lock
2 automatic exposure modes (Av & Tv)	Depth of field preview
8 programmed exposure modes	2–20sec delay self-timer
Manual exposure mode	Optional electronic remote release
3 metering modes (centre - weighted, 3D	Hotshoe for dedicated external flash
colour matrix, spot)	Weight: 595g (body only)
30–1/8,000sec shutter speed range plus B	
4 focusing modes (single shot AF, predictive	

PROS: Excellent specification; comfortable handling; plenty of lenses and accessories to choose from.
CONS: More expensive than equivalent 35mm SLR.

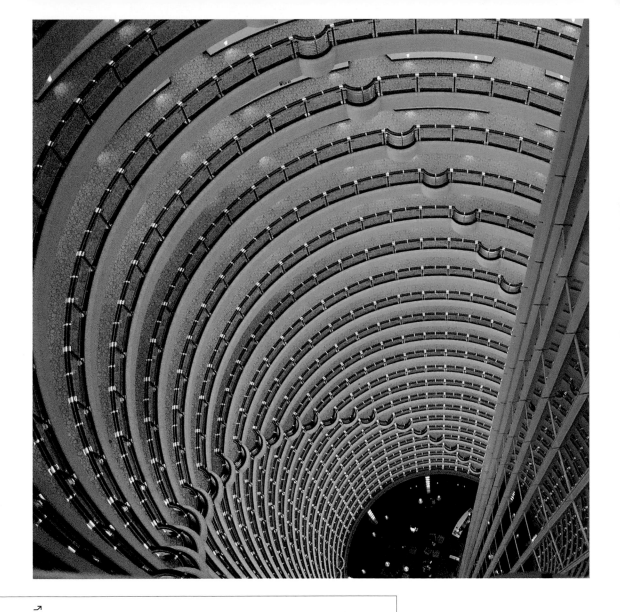

The gate ⤴

When laying eyes on the spiralling effect of the floors of this high rise hotel in Shanghai, the photographer was reminded of a nautilus shell, while the light patterns resembled a scene out of Star Wars. Although bright, the lateness of the hour and absence of ambient light meant a handheld exposure would be too risky for a sharply focused result, so the photographer used a tripod for absolute stillness. The digital camera's automatic white balance system was able to cope easily with the warm colour temperature produced by the lights.

Photographer: Sin Vida Padre

Location: Hyatt Hotel, Shanghai, China

Time: 9pm

Camera: Kodak DCS Pro 14n

Lens: Nikkor 24–120mm zoom

File type: DCR-TIFF

Exposure: Not recorded

Tripod: Yes

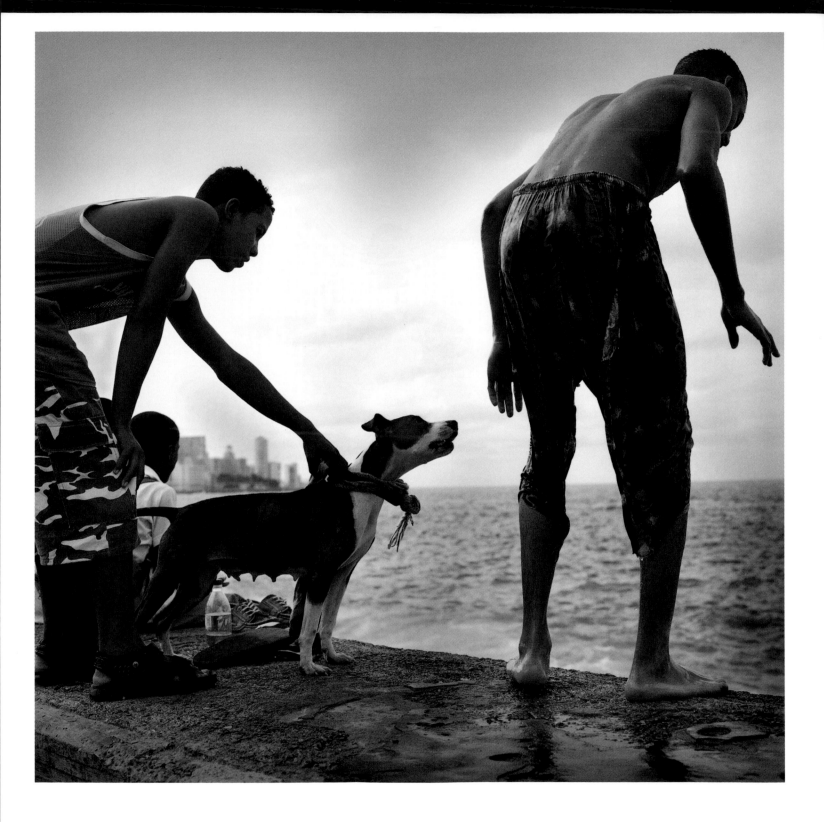

Medium format SLRs

Some travel photographers prefer a film format larger than 35mm. Medium format cameras use roll film, known as 120, upon which the following image formats can be exposed: 6x4.5cm, 6x7cm, 6x8cm, 6x9cm and 6x6cm. Obviously, the larger the format, the bulkier and heavier the camera and lenses tend to be, particularly if that camera is an SLR. Medium format rangefinder cameras are smaller, but SLRs have the advantage of using the same through-the-lens (TTL) viewing principles as 35mm models.

A medium format SLR should be used with a tripod in order to eliminate camera shake and guarantee image sharpness. Medium format images are perceived as being sharper than 35mm. This is because even the smallest medium format – 6x4.5cm – covers an area nearly three times that of 35mm, so it doesn't require the same degree of enlargement for reproduction. As a result any film grain will be less obvious on medium format than with a 35mm image enlarged to the same size. The bigger image size of medium format also stands to make a greater impression with a picture editor, simply because a correctly exposed and focused medium format transparency captures more detail.

The 6x4.5cm format is the most popular, primarily because the cameras are the most affordable, portable and innovative. The latest makes of these cameras also feature autofocus and programmed metering systems based on versions developed for 35mm SLRs.

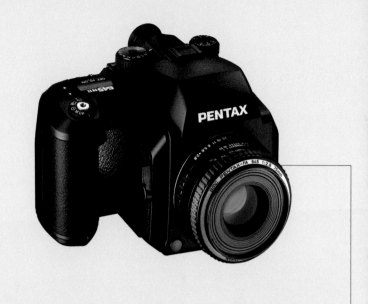

Image courtesy of Pentax

Pentax 645N II – autofocus 6x4.5cm medium format SLR

Specification includes:

2 automatic exposure modes (Av & Tv)	2 film advance modes (single frame &
1 programmed exposure mode (P)	continuous 2fps)
Manual exposure mode	Automatic exposure bracketing
3 metering modes (spot, 6-segment	Exposure compensation +-3.5 stops
evaluative, centre - weighted)	Exposure lock
30–1/1,000sec shutter speed range plus B	Depth of field preview
3 focusing modes (single shot AF, predictive	12sec delay self-timer
AF, manual focus)	Optional electronic remote release
2 film speed setting modes (manual: ISO	Hotshoe for dedicated external flash
6–6400; DX coded: ISO 25–5000)	Weight: 1,280g (body only)

PROS: TTL viewing and metering; format nearly 3x larger than 35mm; responsive AF; grip makes handholding comfortable.

CONS: Very bulky for travel.

Venceremos #12 ↰

Tripods are often used with medium format cameras but in this case the photographer handheld his Hasselblad to make the picture. This is because of the spontaneous nature of his pictures – a series documenting the lives of people on the streets of Havana. In this picture, a group of boys meet on the Malecon, the main road by Havana's sea wall, where they wait for waves high enough in order to jump safely. The tension and anticipation in the boys' bodies is reflected in the stance of the dog and the use of black & white film helps accentuate this mood.

Photographer: Steffen Ebert	**Lens:** Hasselblad Planar 80mm f/2.8
Location: Havana, Cuba	**Film:** Kodak T400CN
Time: Late afternoon	**Exposure:** f/11; shutter speed not recorded
Camera: Hasselblad 202FA	**Tripod:** No

Types of camera

35mm compact

This type of camera is a favourite among holiday snappers. Its diminutive dimensions and point-and-shoot simplicity means a compact (both 35mm and digital) is the most convenient type of camera to carry.

Many compacts feature built-in zoom lenses from around 28mm or 38mm wideangle through to a short telephoto focal length of 80mm, 90mm or even longer. They are also highly affordable and there is plenty of choice on the market. These cameras are automated in every sense: focusing, exposure, film speed selection, film advance and rewind, even flash use.

Compact cameras use a direct frame viewfinder, which shows a scene that is slightly different to the actual view framed by the camera lens. This difference between the viewing area and actual area is known as parallax. It becomes more acute the closer your subject is to the lens. Parallax is the reason why heads can be 'chopped off' in some pictures. It is a phenomenon more common with compacts than any other type of camera.

The appeal of zoom compacts lies in their versatile lenses. However, the maximum aperture can be very 'slow' the further you zoom out. This is because a zoom compact has less 'light grabbing power' (resolution) than a 'faster' zoom of the same focal length range designed for SLR cameras. As a result, when taking pictures in low light, shade or inside, you need to resort to flash or use a faster speed film. For example, ISO 400 film will give you a shutter speed four times as fast as ISO 100 film when used at the same aperture.

Even smaller than zoom compacts are those cameras that use a lens of fixed focal length such as a 28mm or 35mm wideangle. The lenses of these compacts are faster, with larger maximum apertures, making them more versatile in a variety of lighting conditions and a favourite accessory of many travel photographers.

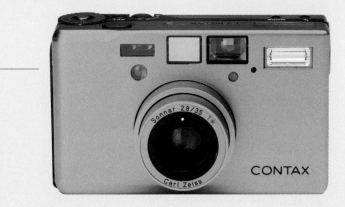

Image courtesy of Contax

Contax T3 – fixed focal length AF 35mm compact

Specification includes:

Fixed 35mm f/2.8 Carl Zeiss Sonnar T wideangle lens
1 automatic exposure mode (Av)
1 programmed exposure mode (P)
2 metering modes (spot, centre-weighted)
1–1/500sec shutter speed range plus T (for time exposures)
2 focusing modes (single shot AF and manual)
2 film speed setting modes (manual, DX coded: ISO 25–5000)
7 custom function settings
Automatic film advance
Built-in flash
Exposure compensation +-2 stops
10sec and 2sec delay self-timer
Automatic focus lock
Weight: 225g (body only)

PROS: Excellent lens and metering, aperture priority; tough metal outer shell.
CONS: Weak built-in flash; no auto-exposure bracketing.

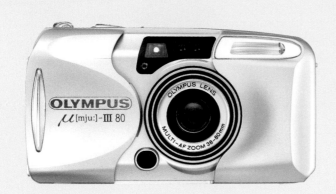

Image courtesy of Olympus

Olympus mju-III 80 – weatherproof 35mm zoom compact

Specification includes:

38–80mm f/5.3–10.4 zoom lens

Single programmed exposure mode

2 metering modes (2-zone and spot)

Automatic shutter speed selection (range: 4–1/500sec)

1 focusing mode (passive-type multi-point AF)

DX coded automatic film speed setting (range: ISO 100–3200)

Automatic film advance

Built-in flash

12sec delay self-timer

Optional electronic remote release

Weight: 180g (body only)

PROS: Light, compact and easy to use; low cost.

CONS: No exposure control; weak built-in flash; inferior lens quality compared to 35mm SLR.

Ephesus, Turkey. In well-lit conditions a small compact camera produces good results on slide film.

Types of camera

Digital compact

Since the late 1990s, digital compact cameras have grown rapidly in popularity with a specification and resolution to match the very best of 35mm compact cameras and at a comparative price. They are now the number one choice in the point-and-shoot camera market because of the additional benefits digital can offer. Users immediately grasp the versatility of the colour monitor for playing back images and as an alternative to the main viewfinder. Then there is the ease with which images can be uploaded to computers and websites or emailed. Users are also attracted to the savings they can make by not having to buy film or having to wait hours or days to see their results. Instead of film, a digital camera uses an image sensor covered in millions of photo diodes known as pixels, which capture the image and then record it on a removable memory card. These cards have different capacities and the number of images that can be stored also depends on the type and size of image file used. These files are usually JPEG, TIFF or RAW (most digital compacts feature more than one type). In terms of controls and handling digital compacts are very similar to their film camera equivalents with identical exposure mode and metering options, shutter speed and ISO ranges. However, digital compacts drain batteries at a faster rate than film cameras, so extra batteries should always be carried. Fortunately, digital compacts are sold with power packs, some styled as docking stations built around an AC mains adapter that recharges the camera's batteries.

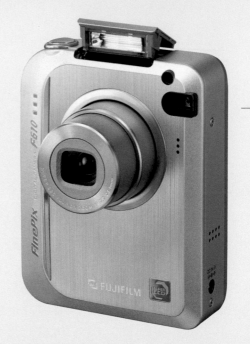

Image courtesy of Fujifilm

Fujifilm FinePix F610 Zoom – megapixel zoom compact

Specification includes:

3x optical zoom (equivalent to 35–105mm in 35mm)
2 LCD screens (including 1.8in LCD monitor)
6.3 million pixel effective resolution
ISO 160–1600 image sensitivity range
5 programmed exposure modes
2 automatic exposure modes (Av) (Tv)

Manual exposure mode
2 focusing modes (single shot AF & continuous AF)
2 film advance modes (single frame & continuous up to 5fps)
Built-in pop-up flash

PROS: Stylish design; easy handling; good colour reproduction.
CONS: LCD monitor difficult to read in bright light; small optical viewfinder.

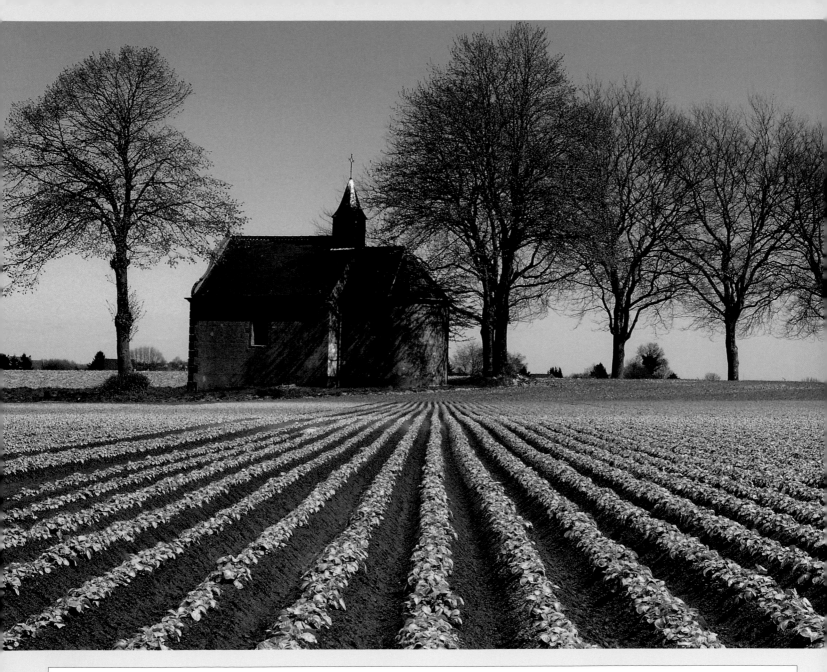

Chapel ↗

Composition and lighting are the key elements in this image. The photographer carefully selected his position so that the rows of fresh green crops act as lead-in lines to the old chapel. He then waited for the sun to drop to the right of the frame, resulting in an angled lighting that creates more relief and texture in the field.

Photographer: John Braeckmans

Location: Flanders, Belgium

Time: Early afternoon

Camera: Olympus C-5050Z

Lens: Built-in zoom

File type: JPEG

Exposure: 1/125sec at f/8

Tripod: No

Types of camera

Rangefinder

One of the oldest camera designs in existence, the rangefinder has proved popular among travel photographers because of its compact dimensions, excellent lens quality and quiet operation. The best known make of rangefinder is the Leica, a 35mm camera favoured by generations of reportage photographers. Other manufacturers of 35mm rangefinders are Voigtlander, Konica, Contax and Hasselblad, the latter being a camera (the Hasselblad XPan) that can extend the format to a 24x65mm panoramic frame at the flick of a switch.

Medium format rangefinder cameras made by Bronica and Mamiya have proven popular with travel and landscape photographers who want the benefit of the larger 6x4.5cm or 6x7cm formats, without the weight and bulk of their SLR equivalents. So why is a rangefinder smaller than a SLR camera and what other advantages are there? Rangefinder cameras are smaller and lighter because they don't have to accommodate the mirror box and pentaprism that make through the lens (TTL) viewing possible on a SLR. Consequently, the rear lens element of a rangefinder is much closer to the film plane, resulting in

less image distortion and sharper pictures. Also, with the absence of the audible clunk of the SLR mirror moving out of the way at the time of exposure, a rangefinder is much quieter when the shutter release is fired.

However, there is a drawback. Unlike a SLR camera, the view through the lens and viewfinder of a rangefinder camera are not directly linked. As a result there is a difference in the framing area of a subject between the viewfinder and the lens. This is known as parallax error (see 35mm compact, p.20), but newer and more costly cameras are able to compensate for this error by showing the 'correct' cropping marks in the viewfinder. This lack of TTL viewing also means the effects of adding filters to your rangefinder camera lenses cannot be seen in the camera viewfinder.

Leica M7 – 35mm rangefinder

Specification includes:

1 automatic exposure mode (Av)	Manual film advance and rewind
Manual exposure mode	Exposure compensation +-2 stops
1 metering mode (centre-weighted)	Exposure lock
32–1/1,000sec shutter speed range plus B	10sec delay self-timer
1 focusing mode (manual focus)	Optional winder for automatic film advance
2 film speed setting modes (manual: ISO 6–6400; DX coded: ISO 25-5000)	Hotshoe for dedicated external flash
	Weight: 610g (body only)

PROS: Rugged build; bright viewfinder; superb lenses; choice of manual and automatic exposure modes; very quiet shutter.
CONS: No TTL viewing means difficult to accurately align graduate filters.

Mamiya 7II – 6x7cm medium format rangefinder

Specification includes:

1 automatic exposure mode (Av)	Manual film speed setting (ISO 25–1600)
Manual exposure mode	Manual film advance and rewind
1 metering mode (centre-weighted average)	Exposure compensation +-2 stops
4–1/500sec shutter speed plus B	Exposure lock
Flash synchronisation at all shutter speeds	10sec delay self timer
1 focusing mode (manual focus)	Hotshoe for dedicated external flash
	Weight: 920g (body only)

PROS: Big format; collapsible lens housing; easy handling; compact and lightweight.
CONS: Filters difficult to use; limited lens range.

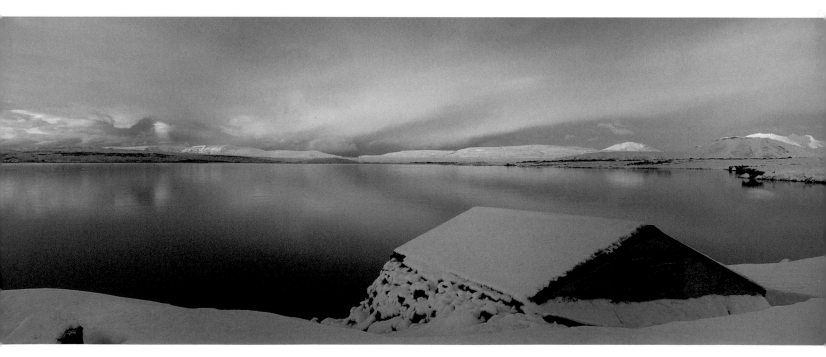

Last Sunday ↗

The panoramic format of the rangefinder Hasselblad Xpan camera is ideal for framing this scene – a beautiful sunset reflection on a still lake, with the snow covered boathouse the only sign of human presence. No lens filters were used.

Photographer: Palmi Einarsson **Time:** Late afternoon **Lens:** Hasselblad 45mm f/4 **Exposure:** 4sec at f/22

Location: Iceland **Camera:** Hasselblad XPan **Film:** Fuji Velvia 50 **Tripod:** Yes

Types of film & format

35mm

The vast majority of travel photographers use 35mm. It is the world's most popular film format, available in a wide variety of exposure lengths, speeds and types. Whether you prefer colour or black & white, slide or negative, the 35mm format caters to the widest range of needs. With dimensions of 24mm (high) x 36mm (wide), the frame area of this film is small (about the size of your thumb), but the quality is unquestionable, with fine grain and impressive resolution that enables enlargements up to A2 without significant loss of detail.

Ideally, travel photographers don't wish to be laden with bulky and heavy camera equipment, but they don't wish to sacrifice quality either. The 35mm format enables them to have the best of both worlds.

Colour reversal (slide) film

For the best quality reproduction, slow speed colour reversal (slide) films are the favoured option. Films such as Fujifilm's Provia 100F, Sensia 100 and Velvia 50 & 100, and Kodak's Ektachrome E100VS, E100G and E100GX are renowned for their exceptional fine grain and colour saturation. However, with a nominal speed rating of ISO 50 or ISO 100, these films require long exposure times when used in heavy shade or fading light.

While using medium speed slide films of ISO 200 and 400 will produce a faster shutter speed, grain will be more noticeable on any enlargement and colour contrast will be reduced. ISO 200 and 400 slide films worth considering are Fujifilm Sensia 200 and 400, Konica Centuriachrome 200 and Kodachrome 200.

Because of its processing method, whereby the positive image is developed directly on the film itself, every frame of a slide film is unique.

Colour negative (print) film

The favourite film type among all consumers is colour print film. Processing is freely available, low cost and quick and there's nothing better than looking at a set of prints in your hand from a once-in-a-lifetime holiday. Faster colour print films of ISO 400, 800, even 1600 have much better grain and colour reproduction than slide films of the same speeds. As a result, if you're using a 35mm zoom compact camera, the reduced maximum aperture of its lens will be best overcome by loading with an ISO 400 or 800 colour print film made by Kodak, Fuji or Konica.

Another advantage of colour print film is the almost limitless number of prints that can be produced from a single negative. But, as every photographer knows, storing your negatives in a way that is easy to find is one of the organisational nightmares of photography!

Black & white film

The main appeal of black & white is the degree of creative expression that is possible when making a print. There are as many types of black & white printing papers as there are films and many photographers have a favourite film and paper combination.

With one notable exception, all black & white films are of the negative (print) variety. The exception is Agfa Scala 200x, a monochromatic slide film with a nominal rating of ISO 200. It is not widely available and requires a special type of processing that takes several days to turn around.

There is a vast range of black & white print films of all speeds to choose from. Some of the best known slower speed black & white films are Ilford Pan F Plus, Ilford Delta 100, Agfapan APX 100 and Kodak T-Max 100. Medium speed films include Ilford HP5 Plus and Kodak Tri-X, while faster films worth trying are Fuji Neopan 1600 and Kodak T-Max 3200P.

Some black & white films can be developed in the same chemistry (C41) as colour print films. These are known as chromogenic film, and the fact that they can be processed by virtually any retail print processor or chemist, makes them a popular choice for photographers who want their prints quickly. Kodak BW400CN and Ilford XP2 Super are the two best known examples of this type of film.

Types of film & format

Roll film

Medium format cameras use roll film in lengths known as 120 or 220. The number of frames possible from each roll depends on the format you are using. For example, on 120 roll film, up to 16 frames can be taken when using a 645 camera, 12 frames for 6x6, ten frames for 6x7, nine frames for 6x8 and eight frames for 6x9. For panoramic formats, the number of frames possible on 120 is even less – just six frames for 6x12 format and four frames for 6x17. However, these frame totals double when loading with 220 roll film.

Although it isn't as easy to load as 35mm film and fewer frames can be exposed, roll film produces a larger image with more detail. It is also a versatile film type due to the number of compatible formats. Photographs taken on roll film also benefit from the physical constraints of using medium format cameras. For instance, a 6x7 camera such as a Pentax 67II, is too bulky and heavy to be handheld for a sharply focused photograph. A tripod is necessary therefore to keep the camera still during exposures. This slows down the whole picture-taking process and thus more attention is taken to composing and setting up each shot. Consequently, it may well take the photographer much longer to finish ten frames on 120 roll film than 36 exposures on 35mm, but chances are there will be a higher percentage of 'usable' pictures.

Roll film is regarded as a 'professional' film type, with dozens of different emulsions available in 120 and 220 lengths for colour prints, colour slides and black & white negatives. Most of the professional film types available in 35mm format (and mentioned above) are also made in 120/220 – such as Velvia 50, Provia 100F and Ektachrome E100VS for slides and Ilford HP5 Plus, Kodak Tri-X, or Kodak BW400CN for black & white prints. Few travel photographers use professional colour print films – instead these have a stronger following among studio, wedding and portrait photographers.

645

6x6

6x7

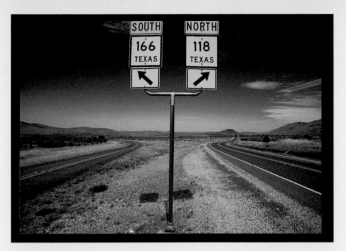

6x8

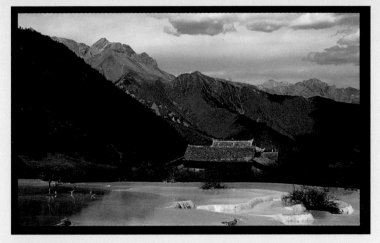

6x9

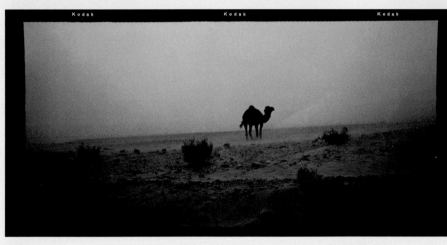

6x12

6x17

Lenses

The need to travel light means that lens choice is critical. The space occupied by one unused lens could easily have been taken up by more film or spare batteries – items just as vital to the globetrotting photographer. For this reason, it's best to take too few lenses rather than too many. Some, however, remain essential.

Zooms

For the 35mm SLR user, standard zooms with a focal range of 28–85mm and 28–105mm are ideal for all-round use, particularly when walking around cities, towns and street markets. A perfect complement to the standard zoom is a telephoto zoom, typically a 75–300mm. Thus, a basic kit of just two zooms gives you coverage from 28mm wideangle to 300mm telephoto. But is this enough?

Unless you're going on safari to the Masai Mara, in which case a 500mm focal length or even longer would be worth packing, the answer is 'probably'. You may even be tempted to make do with just one lens by packing a 28–300mm superzoom. However, these lenses are notoriously slow, with a variable maximum aperture of f/4.5 at the 28mm setting, stopping down to f/6.7 at 300mm. In anything but bright conditions, such a slow aperture makes these lenses practically unworkable at the long end of their range – the resulting shutter speed is likely to be too slow to avoid camera shake, unless you use a tripod or a faster film.

It makes more sense to use the two zoom option and supplement these lenses with some specialist optics that will be useful for the type of situations you are likely to encounter. For instance a fast telephoto lens of say 200mm, 400mm or 500mm for a wildlife safari, or macro lenses of 50mm, 90mm or 100mm for close-ups of flowers and details. With medium format and rangefinder camera systems, fixed focal length lenses are more commonplace than zooms.

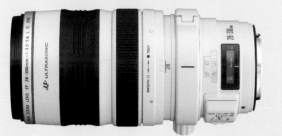

Zoom lenses can cover a vast range of focal lengths. This model from Canon has a range of 28–300mm and also features an image stabilising (IS) system, which counteracts movement when handheld, thereby reducing the effects of camera shake.

Standard lenses

On 35mm format cameras the 50mm focal length is known as the standard lens, so called because it has a field of view similar to the human eye. More importantly, this lens is worth including in your kit because it has a superb image resolution and a maximum aperture between one and two stops faster than many popular zooms. At f/1.8 this maximum aperture makes the 50mm standard a very versatile lens, particularly in low light. These lenses used to be sold as a matter of course with every new SLR before zooms became all the rage, but bargains can still be bought secondhand, as well as new. Standard lenses are more commonly used with medium format cameras where the nominal focal length is 75 or 80mm.

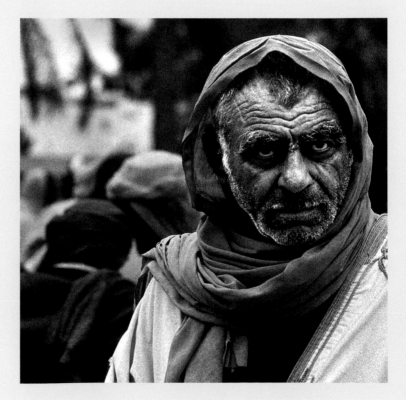

Last light →

The photographer wanted to capture the beautiful tones of the sunset, contrasting with the blues of the boats. The camera's built-in zoom lens enabled the photographer to frame the scene exactly, including enough of the boat's bows to create a lead-in line towards the sunset reflections on the water.

Photographer: Jorge Coimbra

Location: River Tejo, Escaroupim, Portugal

Time: 7.30pm

Camera: Canon PowerShot G3

Lens: Built-in 7.2–28.8mm zoom

File type: JPEG

Exposure: 1/160sec at f/4

Tripod: No

Tunisian character ↙

Shooting at a wide aperture with a telephoto zoom lens means depth of field will be narrow, so focusing is critical for the resulting image to be sharp. Always focus on the eyes when making portraits, and particularly when there is direct eye-to-camera contact. With the background thrown out of focus, the subject's face and eyes stand out even more. Although shot in colour the photographer converted it into black & white and used Photoshop to improve the overall contrast.

Photographer: Jacques Henry

Location: Douz, Tunisia

Time: Noon

Camera: Nikon F4

Lens: Nikkor 80–200mm f/2.8

Film: Kodak Gold 200

Exposure: f/2.8; shutter speed not recorded

Tripod: No

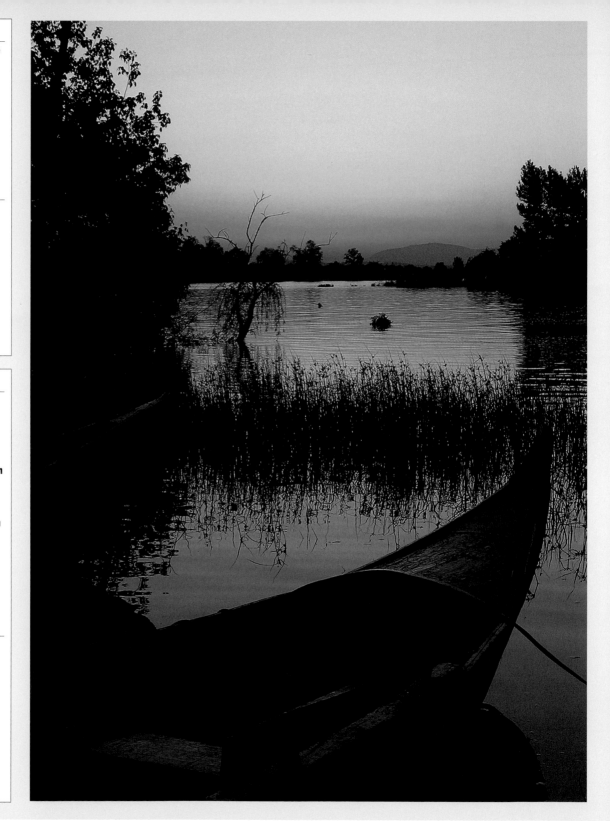

Lenses

Wideangles

As most standard zoom lenses are 28 or 35mm at their widest setting, packing a fixed focal length wideangle of say 24mm, 20mm, or even wider is well worth considering. After all, wideangles are the smallest and lightest lenses around and giving yourself the option of a bit more width than what your zoom can offer may make all the difference to a photograph.

Landscapes may seem like the most obvious use for a wideangle, but they also come into their own for street and village scenes, such as the activity of a market or traditional festivals where the antics of the people are as important as the location. Another effective use of a wideangle is for portraits where you want to show a background scene that places the subject in the context of their environment. This is a type of picture favoured by documentary and reportage photographers. One word of warning though – remember that the wider your focal length the greater the distortion at the edge of the frame. Distortion also becomes more noticeable the nearer the subject is to the lens. Bad for noses!

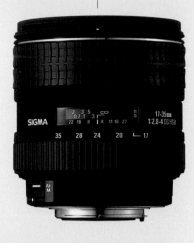

Telephotos

Like the 50mm standard, the 135mm short telephoto has evolved over decades of design and engineering to produce a lens that has an almost unmatchable resolution. Unless you're going on safari, you won't need a fixed telephoto lens longer than this. And even then this lens may seem surplus to requirements if you have a 75–300mm zoom packed.

Instead, a telephoto macro is worth considering. These lenses have grown in popularity as they give the photographer the option of true 1:1 macro as well as the more typical view you would expect from a short telephoto of 90, 100 or 135mm. The 1:1 ratio means that the subject, when correctly focused, will be rendered on film at its actual life-size: for example, close-ups of fine details such as the jewelled inlays in the walls of the Taj Mahal or exotic insects such as tropical species of butterfly.

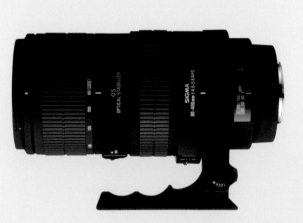

A wideangle zoom such as the Sigma 17–35mm f/2.8–4 EX DG HSM (top) is ideal for landscapes and photographing people in their environment, while the Sigma 80–400mm f/4.5–5.6 EX OS telephoto zoom (above) would be worth taking on safari or making close-ups of architectural details.

Of course the problem with really long fixed focal length telephotos is their size – just ask any wildlife photographer. However, they are essential for this line of work. As well as being long and heavy, fast aperture telephotos such as a 500mm f/4 or 800mm f/5.6 are also very expensive. A solution that could save you money would be to hire such a lens for the duration of your once-in-a-lifetime safari. Alternatively, invest in a shorter telephoto, say a 300mm and buy a 1.4x or 2x converter as well.

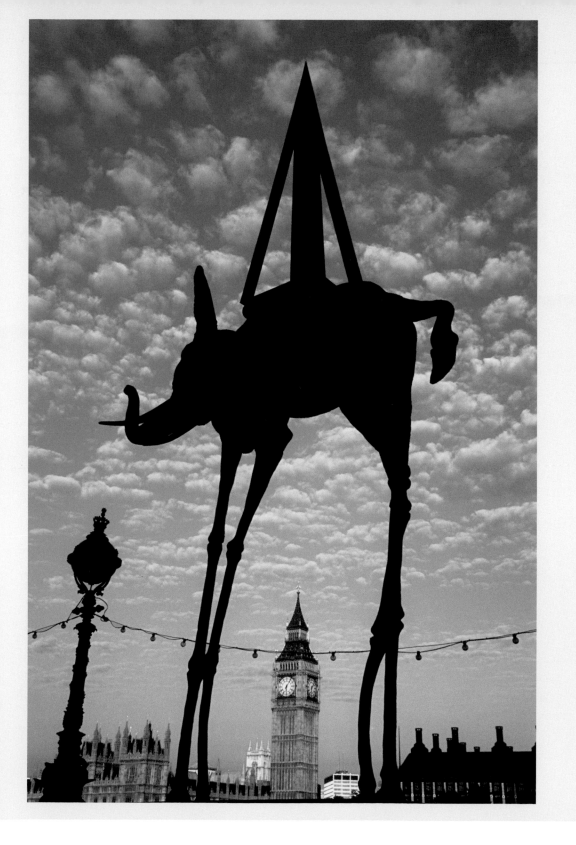

Ephalump ↰

As part of an ongoing project to make fresh and unusual images of iconic London landmarks, Jon Bower headed to the South Bank of the River Thames for the sunrise on the Houses of Parliament. He came across this unusual statue of an elephant to promote a nearby Salvador Dali exhibition and used the wideangle end of his 24–135mm zoom to create a composition as surreal as Dali's own artistic efforts.

Photographer: Jon Bower

Location: Near Westminster Bridge, London, England

Time: 6am

Camera: Canon EOS 30

Lens: Tamron SP 24–135mm zoom

Film: Fuji Provia 100F

Exposure: 1/80sec at f/4

Tripod: No

Tripods & other supports

With its cumbersome size and awkward shape, a tripod may seem like an obvious accessory to leave at home, but its usefulness cannot be overstated. Indeed, many photographs are impossible without one. City skyscrapers at night, landscapes at dawn, light trails and sunsets cannot be executed without some means of keeping the camera absolutely still. These types of picture look best when sharply focused on a fine-grained film, so trying to make do with fast film and a steady hand will only lead to disappointment.

If you're shooting on 35mm then the majority of daytime travel photographs can be taken handheld, but the golden hours around dawn and dusk, invariably require a small aperture and slow shutter speed to achieve the sharpest exposure with maximum depth of field. In such conditions the tripod is the best way of keeping your camera totally still.

Your tripod needs to be strong enough to support your camera with its longest and heaviest lens. Fortunately, the increased use of carbon fibre means tripods can be both strong and light. Before you buy, remember to check the height of the tripod when the legs and central column are fully extended. Obviously, the taller the tripod the greater the cost.

There are two types of tripod head: tilt/pan and ball head. Check out which type offers the greater degree of movements with the most secure settings. A good head should allow you to switch the camera easily between vertical and horizontal positions, without slippage. Some tripod heads include a spirit level, which can be very useful for keeping the camera absolutely level. This is essential if the horizon or a distinct horizontal line such as wall or surface water is included in the frame.

Whichever type of head you choose, an accessory worth getting is a quick release. This is a plate that screws into the tripod bush at the base of the camera and slides into the tripod head. The quick release plate can be locked or unlocked by flicking a small catch and is best kept attached to the camera, unless you're not taking your tripod. Small table-top tripods should only be used for compact cameras and lightweight SLRs. They can be handy if used on a firm flat surface but too many people expect these compact supports to hold more weight than they were designed for.

If you're still not convinced by the virtue of a tripod, a monopod might be a practical alternative, particularly if you're trekking in mountains. Some monopods double up as walking sticks and while not giving the rock-steady support of their three-legged cousins, they can help you reduce the chance of camera shake at slow shutter speeds. A beanbag is also worth packing as it is small, light and inexpensive. It provides support by moulding around the camera and lens base when rested on a firm surface like a wall or car door. Not only does it help dampen any vibration but it will prevent your camera and lens from being scratched on an abrasive surface.

With so many places prohibiting flash photography, you may wonder whether there is any need to take a flashgun on your travels. Some photographers seem to manage without one, but flash does give you more options, even outdoors. The most common usage is for portraits indoors where the available light is too low. Flash allows you to get the picture without having to resort to a tripod, uprate your ISO setting or load with a faster film.

Most cameras feature a built-in flash but this is a low-powered device of limited capability. A separate flashgun not only delivers more power and functions, but it can be used off-camera (with a connecting cable) to avoid the harsh shadows and unflattering redeye of direct flash. Flashguns can also tilt and swivel, allowing you to 'bounce' the flash off walls and ceilings. The effect of this is to diffuse the light and change the direction the shadows fall. Altogether, it makes for a less harsh result than a burst of direct flash.

Flash is most easily used outdoors to add light to areas that are in shade. This is known as fill-in and is very handy when photographing a backlit subject. Without flash, someone photographed with the sun directly behind them would be rendered as a silhouette.

Every camera has a flash sync speed, usually 1/125sec or 1/250sec, sometimes faster. This is the fastest shutter speed you can use with flash, but you can of course use slower speeds, known as slow-sync flash. This technique looks particularly effective on moving subjects at night, the flash freezing the main subject areas close to camera while registering the background as a blur of movement and ambient light. It's best to take a flashgun that's made by the same brand as your camera. This will be a model that is fully dedicated to your camera with many automatic functions at a touch of a button. Experimenting with the various features is made easier with a digital SLR as you can study the result on the LCD monitor immediately after exposure.

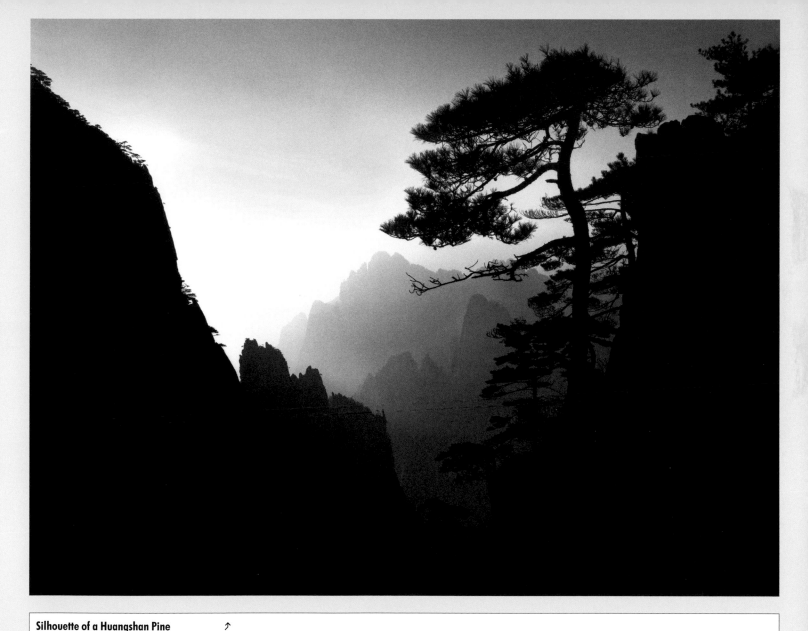

Silhouette of a Huangshan Pine ↗

Upon returning to his ancestral home after decades of living abroad, Leping Zha was captivated by the villages and indigenous pines of the Huangshan (Yellow Mountains). The graphic simplicity of this lone pine silhouetted against the sky and the mountainous background becomes an even stronger composition when photographed in black & white. He added and orange filter to the lens to darken the sky and shadow areas.

Photographer: Leping Zha

Location: Anhui Province, China

Time: Late afternoon, October

Camera: Pentax 67II

Lens: Pentax SMC 45mm f/4 wideangle

Film: Ilford FP4 rated at ISO 125

Exposure: 1/20sec at f/22

Tripod: Yes

Filters

For many, the fundamental purpose of travel photography is to record what you see with as little embellishment as possible. Travel photographers generally aren't the sort who experiment with special effects filters or use Photoshop to paste the Taj Mahal onto the foreshore of Sydney Harbour. Instead, filter selection tends to fall to a favoured few: ultraviolet (UV); polarising filter; skylight & 81 series warm-up, and neutral density (ND) graduate.

UV filter

I bought my first UV filter in Hong Kong when it came free with the 80–200mm zoom I was buying on my way to the Himalayas. According to the salesman, the filter's main purpose was to protect the front lens element from being marked or scratched. And for many that has been the sole purpose of this much underappreciated lens. And yet, given the altitudes I was to ascend in the coming weeks while in Nepal, that humble UV was to prove very useful, blocking out the increasing amount of ultraviolet rays penetrating the thinning atmosphere during our ascent. Too much UV alters the colour temperature of the scene thereby affecting the colour balance of the film. By adding a UV filter, excessive ultraviolet light is blocked from reaching the film, ensuring the film's daylight balance remains neutral. Without the UV, there would have been less contrast and a hazy blue cast to the exposed frames.

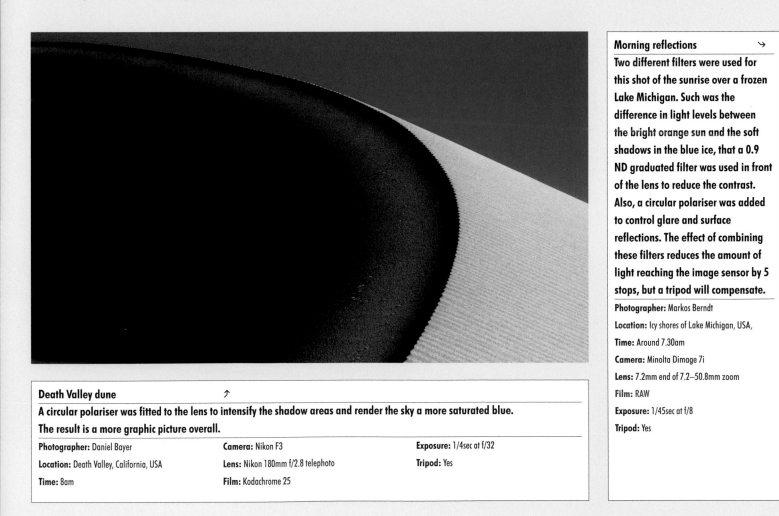

Morning reflections ↘
Two different filters were used for this shot of the sunrise over a frozen Lake Michigan. Such was the difference in light levels between the bright orange sun and the soft shadows in the blue ice, that a 0.9 ND graduated filter was used in front of the lens to reduce the contrast. Also, a circular polariser was added to control glare and surface reflections. The effect of combining these filters reduces the amount of light reaching the image sensor by 5 stops, but a tripod will compensate.
Photographer: Markos Berndt
Location: Icy shores of Lake Michigan, USA,
Time: Around 7.30am
Camera: Minolta Dimage 7i
Lens: 7.2mm end of 7.2–50.8mm zoom
Film: RAW
Exposure: 1/45sec at f/8
Tripod: Yes

Death Valley dune ↗
A circular polariser was fitted to the lens to intensify the shadow areas and render the sky a more saturated blue. The result is a more graphic picture overall.
Photographer: Daniel Bayer
Location: Death Valley, California, USA
Time: 8am
Camera: Nikon F3
Lens: Nikon 180mm f/2.8 telephoto
Film: Kodachrome 25
Exposure: 1/4sec at f/32
Tripod: Yes

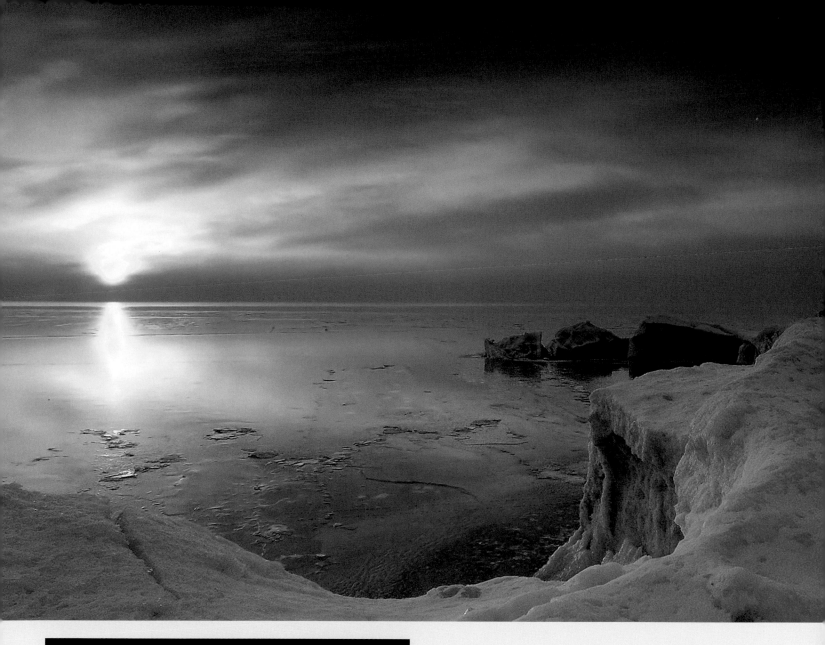

Polarising filter

One of the most popular and overused filters in photography, the polariser can be very effective and versatile when used adroitly. It reduces reflected light from shiny surfaces, particularly water, thereby raising contrast and colour intensity. Polarisation is adjustable by rotating the filter and you can see the degree of this effect while looking through your SLR viewfinder. The sun's position also has an influence on the effectiveness of this filter, with the most marked effect occurring when the sun is approximately 90° to the left or right of the front axis of the lens.

While it is often said that a polariser has no effect when the sun is behind you, reflected light scatters in all directions depending on the angle of the reflected surface to the sun. It therefore follows that in an outdoor setting, particularly on a clear day, there must be some reflections that can be polarised no matter where the sun is in relation to the camera. Polarisers reduce the amount of light reaching the film plane by two stops, so remember to check that your shutter speed is fast enough before firing. Many people overuse polarisers, especially on bright sunny days when contrast levels are high. In these instances a polariser will exaggerate the contrast and could turn the sky almost black in extreme cases.

Filters

Skylight & 81 series

Like UV filter, the skylight is one of the first filters that photographers become acquainted with. The actual effect is slight, an almost indistinguishable reduction in the blue cast that can occur outdoors when shooting in shade. For most photographers the primary purpose of a skylight filter is to act as a protective shield over the lens.

Far more noticeable however are the skylight's amber-tinged brothers, the 81a, 81b and 81c series. Known as 'warm-up' filters, these are designed to block the amount of blue light in shadow areas, resulting in warmer balance to the overall scene. These filters are popular with landscape photographers and the 81c gives the strongest effect, yet reduces light reaching the film by 2/3stop.

Neutral density (ND) graduates

These filters have gained in popularity in recent years because of the way they can help the photographer control the light reaching the film plane or image sensor without bolstering or reducing any particular colour of the spectrum. These filters are clear in one half and tinted in the other half, with the tint density reducing (graduating) towards the centre of the filter, creating a straight but soft line across the middle of the filter. By placing this line on a part of the scene where there is a natural division in the frame, such as the horizon, the effect and use of the filter will not be obvious. ND graduates are used to cut down the amount of light reaching the film in half of the scene. This is useful where contrast variances are too great for transparency film to register. By placing the graduated half over that part of the scene where a lot of light is being reflected, such as water, or an overly bright sky, the overall contrast within the frame can be reduced to a level that is within the exposure tolerances of film. ND graduates such as those made by Lee Filters come in three different densities – 0.3, 0.6 and 0.9 – with each type reducing light by an extra stop.

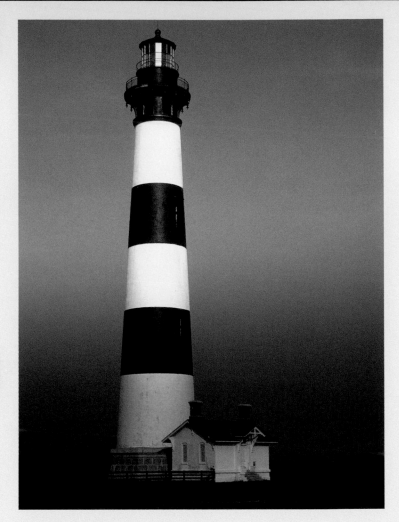

Bodie Island lighthouse ↗

This picture is an example of how filters can be used to overcome lighting conditions that are less than ideal. The photographer, John Orr, had been asked to photograph a number of lighthouses in North Carolina in just one weekend. At Bodie Island, the sky was cloudless and hazy, the sun high in the sky and the light very strong. Orr decided to stack several filters in order to create an impression of a lighthouse being lit by a warm sunset. He used an 81a warm-up filter, a purple graduate for the top half of the picture and a neutral density (ND) graduate filter for the bottom. He relied on the camera's automatic metering system for the exposure and bracketed one stop over and under this reading.

Photographer: John Orr	**Lens:** Nikkor 80–200mm f/2.8 ED zoom
Location: Bodie Island, North Carolina, USA	**Film:** Fuji Velvia 50
Time: 2pm	**Exposure:** f/22; shutter speed not recorded
Camera: Nikon F100	**Tripod:** Yes

Guadalupe dunes →

An hour before sunset, warm side lighting emphasises the sand ripples and surface texture of this dune. The Canon TS-E 24mm lens is more than a wideangle – it is one of a few 35mm format lenses that also feature tilt and shift movements for maximising image sharpness. For this picture the photographer tilted the 24mm lens down to ensure all the foreground was in focus. The top of the dune is high in the picture with only a small expanse of sky in order to give more attention to the foreground ripples at the bottom of the picture. This effect is also helped by the lens distortion that exaggerates the size of the ripples at the bottom edge of the frame.

Photographer: Inge Johnsson

Location: Guadalupe Mountains National Park, Texas, USA

Time: 6pm, October

Camera: Canon EOS 3

Lens: Canon TS-E 24mm f/3.5L tilt & shift lens

Film: Fuji Velvia 50

Exposure: Not recorded

Tripod: Yes

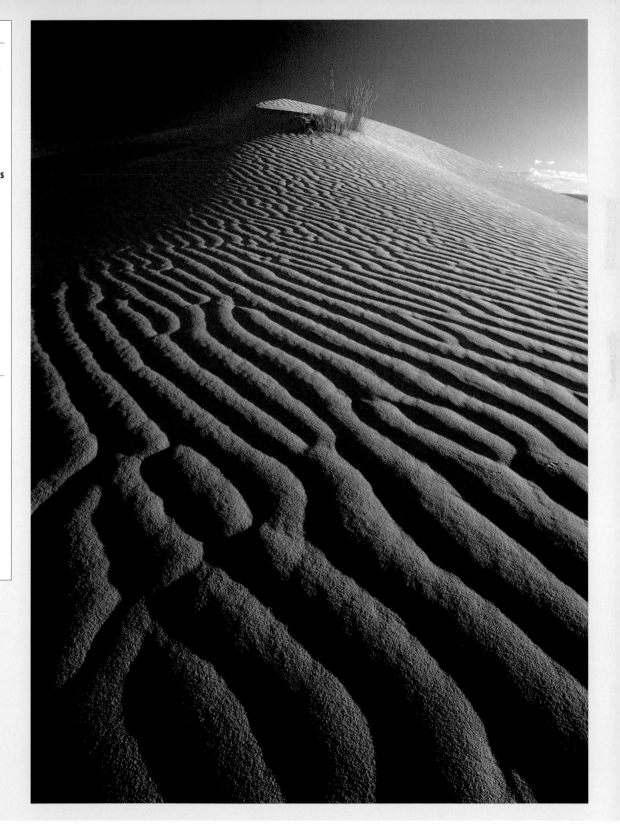

Filters

Camera bags, rucksacks & hand luggage

You should keep all your camera gear, including film, in the same bag or rucksack and keep it separate from the rest of your luggage. There was a time when all camera bags were carried on your side, slung over one shoulder. Nowadays, the rucksack or backpack has taken over as the prime means of carrying camera gear. There are many different makes in dozens of styles and sizes, some specifically designed for medium format and large format camera systems too. The basic design is the same with separate, adjustable padded sections for camera bodies and lenses, as well as smaller compartments for film, batteries, filters, quick release plates and other accessories.

A backpack is the best way to carry lots of gear over long distances and is better for your back in the long term than a shoulder bag. However, the traditional shoulder bag is quicker for retrieving your camera when a picture opportunity suddenly presents itself. Of course, whether you're carrying a backpack or shoulder bag, you could have your camera at the ready by wearing it on a strap around your neck. However, be wary of inviting unwanted attention in areas where crime is a concern.

Some photographers hold their camera gear in photo vests or small packs worn around their waists. Although it is easy to get the desired equipment immediately to hand, waist packs and hip bags prove inconvenient when worn with a jacket, fleece or overcoat. The important thing is to only pack what you need. Don't weigh yourself down with too much gear and only use a bag or rucksack big enough to take on board a plane as hand luggage. It's worth checking with your airline in advance what restrictions there are on size of hand luggage allowed on board. For example, Singapore Airlines allows one item of hand luggage up to 7kg in weight and with dimensions no larger than 115x115cm. Other airlines might not be so generous.

Shoulder bags (below right) are useful if all you need is your camera but rucksacks are specifically tailored to pack a large amount of camera gear (below left), including straps to carry a tripod.

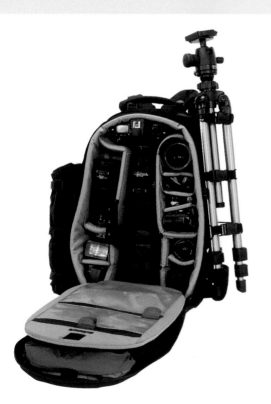

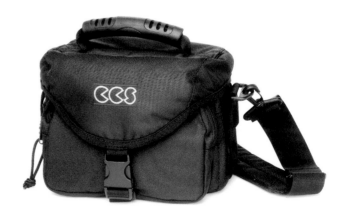

Batteries & other accessories

Carefully chosen accessories could be the added extra needed to getting a once in a lifetime picture. Some are more obvious than others, but here's a list of what else I pack once I've got the cameras, lenses, filters, tripod and film packed.

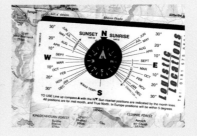

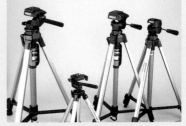

Spare batteries
enough lithium or AA alkaline cells for at least two changes. Double that for a digital camera and don't forget the AC mains adapter as well.

Spirit level
slips onto the camera hotshoe to check the camera (and therefore the horizon) is perfectly level.

Sunrise/sunset compass
find north then see from the month lines where the sun will rise and set at your location.

Tripod quick release plate
keep this screwed to the baseplate of the camera in use in order to speed up connection and disconnection with tripod.

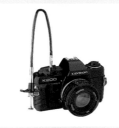

Lens hoods
for all lenses. Handy for cutting out flare particularly when shooting into the light.

Gossen lightmeter
rarely used as camera meters are so much more accurate, but handy for checking the camera's reading in tricky conditions.

Remote release
to trigger the camera shutter from a short distance when the camera is mounted on a tripod.

Small coin
for opening battery compartments. The grooved cap of some battery compartments requires a coin to twist it open.

Lens cloth or wipes
clean your camera and lenses every day when you're away travelling. Dust, grit and salt can cause so much damage if allowed to accumulate.

Notebook & pencil
to record names of places, time of day and exposure details of each frame. This is hard to do when shooting 35mm but much easier to stick to when using medium format.

Security & restrictions

When I'm travelling, I use those hours of confinement on a long haul flight or train journey to think about what lies ahead. If it's a place that I've visited before, I think about the highlights of the previous trip and make a list of subjects that I intend to visit. The time of day, camera position and lighting are things I like to work out in advance. Of course there is the chance of the unexpected, such as a tower of scaffolding or a skyline covered in builders' cranes.

When visiting a destination for the first time, expectations are usually higher, you will have spent hours poring over pictures in guidebooks and magazines, reading travel books, and listening to other travellers' tales. With all this build up it can be all too easy to forget about the obstacles to be encountered at the airport – and beyond.

Airports

Since 11 September 2001, security has become the number one issue affecting international travel. While all travellers have had to adjust to more body searches, longer check-in times, more armed police at airports and a greater number of government warnings about the safety of certain countries, photographers have to deal with other changes that have had a direct impact on their livelihoods. For example, attempting to have your films hand searched instead of scanned by the ubiquitous X-ray machine is becoming more and more difficult. And given the experience of a group of British plane spotters in Greece in 2002, it makes good sense not to take any photographs of planes from anywhere in or around an airport unless you have permission from an airport official to do so. Wherever you see a 'no photography' sign, obey it.

Post-war Bosnia – escape ↘

A simple spiral staircase on the outside of a building wouldn't normally warrant a photograph. However, the bullet holes in the walls contrast markedly with the normality of the exit. The staircase also provides a strong graphic quality to the scene, which holds the viewer's attention.

Photographer: John Orr

Location: Sarajevo, Bosnia

Time: 2pm

Camera: Nikon F100

Lens: Nikkor 80–200mm f/2.8 ED zoom

Film: Fuji Provia 100

Exposure: 1/20sec at f/8

Tripod: Yes

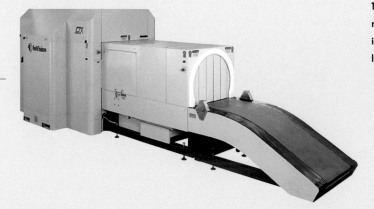

The CTX 5500 explosive detection system (EDS) made by InVision Technologies is used widely in the world's airports for scanning checked-in luggage and will damage film of any ISO rating.

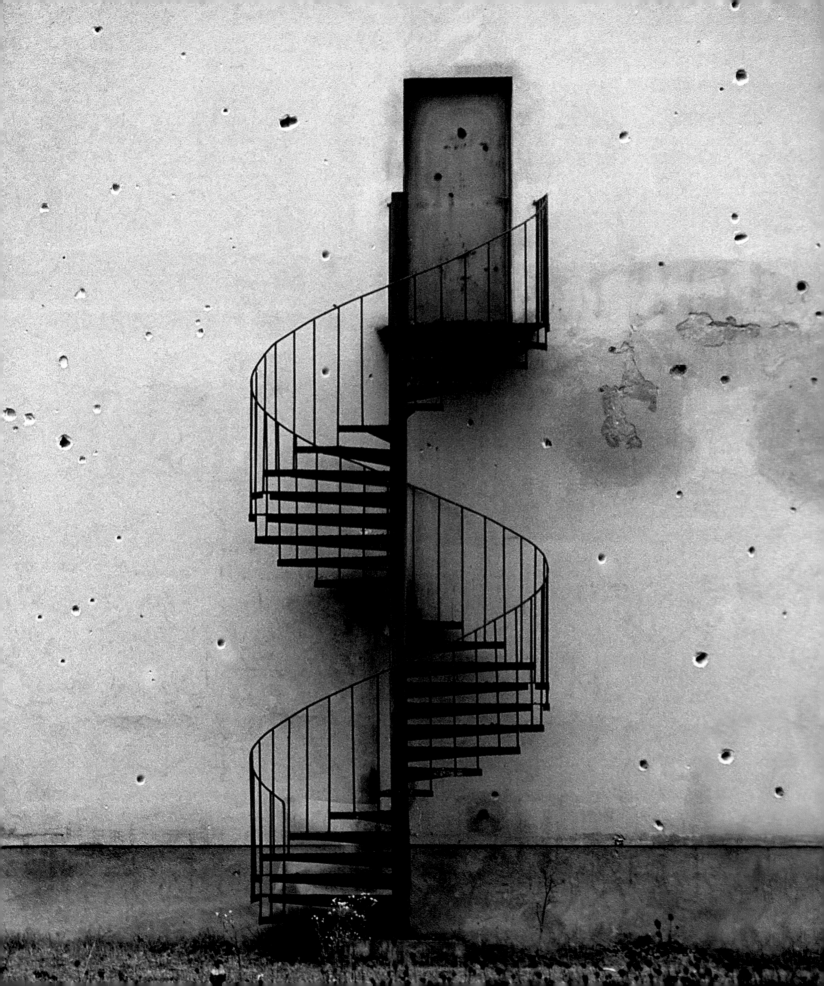

Border crossings

While the 'no photography' sign is a familiar sight at practically every international airport and seaport, the attitude to photography at border crossings can vary substantially from country to country. Whether you can take pictures also depends on the current political climate as border disputes have a habit of flaring up unexpectedly. In well-known sensitive borders such as India/Pakistan, common sense should prevail and the camera kept from view, even if there's no sign forbidding photography.

And yet in other border areas photography is practically encouraged. On one excursion I made to Korea's demilitarised zone (DMZ), our United Nations' guide (a crew-cut all-American soldier) was only too willing to pose for photographs just yards from the border where North Korean soldiers were in eyeball-to-eyeball stand-offs with their UN counterparts. Separating them was a straight, white-painted borderline that neither side dare cross. It was incredible to think that at this most dangerous of all political boundaries (the two sides are still officially at war), tourists by the coachload could snap away freely and enjoy a guided tour of a war zone. While Koreans are forbidden from visiting the DMZ, more than 100,000 foreign tourists visit this area every year.

The DMZ is a surreal example and fortunately most countries sharing borders are plainly at peace, but stay circumspect and don't take pictures unless you are absolutely certain that it is permissible.

Maps & orientation

It is very difficult to know the layout of a place you're visiting without referring to a good quality, large scale map. Don't just rely on the maps reproduced in a guidebook. These won't be detailed enough to show you the key sites, roads and routes. In big cities like Paris, New York, Tokyo and Sydney a good quality street map or atlas will prove indispensible for finding your way around the streets and helping you to work out the quickest way to train stations, bridges and major landmarks.

If you haven't done so in advance, purchasing a local map or street atlas should be a top priority as soon as you arrive at your destination. Check the scale of the map so that you don't underestimate the difference between blocks and study the key until you become familiar with the local map symbols. If you're walking in a big city or town, it's worth timing how long it takes you to walk a block or two. This way, you will be able to work out roughly how much time you will need to get from A to B – and back again. Another tip is to find north on your map and, with the aid of a compass, point it in that direction – this way you can anticipate the direction the sun will fall on various streets and locations before you actually get there.

Of course, maps are essential for safe travelling around rural and wilderness areas, mountain ranges and coastal paths, so don't go anywhere without one. For the photographer they also help you to work out the best place to be for the sunlight at various times of day.

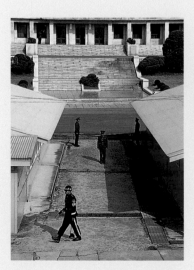
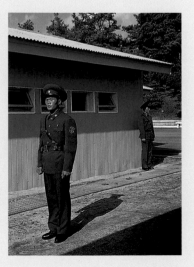

Skywards ↘

This quirky sign painted on the wall of a building scheduled for demolition is either for the seriously disorientated or another example of the unexpected ephemeral art that so characterises 'California cool'. With the sun high in the sky eliminating any shadows on the face of the wall, it proved an easy subject to expose and focus. The photographer used Photoshop to correct the tilted perspective.

Photographer: Stephen Rudy	**Lens:** Built-in Zuiko 9–36mm zoom at 16mm setting
Location: San Francisco, California, USA	**File type:** JPEG
Time: 1pm	**Exposure:** 1/125sec at f/5; ISO 80
Camera: Olympus E-10	**Tripod:** No

Border guards, DMZ, Korea. Officially, they are still at war, but at the DMZ tourists are permitted to photograph the border between North and South Korea.

Acclimatising

Jet lag & local hours

The hardest part of any arrival is getting accustomed to the daily cycle and local rhythms of your destination. This isn't made any easier by jet lag – that peculiar condition experienced by every traveller who has spent long hours flying through numerous time zones in the confined space of economy class. We all know how the fatigue of jet lag feels and the way it affects us in the days after arrival, but the fact remains that the sooner we can adjust to the local hours of our destination, the better. The most sensible advice for any long haul flight is to drink plenty of water. The air in passenger jets is much drier than what we're used to on land and air pressure is kept at a lower level too. These factors cause us to dehydrate at a faster rate than normal.

In many tropical and Mediterranean countries, trading hours begin earlier than they do in northern Europe, North America and other Western countries. They also close for lunch, in most cases not just for an hour, but usually two, sometimes longer. It is advice worth following, because the heat of early afternoon is not a good time to be outside seeing sights. Instead, stop for lunch, a long lunch, have a nap even. The light is too harsh and shadows too dense at this time of day to make good pictures – colours will be burnt out and shadow detail non-existent. Instead, it is far better to do your sightseeing and photography first thing in the morning and late in the afternoon. Check out the local calendar for public holidays and religious festivals. There could be a colourful and busy day of celebration around the time you're visiting and, if you find out in advance, it's worth doing some background reading so that you know what to expect. Being prepared in this way will help you decide what types of picture can be taken and what accessories you should use.

Wherever you are in the world, especially Asia, Africa and Latin America, there is bound to be a number of local markets. The days and times of these are worth noting because they are the focal point for many communities and, as a result, a rich source of photographs.

Finally, in cities and towns find out when places generally close in the evening and what areas should be avoided late at night. Travellers with lots of obvious camera gear tend to attract the wrong sort of attention after dark.

Local supplies

No matter how well you prepare, you are bound to need something that you didn't pack or that you run out of before the end of your trip. And then there is the possibility of losing something that you can't do without: batteries, a polarising filter, memory card, quick release plate, to name a few. Before you travel, ascertain how far you will be from a well-stocked photographic supplier at your destination. If you can't be certain that you will be able to get what you want while you're there, then make sure you pack as much as you will need.

Camera & lens care

Proper maintenance of your camera will help ensure a high standard of performance for many years. Fortunately, the cost of running and maintaining a camera and lens system is minuscule and requires only a few minutes of your time. At the end of each day's shooting, use a small blower brush and a lens cloth to brush away any dust or hair from the camera body and lens barrel and gently wipe the front of the lens with the cloth. To protect your lens keep a skylight filter attached to your lens. Carry your camera in a bag or backpack rather than around your neck or shoulder and only bring it out when you are ready to make a photograph.

Most people don't pay much attention to those little sacks of silica gel found in camera and lens boxes when bought, but they have great practical value when travelling through humid countries. Silica absorbs excess moisture in the air, thereby reducing the risk of mould forming inside the camera or lens. Put at least two silica gel sacks in your bag, next to your gear, and check its condition every few days. If it has become moist it will need replacing or drying out. Another characteristic of travelling through tropical countries is the build-up of condensation on the surface of the lens and viewfinder. This is caused by the rapid change in ambient air temperature, when moving from a cooler space, such as an air-conditioned hotel room, to the humidity of the street outside. Don't immediately wipe the surface of the camera or lens, as the condensation will return. Instead, just wait for your equipment to warm up and the fog on your lens will soon clear.

By day, much of Washington DC is overrun with tourists, but late at night it is a different proposition. Even the Jefferson Memorial is deserted. The combination of black & white film, the late hour and a strong wind to blow the woman's hair over her face have resulted in a moody image that conveys loneliness and isolation within the grand designs of the Memorial.

Photographer: John Orr

Location: Jefferson Memorial, Washington DC, USA

Time: 2am

Camera: Nikon F100

Lens: Nikkor 17–35mm f/2.8 AF-S ED zoom

Film: Ilford Pan F 50

Exposure: f/22; shutter speed not recorded

Tripod: Yes

Sunrise & sunset times

As every landscape photographer knows, the best light for photography is at those hours around sunrise and sunset. The sun is low in the sky and the resulting golden light gives a pleasing warm cast to everything it touches.

When arriving at your destination, one of the first things you should do is to find out the local sunrise and sunset times. These times are published in every local newspaper and the information is vital for planning your day. Ask the locals where the sun rises and sets – it's not always the case that the sun 'rises in the east and sets in the west' because, depending on the latitude of your location, there can be enormous variances at different times of year.

For years television and film camera crew have been using a sunrise/sunset compass. This is a special compass that not only points to True North, but it also gives the estimated sunrise and sunset positions at every mid-month of the year for a number of locations at the equator and up to 50° from the equator. Not surprisingly, many professional travel and landscape photographers carry this compass in their backpacks. It is a very useful and inexpensive accessory.

A sunrise/sunset compass is a useful tool to keep in your camera bag.

Sabah sunset　　　　　　　　　　　↘

Having watched the previous night's sunset over the South China Sea, I knew exactly where to point the camera. During the day I scouted around for a suitable viewpoint and this aspect on a small hotel beach with its palm trees and view of nearby islands provided features that would produce distinctive silhouettes when exposing for the sunset. Sky and water are full of colour and, with a film like Velvia which saturates colour, no filters were necessary.

Photographer: Keith Wilson

Location: Kota Kinabalu, Sabah, Malaysia

Time: 6.30pm

Camera: Pentax 67 II

Lens: Pentax 90mm f/2.8

Film: Fuji Velvia 50

Exposure: 2sec at f/16

Tripod: Yes

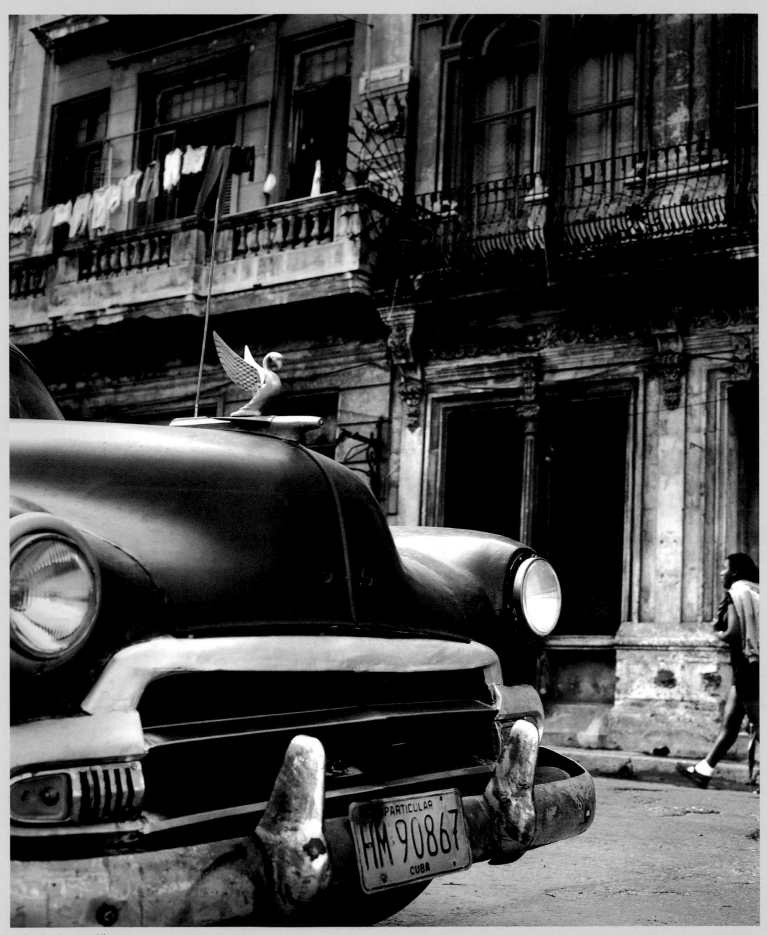

Steffen Ebert (see page 54)

Section 2
On arrival

Even to the most experienced traveller the excitement of a new location can lead to an immediate dash for pictures from the moment of arrival. This isn't wise. Restraint is needed; just spend a small part of your time to plan and prepare for the days that lie ahead.

Focusing

Autofocus SLR cameras first appeared on the scene in the mid-1980s and in the years since AF systems have developed to such a level of sophistication that it is hard to imagine a situation where there is still a need for manual focus. Practically all AF SLR cameras – digital or film – provide a choice of single shot and continuous focusing modes. The former is ideal for landscapes, architecture, posed portraits and any other inanimate subjects.

Continuous AF is best selected when photographing a subject on the move – wildlife, vehicles and sports action. The first AF cameras had only one focusing frame in the viewfinder, now some models have several dozen covering a wide area of the frame to maximise the speed at which you can focus the camera and get the picture. This degree of automation, coupled with high speed frame advance, has revolutionised action photography, making it possible to have a rapid sequence of frames of a fast moving subject, each one sharply in focus. Knowing that you can rely on the camera to keep your subject in focus allows the photographer to consider other factors such as composition, background, and handling.

Most photographers use single shot AF for the majority of situations. While AF makes it more likely to get a sharp grab shot, there is a danger of always composing your subject centrally in the viewfinder, aligned with the central focusing frame. There are two ways of avoiding this: either manually set one of the off-centre focus frames and align your subject with that or focus centrally, then lock focus and recompose so the subject is off-centre. One area of photography where manual focus is still superior is for macro work. When using macro lenses or extension tubes to take extreme close-ups of flowers, insects or surface details, the plane of focus is so narrow that sensitive adjustments are done more accurately by hand.

Manual focus has another great advantage – it is silent. The noise of a camera's AF whirring can be irritating at a time that demands reverence and quiet. Fortunately, there are some AF camera and lens combinations that use silent motors, which help the photographer to work discreetly in situations that call for it, particularly important religious ceremonies.

Using hyperfocal distance & depth of field

Along with focusing and composition, controlling depth of field is fundamental to the overall impact of an image. Most travel photographers like to photograph a scene with as much detail and image sharpness across the frame as possible. For this reason, they will select a small aperture, but if they're handholding the camera, having an aperture/shutter speed combination that doesn't result in camera shake becomes a greater priority than maximising depth of field.

To get the greatest possible depth of field your camera needs to be mounted dead still on a tripod. This way you can set an aperture of f/22 or even f/32, knowing that the resulting slow shutter speed will not lead to image blur.

Of course, the closer your subject is to the camera, the narrower the plane of focus (or depth of field) will be. But whether your subject is a few feet from your lens or on the horizon, it is where you place your focusing point – the hyperfocal distance – that will determine how much area behind or in front of your subject will be sharp.

The temptation is to always focus directly on your subject, particularly when using AF. This is convenient but by focusing on part of the frame that is around a third or halfway between the nearest and farthest points of the scene you want in focus, you will be truly maximising the depth of field of your chosen aperture. Most AF SLR lenses made today no longer include the depth of field scales that showed so clearly the hyperfocal distance for every aperture setting. Instead, we need to rely increasingly on a camera's depth of field preview facility, which is fine in principle but results in a darkening viewfinder image the more you stop your lens down.

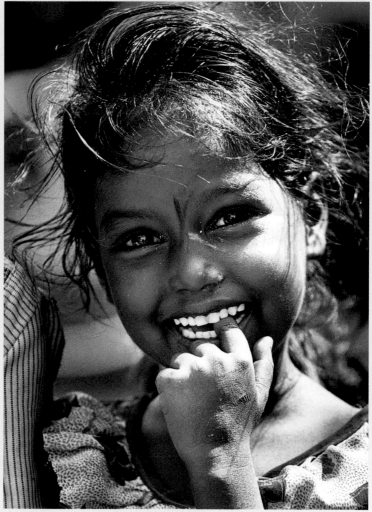

Robe ↗

A large format camera was used for this shot by **Christophe Cassegrain** who wanted maximum depth of field, so that no part of the image was out of focus. With large format cameras you can tilt and shift the lens with precise movements, altering the plane of focus within the frame. Stopping the aperture right down also increases depth of field. Establishing the right combination of lens movements and aperture setting eventually led to the desired result – a crisply focused and beautiful exposure of a fragile landscape.

Photographer: Christophe Cassegrain	**Lens:** Apo-Symmar 120mm f/5.6
Location: Paria Plateau, Arizona, USA	**Film:** Fuji Velvia 50
Time: Five minutes before sunset, November	**Exposure:** 1/2sec at f/32.6
Camera: Linhof Master Technika 4x5	**Tripod:** Yes

Indian beauty ↗

In the last minutes before sunset, this young girl is evenly lit by the light, which is bright but not too harsh. Shadows are few and the even coverage of light across her face and clothes meant the photographer, **Alan Chan**, could rely on his camera's automatic exposure system for an accurate reading. He just waited for the right moment when her striking eyes looked away in a moment of curiosity. The shadow of another child can be seen on the wall to the left of the picture, a clue that she wasn't alone.

Photographer: Alan Chan	**Lens:** Summilux 35mm f/1.4
Location: Kashmir, India	**Film:** Fujicolor 400
Time: Late afternoon	**Exposure:** 1/30sec at f/2.8
Camera: Canon EOS 1	**Tripod:** No

Focusing

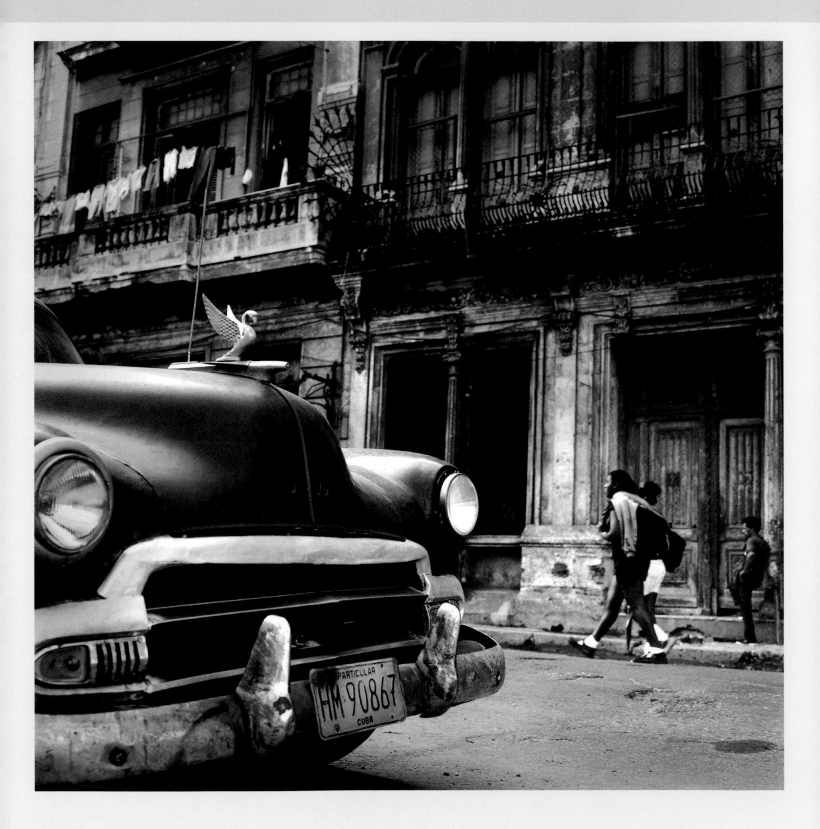

Venceremos 13 ↖

Old model American cars from the 1950s are a prominent feature of Havana's streets, which are also characterised by the decaying Spanish colonial architecture. Capturing both elements in focus for this picture required using the hyperfocal distance technique, whereby the photographer aligns the lens depth of field scale of his chosen aperture with a focusing distance that ensures the maximum depth of field. The smaller the aperture setting, the greater the depth of field. In this case, the photographer chose f/16 while still being careful to have a fast enough shutter speed for handholding the camera without causing blur .

Photographer: Steffen Ebert
Location: Havana, Cuba
Time: Around noon
Camera: Hasselblad 202 FA
Lens: Hasselblad Planar 80mm f/2.8
Film: Kodak T400CN rated at ISO 200
Exposure: f/16; shutter speed not recorded
Tripod: No

Pride ↗

Strong eye contact is the characteristic of this portrait. The soft, almost monotone, natural colour helps accentuate the eyes and a wide aperture – f/4 – has narrowed the plane of focus so that nothing in the background distracts from the eyes. With such a wide aperture on a telephoto zoom, there is shallow depth of field, so focusing has to be critical, in this case always on the eyes of the subject.

Photographer: Hans Molenkamp
Location: Mali
Time: Late afternoon
Camera: Nikon F3
Lens: Nikkor 80–200mm f/2.8 zoom
Film: Fujicolor 100
Exposure: 1/60sec at f/4
Tripod: No

Focusing

Cleared for take-off ↖ ↗

Initially photographed in colour, this gentle sequence of pictures showing a seagull taking off from its perch was later converted into black & white in Photoshop, using Channel Mixer. It was a warm day, but so hazy that the horizon was blocked from view. The scene was lacking in contrast and Arthur Sevestre focused manually to take these pictures and spot metered from the darkest part of the water. Exposure was entirely automatic and no override was implemented.

Photographer: Arthur Sevestre **Time:** Latter half of the morning **Lens:** Sigma 50–500mm f/4–6.3 EX APO zoom **Exposure:** f/6.3; shutter speed not recorded

Location: On a beach near Schoorl, the Netherlands **Camera:** Minolta Dynax 7 **Film:** Fuji Velvia 50 **Tripod:** Yes

Understanding exposure

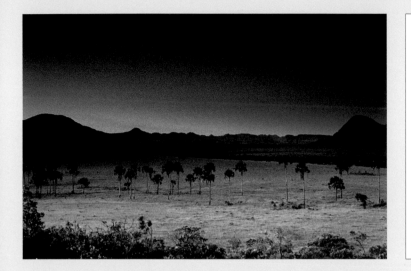

Maytrea's crepuscle ↖

Twilight is a brief but beautiful time when the sky reflects a rich and dark colour gamut. There is also a gradation in the sky as the fading light of sunset gives way to increasing darkness. In this scene, the areas of light and dark in the sky are symmetrically balanced. A blue polariser has further saturated the colour in the sky, and a 1.3 neutral density graduate filter was added to balance out the exposure difference between highlights and shadows. These filters reduced the amount of light hitting the film plane by 6 stops, resulting in a long exposure of 10sec.

Photographer: Marcio Cabral

Location: Maytrea Gardens, Veadeiros Tablelands, Brazil

Time: 20 minutes after sunset

Camera: Nikon N80

Lens: Nikkor 28–70mm f/2.8 zoom

Film: Kodak E100VS

Exposure: 10sec at f/11

Tripod: Yes

Most cameras made today have a gamut of programmed exposure modes, indeed some have nothing else. These automatically set the shutter speed and aperture for correct exposure based on the camera's metered light reading. There's a mode for portraits, another for landscapes, one for action, another for macro – there seems to be one for every eventuality. For each of these modes, correct exposure is determined using different combinations of aperture and shutter speed.

By leaving this calculation to the camera's on-board computer, you are trusting it to set the right combinations and define the correct exposure every time. Working in this way is to forsake control. For certain effects, you need to steer the camera away from programmed modes and have a direct input on the shutter speed, aperture settings or both. It is important also to understand the meaning of correct exposure. Most in-built camera meters are very reliable and the addition of a spot metering facility allows you to take individual readings of different parts of the scene to check the exposure variance within the frame. Camera meters generally give an average reading of the overall scene, but this isn't necessarily 'correct' exposure. Correct exposure is where a photograph renders detail in both highlight and shadow areas of the scene. In low contrast scenes, this holds true but, in scenes of high contrast or extreme brightness, a camera meter is likely to give a reading that, if followed, would lead to underexposure. In such a scenario, the photographer needs to override the metered reading and compensate the exposure.

Aperture priority

Allows you to set the lens aperture, while the camera works out the corresponding shutter speed for correct exposure. As we have seen above, apertures have a direct effect on the depth of field of a photograph. For views of stunning natural landscapes, distant panoramas or coastal sunsets, stopping down your lens while working in aperture priority is ideal. Conversely, portraits require you to open up the aperture to render the background out of focus, thereby making the focused eyes stand out even more.

Shutter priority

In shutter priority you select the shutter speed and the camera determines the resulting aperture. This is the mode to use for shots of moving subject, or when working with telephoto lenses, which magnify any movement while being handheld.

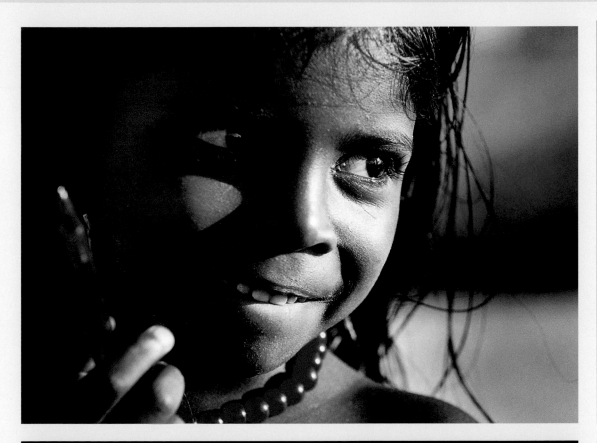

Indian girl ↩

This young girl was spotted playing among a group of children on open ground in bright sunshine. Alan Chan, chose an angle where they would be subjected to side lighting. He engaged with them by pulling faces. By focusing on her eyes he was ready to fire the shutter when the right moment arrived. An aperture of f/5.6 meant the background would be out of focus and therefore not distract from the girl's eye contact.

Photographer: Alan Chan

Location: Madurai, India

Time: 11am

Lens: Canon 70–200mm L f/4 zoom

Camera: Canon EOS 1

Film: Kodak Gold 100

Exposure: 1/250sec at f/5.6

Tripod: No

Cloister ↩

Such is the sophistication of modern camera metering systems that even a scene of great contrast such as this cloister can be accurately rendered. To record the right balance between light and shade, Josep Lluis Grau merely set his camera to auto. He composed the picture carefully, making sure that the turning point of the cloister remained within the edge of the frame.

Photographer: Josep Lluis Grau

Location: Roda de Isabena, Spain

Time: 2pm

Camera: Nikon F70

Lens: Sigma 24–70mm AF-D zoom

Film: Fuji Sensia 100

Exposure: Not recorded

Tripod: No

Exposure compensation & bracketing

Camera meters are calibrated to reproduce a scene as an 18% shade of grey. As a result an all-white scene such as a snow-covered field is reproduced grey when exposed at the camera's metered reading. In such a situation additional exposure is needed and this can be applied via the camera's exposure compensation dial or button. Most cameras allow you to compensate exposure in 1/3 or 1/2 stop increments. How much exposure compensation you give depends on the amount of white or highlights in the frame. For instance, snow or sand beneath a bright sun reflects a lot of light and will fool your camera meter into underexposing, so keying in exposure compensation of +2 stops might well be necessary.

A less extreme but common example is the summer landscape with a clear blue sky occupying the top half or third of the frame. Here the meter is likely give a reading bias towards a perfectly exposed sky, but resulting in the foreground subject matter being too dark. Exposure compensation will also be required but only around a 1/2 stop. For a balanced exposure that reproduces highlights and colours accurately and reveals shadow detail, a single compensated exposure may not always give the best possible result. So, given that 'correct' exposure – like beauty – is in the eye of the beholder, a productive course of action is to take a bracketed sequence of images. Bracketing is the practice of taking two additional shots, either side of the 'correct' reading, at values above and under this exposure. Whether you bracket by 1/3 stop, 1/2 stop, 1 stop or more around your correct exposure depends upon your personal taste and experience. Like so much of photography, it boils down to trial and error based upon myriad situations.

St Mark's basilica framed by a window ↗

On a visit to the Doge's Palace in Venice, Jon Bower couldn't resist using this window as a means of framing the roof of St Mark's in the distance. However, the huge exposure variance from the dark, shaded interior to the bright, sunny conditions outside meant he had to bracket his exposures around his selected meter reading. He ended up shooting a whole roll trying different exposures and bracketing variances.

Photographer: Jon Bower	**Lens:** Canon EF 24–70mm f/2.8 L zoom
Location: Venice, Italy	**Film:** Fuji Velvia 50
Time: 2pm	**Exposure:** Bracketed in 1/3 stop increments
Camera: Canon EOS 3	**Tripod:** No

Nordic summer ↘

In the mountains of Norway, on days where the sun shines directly onto snow, contrast levels can be too extreme for the exposure latitude of film. In these conditions light meters tend to underexpose and the resulting exposure renders the snow as grey instead of white, while losing all the details in the shadow areas. To overcome this the photographer bracketed in 1/2 stop increments around an exposure reading made with a handheld light meter. He also used a skylight filter to cut down on any excessive blue light the film might register at higher altitudes.

Photographer: James Silverman	**Lens:** 40mm
Location: Norway	**Film:** Fuji Velvia 50 rated at ISO 40
Time: 2pm	**Exposure:** 1/4sec at f/22
Camera: Bronica SQAi with 6x6cm format back	**Tripod:** Yes

Exposure compensation & bracketing

ISO settings & white balance

Every film has an ISO rating, which is set automatically in most cameras when loaded. The higher a film's ISO rating, the more sensitive it is to light – for example, an ISO 200 film is twice as light sensitive as an ISO 100 film. This has an affect on exposure values in that the same scene photographed at 1/250sec at f/8 on ISO 200 film, would require an exposure of 1/125sec at f/8 on ISO 100, and 1/60sec at f/8 on ISO 50. As with shutter speeds and apertures, differences in full ISO settings are measured in values of a 'stop'.

ISO settings can be manually adjusted as another means of overriding exposure. They can also be adjusted to attain an even faster shutter speed when the lens is already at its maximum aperture in low light. For instance, uprating a film's nominal ISO setting by 1 stop from say ISO 200 to ISO 400, will result in a 1 stop faster shutter speed. This technique is known as pushing film and the film must be given additional development time to compensate for the deliberate underexposure. The limiting aspect of this technique is that as the whole film will be given additional development time, every frame needs to have been pushed to benefit. Otherwise, frames not pushed will be overdeveloped and overexposed as a result.

There are no such problems with digital cameras where ISO settings can be adjusted for every individual shot. This makes the camera tremendously flexible in the way it responds rapidly to changing light and contrast levels. However, ISO ratings of 400 or more produce noticeable noise (image blocking) on digital images – akin to the visible grain on faster films.

White balance is a feature you won't find on film cameras, but it has an influential bearing on the quality of light recorded with a digital camera. There are three primary colours existing in varying proportions in a light source, depending on its colour temperature. These are red (R), green (G) and blue (B), usually abbreviated as RGB. When the colour temperature is high, there is more blue. And when the colour temperature is low, there is more red. As the colour temperature increases from low to high, the colour cast changes in the following sequence: red, orange, yellow, white, and bluish white. For example, if you have a white object under a tungsten light bulb, it will look red or orange in the photograph. If it is under fluorescent light, it will have an unattractive green cast.

To the human eye, a white object still looks white almost regardless of the type of lighting. But whereas the human eye is highly adaptive to different types of lighting and colour temperatures, a film camera is not and requires a colour correction filter to the lens or tungsten film to compensate for the colour cast caused by the light source's colour temperature. With a digital camera's white balance setting, you can digitally compensate the colour temperature so that the colours in the image look more natural.

Training wheels ↰

This photograph was taken in a street next to the famous Leaning Tower of Pisa, although there is nothing included in the scene to suggest this. Instead, Charo Diez was attracted to the colour of the building enhanced by the warming sunlight of late afternoon. A perfect background, all she needed was someone to walk into the scene. This little girl on her tricycle obliged and Diez took a spot reading from her and closed down the aperture by 2 stops to render her subject as a silhouette. The result is a far more original image than yet another snap of the tower.

Photographer: Charo Diez

Location: Pisa, Italy

Time: 5pm in September

Camera: Nikon F80

Lens: Sigma 28–200mm 3.5-5.6 Aspherical zoom

Film: Fuji Sensia 100

Exposure: Not recorded

Tripod: No

Holy light ↗

A narrow band of warm yellow light illuminates part of the sheer face of El Capitan, one of Yosemite's largest monoliths. By contrast, the light is fading in the rest of the valley, taking on a blue cast as the sun recedes. In a few more minutes, the shadows will deepen and the band of yellow sunlight will move higher up the face of El Capitan before slipping off the top altogether, leaving only the sky with the last light of day. No colour correction filters were used in this image.

Photographer: Leping Zha

Location: Valley view, Yosemite Valley, California, USA

Time: Just before sunset, December

Camera: Pentax 67II

Lens: Pentax SMC 55–100mm f/4.5 zoom lens at 55mm setting

Film: Fuji Velvia 50

Exposure: 1/2sec at f/22

Tripod: Yes

Natural light

Many of the photographers featured in this book talk about their attempt to capture the light they see before them. Outdoors, the sun is our main light source, but it is remarkable how its quality and intensity vary during the course of a day and year. Wherever you are in the world, early morning and late afternoon light is preferred because of the warmer hues it casts on the subject. The sun's low position at these times of day also has the effect of revealing surface details and textures through the oblique angle of the resulting shadows.

The quality of light is also affected by the atmosphere. Anyone who has ever been to alpine, polar, or desert locations knows how clear everything seems – you can, literally, see for miles and miles. By contrast, the humidity of equatorial climates means there is more moisture and other particles in the atmosphere, resulting in a light that is often hazy and misty. Experience of these conditions teaches us what type of light is best for different subjects and how to make the best use of the light we have. Bright, overhead sunlight has few redeeming qualities, but if you're photographing a scene or event that is unlikely to be repeated, then you have little choice but to shoot. Filters can improve the overall image without resorting to questionable special effects (see Filters, p36). Also simple techniques like seeking open shade, using lens hoods to control flare or waiting for the sun to disappear behind a cloud can make a world of difference.

Of course, you can't plan for the unexpected, but it helps to be alert to dramatic lighting intensifying in front of you, such as a shaft of sunshine breaking through a passing storm cloud. It's these moments that you should seize without hesitation, because it is this sort of light that gives a unique take on even the most photographed of locations.

Bronze light ←

In this beach scene foggy conditions have mixed with the late afternoon sun to produce an image of soft bronze coloured tones. The curved line of footprints has been included to lead the viewer's eye to the water's edge. The photographer has kept the white balance setting on auto and underexposed the metered reading by 2/3 stop. No filters were used.

Photographer: Jorge Coimbra	**Lens:** Built-in 7.2–28.8mm zoom
Location: Adranga Beach, near Sintra, Portugal	**File type:** JPEG
Time: 6.30pm	**Exposure:** 1/320sec at f/8
Camera: Canon Powershot G3	**Tripod:** No

Before the storm ↗

With storm clouds approaching Ioanis Gousgounis wanted to capture the rays of light breaking through the clouds and reflecting from the sea. He set up his camera on a tripod and composed the scene, using the line of the balcony as foreground to lead the eye into the centre of the picture. After the photographer had made a couple of shots, a cat that had been lying nearby decided to walk along the balcony. When it started to approach the centre of the frame, Gousgounis fired the shutter .

Photographer: Ioanis Gousgounis	**Lens:** Tamron 28–300mm f/3.8–5.6 zoom
Location: Monemvassia, Greece	**Film:** Kodak Ektachrome 100
Time: Mid-morning	**Exposure:** Not recorded
Camera: Nikon FM2	**Tripod:** Yes

Flash & time exposures

Flash is extremely useful for providing additional lighting at times when there isn't enough or any available light or it is in the wrong place for your subject. The most useful flash technique for the travel photographer is 'fill-in' – the use of a small amount of flash by day to illuminate areas of the subject that are in shadow. Fill-in flash can be used with any flashgun, including the smallest built-in unit on a point and shoot camera. Indeed, when photographing someone against the light, you should use flash in order to prevent your subject from being thrown into silhouette.

It is important to know the limitations of your flash unit, namely the nominal flash to subject distance and the angle of coverage. The workable flash range on a typical built-in unit is around 3m (10ft) at ISO 100. Using a faster film or ISO number will extend this range, but if you need more power, you will have to use a separate flashgun. With a separate flashgun you can control the flash output to 1/2, 1/4, 1/8, even 1/16 power. It's also possible with some models to place the flash off-camera and fire it remotely.

Slow sync flash is a popular technique with moving subjects. It entails setting a slow shutter speed to record any movement or areas lit by ambient light while the subject illuminated by the flash is 'frozen' by the faster flash sync speed. This looks most effective when photographing a car, cyclist, dancers or other fast moving subject at night when trails of ambient lights streak across the background.

Many flashguns have a facility known as second curtain sync whereby the flash fires as the camera's second shutter curtain begins to travel across the film plane or image sensor. As a result any ambient streaks are recorded before the flash fires, thereby appearing behind the flash frozen image and helping to emphasise the direction of movement.

Some night scenes are better photographed without flash; all they need is a long exposure of many seconds, even minutes, sometimes longer. These are called time exposures and the camera has to be mounted on a tripod or firmly supported by other means. Typical subjects for a time exposure include: a floodlit landmark or building, fireworks, the lanes of car lights from traffic passing over a bridge, arcs of star trails or the Northern Lights in the night sky. Time exposures are fun because how long you leave the shutter open is down to guesswork and experience, but the results are often surprising.

Inverse square law

Whichever flash you use it pays to remember the inverse square law. This stipulates that as you double the subject distance from the flash, the amount of light reaching the subject reduces by a quarter. If you were to double the distance again, the light would only be 1/16 of the intensity at source. This law reminds us that flash is ineffective with long range subjects.

Star trails over cactus →

To photograph star trails in the night sky requires a long exposure, with the camera firmly mounted on a tripod. Desert skies are very dark because there is no light pollution, commonplace in towns and suburbs with lots of floodlighting and streetlights, so the stars are more visible. For this stunning image the photographer, Leping Zha, aimed his camera directly at the Polar Star and repeatedly fired a Nikon SB28 flashgun manually at the cactus. He also used a flashlight to 'paint' the cactus for around ten minutes. The four hour exposure time was necessary to record a long and bright trail of stars, seemingly revolving in concentric circles around the Polar Star.

Photographer: Leping Zha	**Lens:** Pentax SMC 45mm f/4
Location: Pipe Organ National Monument, Arizona, USA	**Film:** Fuji Velvia 50
Time: A night in March	**Exposure:** Four hours at f/5.6
Camera: Pentax 67II	**Tripod:** Yes

Chain Bridge, Budapest — Overleaf

City architecture takes on a totally different appearance at night. Carefully placed floodlights illuminate the form and shape of the structure in a more graphic way than is possible by day. The Chain Bridge in Budapest is a classic example, although making this image was a dangerous undertaking as the photographer had to set up his tripod at a traffic circle, which meant cars were whizzing past on three sides. The 12sec exposure is too long to freeze any of the fast moving cars in the image. Instead, their lights have left a ghostly wash of light on the road.

Photographer: John Orr	**Lens:** Nikkor 17–35mm AF-S ED zoom
Location: Budapest, Hungary	**Film:** Fuji Reala 100
Time: 8pm	**Exposure:** Approx 12sec at f/16
Camera: Nikon F100	**Tripod:** Yes

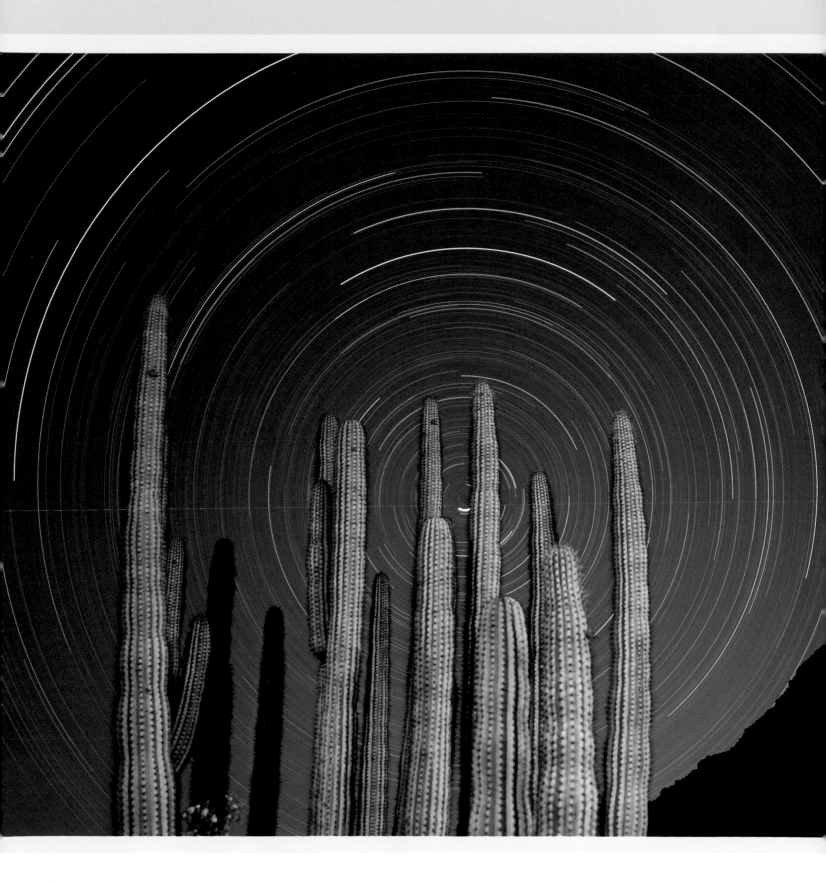

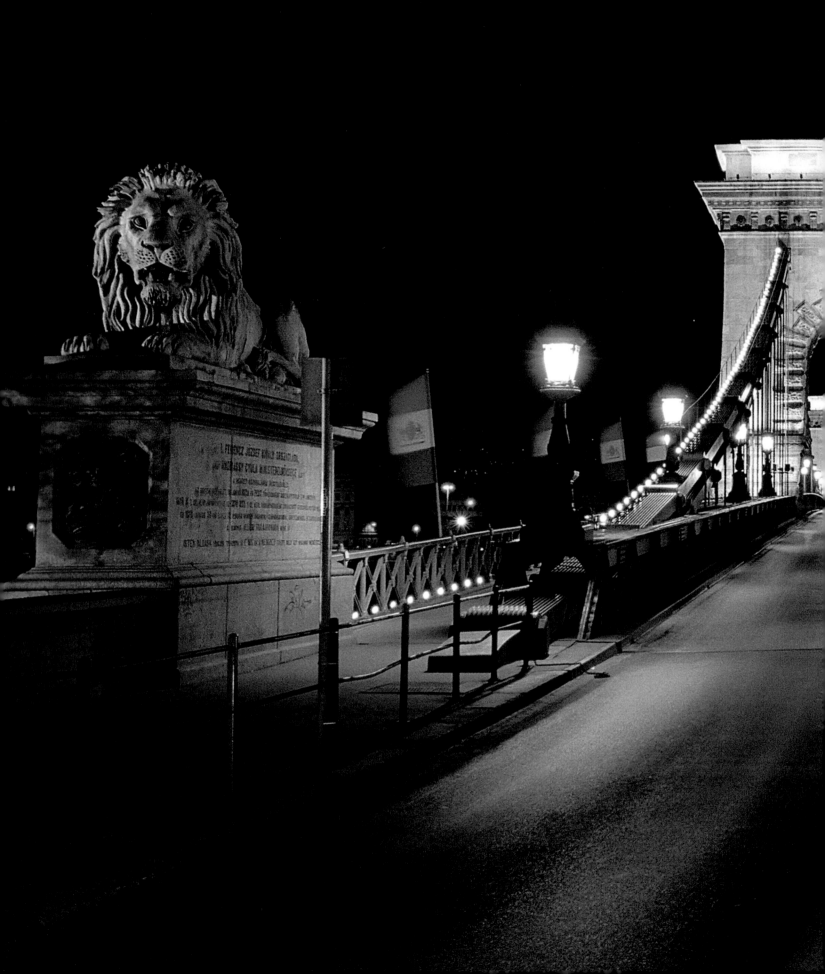

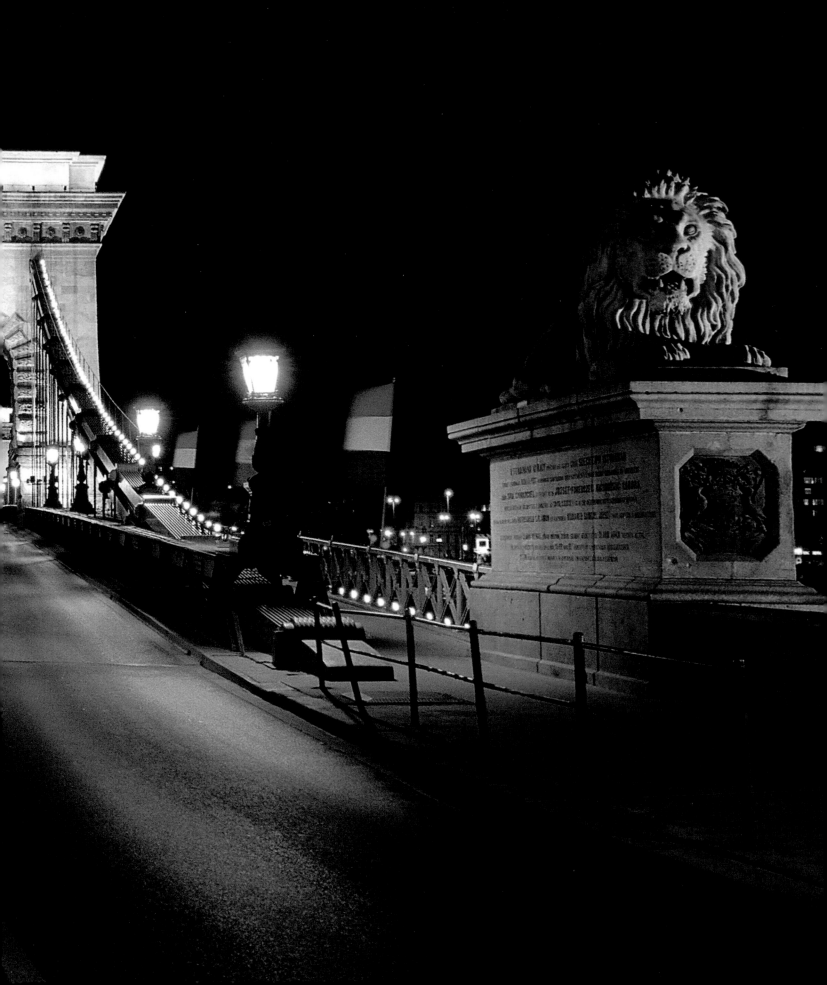

Flash & time exposures

Light fishing →

Light fishing

John Orr used a technique known as 'painting with light' to create this image. After setting up the camera on a tripod, he kept the shutter open while shining a flashlight to 'paint' the grass evenly for one and a half minutes. A gel filter was placed over the head of the torch to diffuse the light. The camera was loaded with tungsten-balanced film which created the day-time effect.

Photographer: John Orr

Location: Point Lookout, Maryland, USA

Time: 1am

Camera: Nikon F100

Lens: Nikkor 17–35mm f/2.8 AFS ED zoom

Film: Fuji 64T

Exposure: Four and a half minutes at f/4.5

Tripod: Yes

Symphony of lights ←

Slava Epstein had seen pictures of the Gaudi-designed house Casa Battlo and decided to include it as part of a personal project to record the achievements of Art Nouveau. Metering was largely guesswork, with several bracketed long exposures. Epstein used a perspective control (PC) lens to reduce the effect of converging verticals, a common problem when shooting high buildings from the ground.

Photographer: Slava Epstein

Location: Casa Battlo, Paseo de Gracia, Barcelona, Spain

Time: 10pm

Camera: Nikon F3T

Lens: Nikkor 28mm f/3.5 PC wideangle

Film: Fuji Provia 100

Exposure: 16sec at f/11

Tripod: Yes

Composition

Too many images are let down by poor composition. Common mistakes include placing the subject in the centre of the viewfinder and always framing the scene from a standing position. Other images are let down by extraneous detail intruding into the margins of the frame. This can be irritating but photographers aren't helped by the fact that most camera viewfinders do not show the entire field of view of the lens in use.

On the whole good composition is a product of good observation. However, it is worth reviewing the main guidelines of composition, namely the rule of thirds, placement of foreground interest and the use of lead-in lines, to see how instinctive we have become in their application.

The rule of thirds involves dividing the scene in the viewfinder into nine equal rectangles by drawing two vertical lines and two horizontal across the image. Any one of the four points where these lines intersect is deemed to be the ideal position for placing the main subject in the frame.

Lead-in lines can be natural or manmade features, such as a stream, path or line of fencing that draws the eye into the picture, usually to the main area of interest. Winding or diagonal lines tend to work best, more so if they lead into the central part of the picture from one of the bottom corners of the frame. These lines also help to add depth to a scene.

Reflection ↰

The beauty of a reflection is that it creates a symmetrical pattern out of a scene that wouldn't exist if viewed in isolation. In this example, the reflection goes further by revealing another band of colour above the windows, otherwise hidden by the trees. The line of reflection runs right across the centre of the frame adding to the symmetrical balance between the subject and its reflection. The passing dog had escaped from its owner and its presence breaks up the pattern of well-ordered trees, thereby adding another subtle but dynamic element to the composition.

Photographer: Jean Schweitzer

Location: Horsholm, Denmark

Time: 5pm

Camera: Olympus C-3000

Lens: Built-in zoom at widest setting

File type: JPEG

Exposure: Not recorded

Tripod: No

Long way ahead ↗

The pillars of this temple at Bagan cast a pattern of long shadows that accentuated the vanishing point from which the young monk was emerging. With a lead-in line created by the junction of vertical and horizontal shadows, the monk is the obvious focal point of this picture. There is a nice symbolism in the composition too – the lengthy walk along the temple corridor representing the long personal and spiritual journey that lies ahead for the novice.

Photographer: Alan Chan	**Lens:** Canon 70–200mm f/4 L zoom
Location: Bagan, Myanmar	**Film:** Kodak Gold 100
Time: 10am	**Exposure:** 1/125sec at f/8
Camera: Canon EOS 1	**Tripod:** Yes

School's out ↗

Cuba is famed for its ageing collection of 1950s' American cars, many painted bright colours that make wonderful photographic subjects. It was this loud, purple vehicle that attracted the photographer and the promise of something happening in the doorway that might complement the scene. Direct sunlight on the flight of steps leading down from the entrance to the footpath and kerb also created a nice diagonal link. When the children appeared, dressed in uniforms of a colour almost identical to that of the car, and ran towards the entrance, the waiting photographer knew he had everything in place for a colourful and lively image. No filters were used.

Photographer: Rob Whitrow	**Lens:** Nikkor 50mm f/1.8
Location: Santiago, Cuba	**Film:** Kodak E100VS
Time: Afternoon	**Exposure:** Not recorded
Camera: Nikon F100	**Tripod:** No

Colour

A sharp area of foreground interest will be a considerable help to the compositional balance of the scene, particularly for landscapes taken with a wideangle lens. Like lead-in lines, a foreground subject placed off-centre near the bottom of the frame can draw the eye into the picture. Distinctively shaped objects or figures are ideal for this purpose.

Of course, you cannot make absolute rules about composition without considering what colours are at play in the picture. Red is the dominant colour of the spectrum – a small amount will always draw the eye, so you have to be careful where you place it in the picture. Red is not a colour to recede in the background.

It is important to understand the relationship of colours to each other. For example, the three primary colours – red, yellow and blue – have three complementary colours – respectively green, violet and orange. High contrast results when a primary colour is placed next to its complementary colour, such as red with green, yellow with violet and blue with orange. These juxtapositions are both naturally occurring and the work of man's decorative instincts. However, where you place such colours in your picture has less to do with foreground interest and the rule of thirds and more about emphasising pattern and symmetry. A splash of vivid colour hardly needs a lead-in line to attract the viewer's attention.

Graphic gable ↖

Geometrical shapes make powerful compositional elements, but few subjects can be as obvious or graphic in their use of triangles, rectangles and squares as this building in Augsburg. Closer examination reveals an exterior of painted shapes in different shades of red and blue. The bright winter light has helped define the design and texture of the building, while the cloudless blue sky makes an ideal backdrop, contrasting vividly with the surface colour of the building. The roofline has been positioned in the frame so as to make identical triangles of the blue sky, neatly separated by the apex of the roof.

Photographer: Jean-Luc Benazet	**Lens:** Nikkor 80–200mm f/2.8 zoom
Location: Augsburg, Bavaria, Germany	**Film:** Fuji Velvia 50
Time: 11am on a December day	**Exposure:** 1/500sec
Camera: Nikon F90x Pro	**Tripod:** No

Curious cat ↗

Cats of all colours and sizes are commonplace in the islands and fishing ports of Greece, so the sight of this young ginger-coloured feline wasn't unexpected. It is tempting to think that the photographer may have set up this picture where different hues of orange are evident in the rope, lifebuoy and even the grain of the timber. However, nothing was set up and the photographer merely responded by making a composition where the colours of the background objects complement the colour of the cat.

Photographer: Piotr Kowalik	**Lens:** Canon 70–200mm f/4 L
Location: Thassos, Greece	**Film:** Fuji Velvia 50
Time: Midday	**Exposure:** f/4; shutter speed not recorded
Camera: Canon EOS 50E	**Tripod:** No

Black & white

The first travel photographs were made in black & white. Francis Frith's plates of Egypt's ancient sites from the mid-19th century excited all who saw them. They still do. However, the way colour is depicted in festivals, religious ceremonies, costumes and architecture is core to so many travel images that it seems almost absurd to consider registering these subjects in shades of grey.

But black & white has a timeless quality that colour struggles to match. With no colour to divert the eyes, a black & white composition can make a bigger impact as the viewer takes more notice of the compositional values, the use of shape, line and form. These more elemental qualities stand out conspicuously in the absence of colour.

For this reason, why not consider making a series of black & white images concentrating on a particular subject or event from your travels? After all, documentary photography, like travel, knows no boundaries and its themes are universal, more so when shot in black & white. The pictures reproduced here illustrate this point. They are part of a series by Steffen Ebert showing young children training as boxers on the streets of Havana, Cuba. Boxing is one of Cuba's national sports, and these images are a classic example of reportage. Together they tell a story in a distinctive style that reveals more about the subjects than a formal head-and-shoulders portrait. Here, we see lives played out in a series of dynamic compositions that are still recognisably Cuban in their sense of place and time.

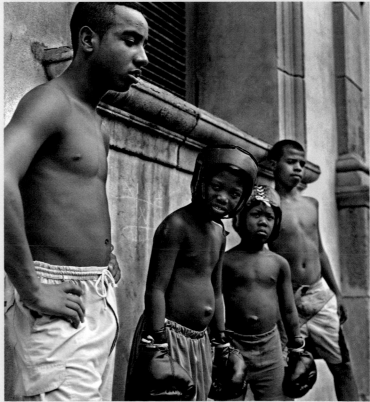

School of hard knocks ↳

Two small boys with gloves too big for their hands; a serious looking trainer with hands on hips; and a bemused passer-by. These are just a small selection of images from Steffen Ebert's project to show how people live on the streets of Havana. His photographs were taken handheld, using a Hasselblad 202FA, a camera most photographers use with a tripod, while the choice of black & white film instils a timeless quality in the project.

Photographer: Steffen Ebert

Location: Havana, Cuba

Time: Around noon

Camera: Hasselblad 202FA

Lens: Carl Zeiss Planar 80mm f/2.8

Film: Kodak T400CN rated at ISO 200

Exposure: f/11; shutter speed not recorded

Tripod: No

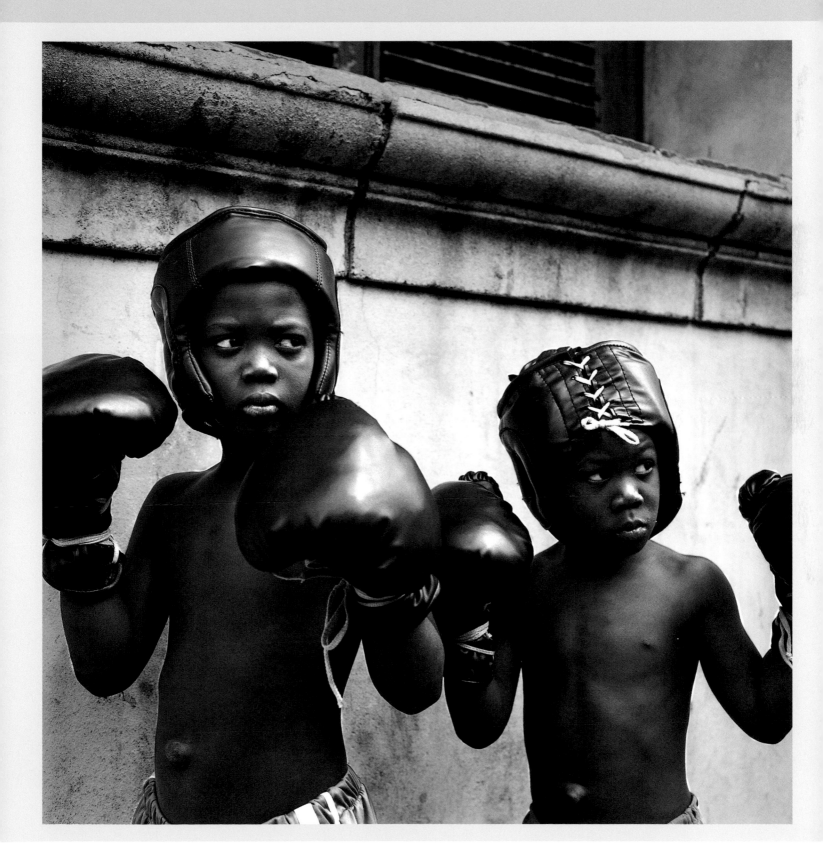

Close-ups & details

When visiting destinations for the first time most people take a wideangle vista to match the image seen in a holiday brochure, guidebook or postcard. And yet so much detail is missed because people don't bother to move closer to the subject and examine it more intently. Robert Capa's much quoted comment, 'if your pictures aren't good enough, you're not close enough', while primarily aimed at the war and documentary photographer, holds true for other types of photography. If we are to get close enough to our subjects while travelling, then we need to engage more with the local people and spend more time trying to understand the intricacies of their art and culture.

It helps to have the right lenses. Telephoto zooms are so versatile – they can make a tighter crop of a subject that is impossible to get nearer to, such as a pride of lions on the Serengeti or a high altitude Himalayan peak. Such scenarios are the preserve of the telephoto, but they can also be used to make a closer examination of something smaller or more intricate – a discrete inscription or religious carving in a Buddhist temple. These are the sorts of detail that you won't see in the guidebooks or on postcards, but the scope for making a truly original and evocative image is so much greater.

The drawback of telephoto lenses is their minimum focusing distance – a few metres or more in some case. Contrariwise, a macro lens lets you get very close to your subject, but the price for such intimacy is a loss of depth of field. It is a lens more for natural history than travel, but in situations where the two disciplines merge, such as the garden blossom of Kyoto or the indigenous plants and insects of a rainforest, a macro lens gives you the capability to produce an image that is uniquely your own. Do remember the tripod, however, and remember that finer focusing is best achieved by hand.

Dragonfly on prayer blocks　　　　　↙

Nikko is one of the most important historical and religious sites in Japan. With so many grand subjects, these wooden prayer blocks would have been overlooked if it hadn't been for the lucky sighting of this dragonfly at rest. The cool mountain air meant the dragonfly would stay in place for sometime until it warmed up, making it easier to approach for this image .

Photographer: Keith Wilson	**Time:** Late afternoon , October	**Lens:** Canon EF 50mm f/1.8	**Exposure:** Not recorded
Location: Nikko, Japan	**Camera:** Canon EOS RT	**Film:** Kodachrome 64	**Tripod:** No

Winged beauty　　　　　↱

Butterflies are beautiful natural history subjects and their colours can be fully appreciated in a still image, but trying to photograph one in its natural habitat isn't so easy. Butterfly collections in greenhouses and other captive environments are a better alternative and it was in such a place that Arthur Sevestre made this picture. He mounted the camera on a tripod, set it to aperture priority and used only the natural light of the greenhouse for his exposure. A spot meter reading was taken off the green background and no adjustments made to the exposure value. Depth of field is shallow but the composition is enhanced by the strong diagonal running from the leaf in to top left corner of the frame down to the tip of the butterfly's wings near the bottom right.

Photographer: Arthur Sevestre	**Lens:** Sigma 24–70mm f/2.8 EX Aspherical
Location: A greenhouse in the gardens of Dieren Vlindertuin, Berkenhof, the Netherlands	**Film:** Kodak Elite Chrome 100 EC
	Exposure: f/5.6; shutter speed not recorded
Time: 11am	**Tripod:** Yes
Camera: Minolta Dynax 7	

Josep Lluis Grau (see page 130)

Section 3

Exploring & discovering

As a genre, travel photography covers a diverse range of subjects. In this section we seek to explore all the exciting photographic opportunities travelling provides.

Street candids

By their definition, candids are images of people who aren't aware of being the subject for a photograph, or who aren't posing consciously for the camera. Busy streets and squares and coastal promenades are primary locations for this type of photography, particularly during the working week, when people are sticking to a schedule and are absorbed in the business of the day.

As most people are on the move, it makes sense for you to spend a few minutes in one spot observing the patterns of movement around you and the main points of attraction. For example, in a busy city street on a weekday morning, look at what people are drawn to as they make their journeys: newspaper sellers and cafés provide distractions where people stop briefly, engage with someone else and momentarily change expression to reveal something of their character.

Even if you try to remain discrete, you will be noticed at some point – cameras are conspicuous and the actions of a photographer even more so. Some of us are embarrassed about making pictures of people in public, even though the best travel images feature people. Resorting to telephoto lenses may increase your chances of getting that close-up portrait without your subject knowing, but the size of the lens may actually make you more noticeable to others.

Instead, save your embarrassment and move freely about, smiling to those who look at you and using gentle gestures and a few words of courtesy to let people know that you would like to take their picture as they go about their business. If they say no or seem reluctant, don't persist. Simply follow the principle of treating anyone you speak to in the manner that you would like to be treated by them – be friendly.

There are also some technical reasons for not hiding behind a telephoto lens. The longer the focal length the narrower the depth of field, so focusing on your subject's eyes has to be more precise. A blurred result ('camera shake') is more likely due to the greater image magnification, so a faster shutter speed must be used. Of course, the faster your shutter speed, the larger your lens aperture needs to be, which means reduced depth of field.

In practice, wideangle and standard focal length lenses are a better choice for street candids. With wideangles, depth of field is much greater and more background can be included, giving the photograph context and placing the location more obviously for the viewer. Whichever lens you use, remember to focus on your subject's eyes and to take your meter reading from their face. If your camera has a spot or partial metering mode then use this and lock that exposure before re-framing to get the composition you want.

It pays to wait before pressing the shutter button in order to check that there isn't anything too distracting or obtrusive in the background. With your exposure locked you also can wait for the moment when your subject makes an expression or movement that adds another element to the scene.

Digital cameras have the advantage of allowing you to check the recorded image on the monitor immediately after exposure. By contrast, with film it's not until you get your prints or slides back that you see if there were any mistakes in your composition or timing, such as your subject blinking at the time of exposure. The same accident of timing can happen with a digital camera, but at least you can erase the image then and there and get over the disappointment a lot sooner! Having said that, some digital cameras have a longer time lag between pressing the shutter button and the picture being taken, so the 'decisive moment' can still prove elusive.

Petanque ↗

Candid images aren't always a case of grabbing a portrait of someone when they're not looking. Recording some small detail, characteristic or symbol of identity can be just as effective. The photographer had already envisaged this shot upon arriving at the Luxembourg Gardens in Paris and waited for the right moment before using his telephoto zoom lens to crop tightly on the petanque player's hands.

Photographer: Frantisek Staud	**Time:** Early afternoon	**Lens:** Tamron 80–210mm f/2.8 zoom	**Exposure:** xf/4; shutter speed unrecorded
Location: Luxembourg Gardens, Paris	**Camera:** Nikon F100	**Film:** Kodak T400CN	**Tripod:** No

Street candids

The simple juxtaposition of primary colours in a street makes an interesting subject for the camera in its own right and it was the pairing of this pale blue door and yellow wall that fascinated the photographer. While looking through the viewfinder and metering for the scene, this schoolgirl suddenly appeared, walking quickly. There was time only for one shot and although her legs are 'chopped off' the timing of the exposure is perfect – she is in full stride and her body framed entirely by the yellow wall. Had the girl crossed the line of the door, the result would not have been as strong. The composition is also strengthened by the girl's dress being another shade of blue and her bag green – a complementary colour to the primary yellow and blue. The colours are entirely natural and the only filter used was a skylight.

Photographer: Charo Diez

Location: Santa Maria, Salt Island, Cabo Verde Islands

Time: 8am

Camera: Nikon FM10

Lens: Sigma 28–200mm f/3.5–5.6, aspherical zoom

Film: Fuji Sensia 100

Exposure: Not recorded

Tripod: No

Candids

- Spend some time observing the people around you from a discrete distance.
- Don't make yourself conspicuous by having your camera gear on constant display — only take it out of your bag or backpack when you are ready to shoot.
- Bracket your exposures by 1/2 or 1 stop either side of 'correct' exposure.
- Check the results on your LCD monitor to see which image is the most accurate.

Double luck ↑

In an inspired moment the photographer who chanced upon this scene in a quiet village street decided to use the sepia mode of his digital camera. It was a pure snap relying on the camera's automatic exposure system and focusing for the result. Fortunately, the shutter speed was just fast enough for a handheld exposure and the composition thoughtful enough to include the Chinese New Year calligraphy banners on either side of the twins.

Photographer: Juergen Kollmorgen

Location: A village in Guangdong Province, China

Time: Late afternoon in January

Camera: Sony Cybershot DSC-717

Lens: Built-in Carl Zeiss 9.7—48.5mm zoom

File format: JPEG

Exposure: 1/60sec at f/2.2; ISO 100

Tripod: No

Street candids

Technical tip

Use your camera's spot or partial metering mode to take an exposure reading from your subject's face and remember to focus on their eyes. Take a burst of pictures with your camera's drive set to continuous mode.

Zhongdian Monastery ↗

The heavy folds of the monks' robes become a perfect neutral background when photographed in black & white and the wrinkled face of the old monk looking out from off-centre delivers tremendous impact. The photographer tried several compositions including the faces of the other monks but these proved too distracting – the simpler composition of one face peering out from the robes is far stronger. The lighting was flat and overcast, perfect for portraits and the photographer made a meter reading using a handheld lightmeter.

Photographer: Rob Whitrow	**Camera:** Nikon FM2	**Film:** Kodak T-MAX 400
Location: Zhongdian, China	**Exposure:** Not recorded	**Tripod:** No
Time: Early afternoon	**Lens:** Nikkor 50mm f/1.8	

Group shots

As any wedding or school photographer will tell you, photographing groups of people is far from easy. These occasions are formal and cannot be repeated and the style of photography has changed little in generations.

Fortunately, travel photography is far more spontaneous and less restrained by convention. There is still the same degree of never to be repeated encounters, but that unpredictability is a large part of the allure.

Wherever you go in the world, you will notice that people tend to move in groups of two or more and with a surprising amount of uniformity, whether it be suited office workers, a busload of schoolchildren, the ceremonial ranks of soldiers or orange-robed Buddhist monks. The uniformity of a group's style of dress and colour can lead to a stronger composition because it makes the real differences in the image – people's faces and their expressions – more noticeable. Also, if there is one person in the group who is dressed differently, or looking directly at the camera while the others are looking elsewhere, then you immediately create an even more obvious focal point for your photograph.

Of course, uniformity isn't just about the clothes people wear. It can be about gender, physical likeness, hairstyles, body language and expression of purpose. The point is that many group shots succeed because the photographer has emphasised the difference. It's like playing spot the difference or picking the odd one out. It may not be obvious at first, but once identified and captured in a still image, then that difference becomes the point of the photograph and can tell us a lot about the individual within the group.

The techniques of focusing, framing and use of depth of field are the same for a group shot as they are for a single portrait or candid. However, your first decision needs to be whether to make the whole group your subject or to have one person's face standing out from the rest. For the group subject, and assuming you're shooting in a spontaneous manner, you need to crop the scene (zoom lenses are an advantage here) so that the faces create a balanced composition, filling the frame front to back. It's unlikely that everyone in the group will be on the same plane of focus (unless they're all in a line as in a wedding or school photo), so choose the most centrally positioned figure and focus on their eyes. That way, you'll be maximising the depth of field of your chosen aperture for the people both in front and behind.

Picking someone to stand out more conspicuously in a group is best achieved by focusing on their eyes and using the widest aperture setting of your lens, say f/2.8 or f/3.5. The resulting depth of field will be small (even smaller with a telephoto lens), rendering the other people in the frame out of focus.

Whether you're shooting digitally or on film, SLR cameras are best for photographing people, as the image you see in the viewfinder is exactly what the lens sees. This can be crucial where precise framing is needed to crop out any potentially obtrusive background elements. Such details are likely to be missed with a compact camera because it uses a direct viewfinder, which is slightly out of line with the actual view as 'seen' by the lens. Playing back the image on the screen of a digital camera will provide you with the reassurance you need.

Turkish kids ↘

Kids are kids the world over. On a quiet empty street in Selcuk, Turkey, Rene de Haan stopped to photograph a small dog sitting quietly on the kerb. Seconds later, this group of children appeared as if from nowhere and insisted on having their picture taken. Although, posing consciously for the camera, their reaction was spontaneous and the way they have arranged themselves in the group reflects this. It is worth noting how the boy holding the ball has positioned himself centrally and is the only one who has stepped forward onto the kerb. This breaking of ranks has helped create some depth and shape to the composition.

Photographer: Rene de Haan

Location: Selcuk, Turkey

Time: Late morning

Camera: Canon A1

Lens: Canon 50mm f/1.8

Film: Fuji Velvia 50

Exposure: 1/60sec at f/4

Tripod: No

Technical tip

For posed group shots, don't wait till everyone's ready and looking at the camera — start firing the shutter even when most people aren't ready and looking in different directions. You will have a more natural and amusing shot as a result — a real alternative to the formal composition.

Group shots

- Choose one person in the group as your focal point and focus on him/her.
- Look for differences — if you're photographing a group of uniformly dressed people, look for someone who stands out for other reasons — height, gender, eye contact, expression or gesture.
- Make sure there is nothing intrusive or obstructive in the background.

Group shots

Festival procession →

On the Indonesian island of Bali there are festivals known as 'odalan' to celebrate the birthdays of local temples. As part of the celebrations, women form a procession, carrying offerings of fruit and flowers. On this occasion, a sky heavy with rain clouds meant the light was flat and overcast and with such a slow film loaded – ISO 64 – the resulting long exposure meant there was a real risk of camera shake without using a tripod. Several grab shots were made and this was the pick, thanks to the woman looking over her shoulder and directly at the camera. Seconds after this picture was made, there was a deluge as the heavens opened.

Photographer: Jon Bower

Location: Ubud, Bali

Time: 2pm

Camera: Olympus OM4 TiOlympus OM4 Ti

Lens: Zuiko 85mm f/2

Film: Kodachrome 64

Exposure: 1/50sec at f/2.8

Tripod: No

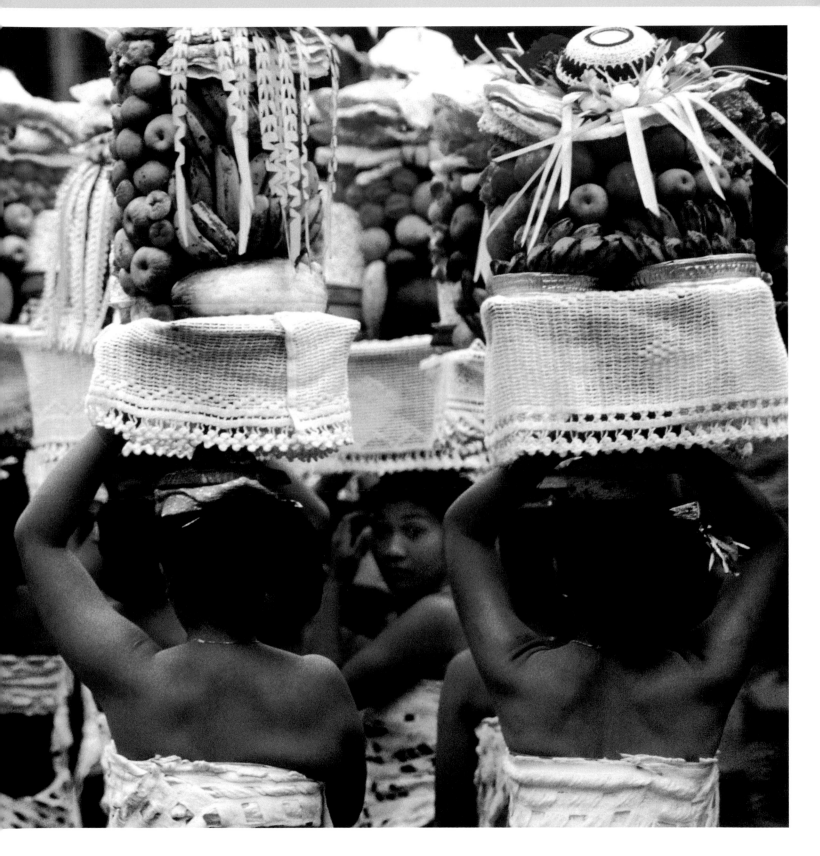

Group shots

The second day ↗

It was a very hot day in June 2003, with the temperature approaching 30°C in the midday sun – not a time for taking photographs, according to most guidebooks. However, the short shadows, the colour of the sea, the umbrella used as shade and the white robes all combine to depict an image of a hot day. You don't need to see the faces of the three nuns to know that this is a moment of reflection – the arms resting on railings, an umbrella shared, these clues suggest a relaxed group of individuals. The photographer's only concern was the possibility of underexposure caused by the white robes. However, using a digital camera, he was able to immediately check exposure accuracy on the LCD monitor.

Photographer: Willem Dijkstra

Location: Ortygia, Sicily, Italy

Time: Midday

Camera: Sony DCS-F707

Lens: Built-in zoom lens (equivalent to 38–190mm in 35mm format), at full telephoto setting

File type: JPEG

Exposure: 1/800sec at f/3.2; ISO 100

Tripod: No

Royal guards ↙

Photographer Allan Wallberg describes his photograph as a candid street shot, taken on impulse as Sweden's royal guards were relaxing between duties. Normally, these immaculately attired soldiers are seen riding their horses in disciplined formation, so seeing them momentarily off-guard is an opportunity too good to miss. As a group shot it succeeds because the uniformity of their ceremonial dress is interrupted by the random differences of their posturing. Also worth noting is the use of black & white film. A subject such as this, featuring a traditional style of dress from another era, becomes harder to date accurately when photographed in mono.

Photographer: Allan Wallberg

Location: Stockholm, Sweden

Time: 11am

Camera: Canon T90

Lens: Canon FD 100mm f/2.8

Film: Kodak T-Max 400

Exposure: 1/250sec at f/11

Tripod: No

People in the environment

For the travel photographer, one of the main attractions of photographing people is witnessing their home environment and including an element of this in the image. So much of travel photography falls into this realm. Indeed, some may ask what is the point of photographing people abroad if it isn't obvious which country or city the image was taken?

Of course, sometimes it is obvious where a photograph was taken because the subject's physical features or clothes are so distinctive and universally recognisable. Take for instance the tattooed features of a New Zealand Maori, the colourful kimonos of a Japanese geisha or the orange robes of a Buddhist monk. However, this is proving more difficult as Western influences continue to dilute traditional forms of dress, make-up, decoration and other visible features of cultural identity. As a result, framing your subject with a well-known landmark in the background can serve to 'place' your photograph, but this has become a time worn cliché (such as the ubiquitous Egyptian camel driver by the Great Pyramids of Giza or the Changing of the Guard at Buckingham Palace).

To avoid the cliché, it's better to take your environmental portraits in lesser known parts of a location where identity symbols are more subtle. Wideangle lenses are good for this purpose, because their increased angle of view and greater depth of field brings more of the surroundings into the frame. Often, it can be the simple everyday things in those surroundings, such as the language on a street sign or the produce in a shop window that provides the visible clues as to the photograph's location.

In more rural areas or open spaces, 'placing' your portrait becomes more difficult, unless the natural scenery is as recognisable as a major city landmark. But sometimes the very nature of the person's vocation is as unique as the location itself, such as the Aboriginal horseman on an outback cattle station, the Hindu priest praying under a canopy by the Ganges or the sari-clad worker picking tea on a hill station in Sri Lanka. Ultimately, the location should remain a secondary issue to the technical and compositional needs of the portrait itself. In this respect, it is important to focus on the eyes, and make your exposure reading from the face using your camera's spot or partial metering mode. As with all photography, managing the available lighting conditions is critical to your exposure. Bright direct sunlight at any time of day should be avoided. Not only does it make your subject's eyes squint, but strong sunlight casts dark, unflattering shadows on people's faces.

Diffused, shadowless lighting, the sort you get on a cloudy overcast day, is best for portraits – there are no problem shadow areas, less contrast and it is easier to meter from. If you do find yourself faced with bright skies while photographing people outdoors, look for areas where there is diffused shade.

Cairo café	↳	
Against a backdrop of blue painted walls and tiles, the face of this Cairo café owner is softly lit by window lighting from the side and bright, reflected light from outside. Rob Whitrow asked him to look up at the camera, but left him to decide his own posture and stance as he wanted to contrive the image as little as possible. The fairly even tonality of the scene presented no problems to the camera's meter reading and no filters were added to the lens.		
Photographer: Rob Whitrow	**Camera:** Nikon FM2	**Exposure:** Not recorded
Location: Cairo, Egypt	**Lens:** Nikkor 28mm f/2.8 wideangle	**Tripod:** Yes
Time: Morning	**Film:** Fuji Provia 100F	

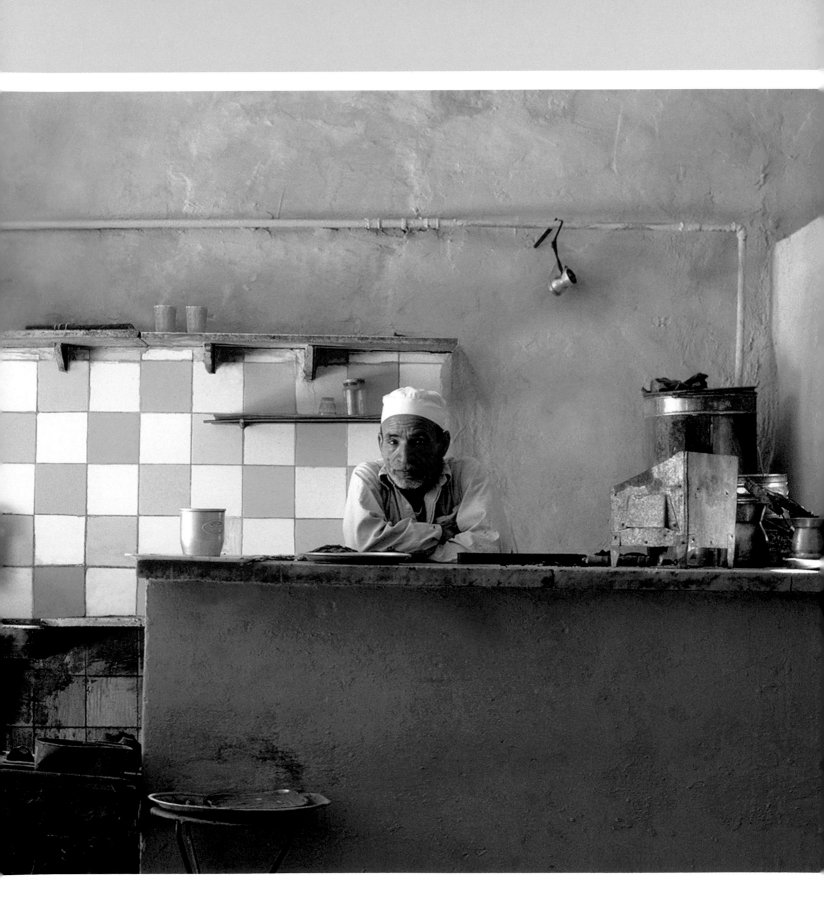

Store in Mariental ↗

Sometimes people recede so much into their environment that they become part of the background. The woman standing in the doorway may be the focal point of this picture but by not stepping forward from her surroundings she becomes another feature of the shop façade, perfectly framed by the entrance but partly obscured by shadow. The shop front is evenly lit by the midday sun and the photographer has made the composition as symmetrical as possible.

Photographer: Alex Sievers	**Lens:** Canon 135–300mm zoom at 200mm setting
Location: Mariental, Namibia	**Film:** Fuji Sensia 100
Time: Noon	**Exposure:** Not recorded
Camera: Canon EOS 10	**Tripod:** No

Children of Angkor ↘

The former Cambodian capital of Angkor is renowned for its ancient collection of Buddhist and Hindu temples and monasteries. The extraordinary architecture and exquisite stone carvings make a unique backdrop for candid pictures of monks, nuns and other people who live here. Alec Ee witnessed such a scene when he saw this girl and her little brother sitting on the ledge of a stone window. They are beautifully framed and backlit by the afternoon light, but would have been rendered as silhouettes if photographed without overriding the camera's automatic exposure reading. Instead, the photographer metered from the girl's clothes and used the camera's exposure lock to hold this setting while releasing the shutter. The resulting exposure of 1/60sec has ensured their faces and bodies can be seen, but the boy's left hand is slightly blurred, having moved during the exposure.

Photographer: Alec Ee	**Lens:** Built-in Zeiss zoom lens
Location: Angkor Wat, Cambodia	**File type:** JPEG
Time: 3.30pm, November	**Exposure:** 1/60sec at f/2; ISO100
Camera: Sony F505V	**Tripod:** No

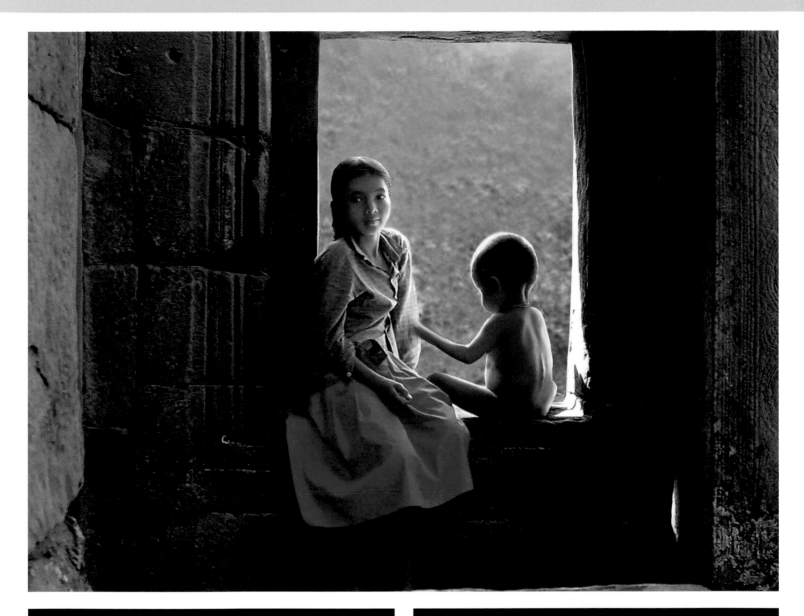

Technical tip

If the lighting is too 'contrasty' to find an obvious mid-tone to meter from, try taking a reading from the back of your hand. It's also worth carrying a small piece of grey card in your camera bag to meter from in high contrast conditions.

People in the environment

– Avoid using iconic landmark features as a background to pictures of local people – these can be a cliché and distract from the true subject of the photograph.
– Use wideangle lenses – they include more background detail and have greater depth of field.
– Use soft, diffused ambient light where possible and avoid harsh overhead sunlight of a bright day.

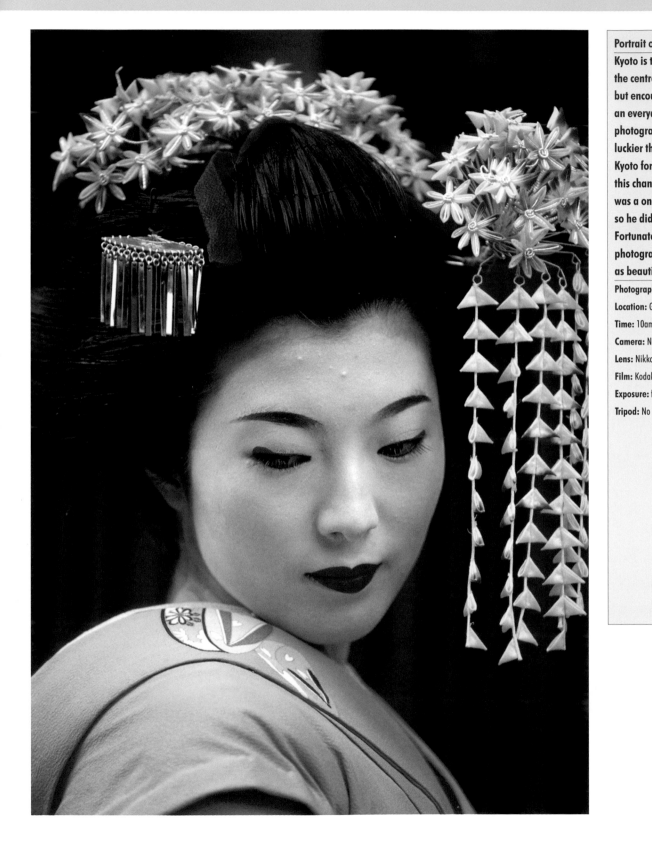

Portrait of a geisha apprentice ↖

Kyoto is the cultural capital of Japan, the centre of many of its traditions, but encounters with geishas aren't an everyday occurrence. The photographer, Frantisek Staud, was luckier than most because he lived in Kyoto for two years. Even so, he knew this chance meeting in a side street was a once-in-a-lifetime situation so he didn't try to save on film. Fortunately, the geisha was photographer friendly as well as beautiful.

Photographer: Frantisek Staud

Location: Gion district, Kyoto, Japan

Time: 10am

Camera: Nikon F601

Lens: Nikkor 105mm f/2.8

Film: Kodak E100S

Exposure: f/2.8; shutter speed not recorded

Tripod: No

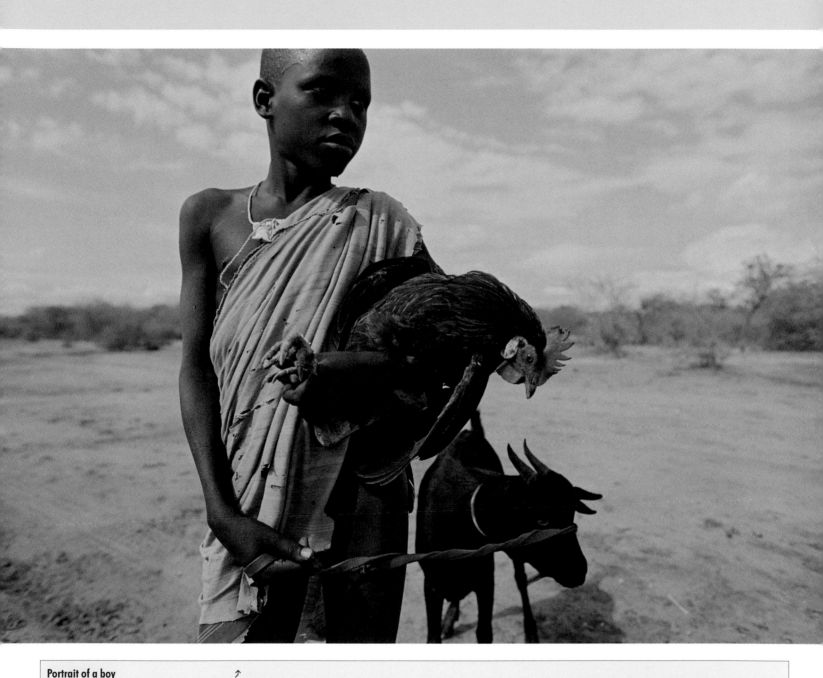

Portrait of a boy ↗

Photo reportage is arguably the most provocative genre of photography, recording the human condition and building stories around everyday events and issues. This portrait of a boy in southern Sudan is a typical reportage study, revealing more than the physical make-up of the subject. He carries a chicken and leads a tethered goat, on a dusty track seemingly in the middle of nowhere. Such a composition raises questions in the viewer's mind: is he taking the animals to market? Are they the next meal for his family? Is he alone or displaced?

Photographer: Piotr Zaporowski	**Time:** Noon	**Lens:** Canon 50mm f/1.4	**Exposure:** 1/1000sec at f/2.8
Location: Yei, Sudan	**Camera:** Canon EOS 1	**Film:** Ilford HP5; ISO 400	**Tripod:** No

Markets & festivals

Village street markets offer an exciting array of portrait possibilities. Whether it's candid images, group shots, portraits, people at work or a more documentary style of photography that you're pursuing, markets are the places to head for. Most markets begin early, with stalls often setting up at dawn. Although it means an early rise, getting to a market at this time can pay dividends as there will be plenty of action to witness and fewer paying customers getting in the way of your lens.

It also helps to approach the stallholders at this time to let them know what you're up to and find out if anyone has any objections to photography. That way, when the serious business of trading gets under way, they will know who you are, why you're taking pictures and how long you will be staying. These are businesspeople so they will be grateful for the effort you've made to be courteous and not to get in their way.

Coming early also helps you to see the layout of the market and to see which areas will provide the most interesting and well-lit backgrounds. When it comes to taking photographs, markets provide plenty of candid opportunities because they attract many different types of people, going about their business in a busy, colourful environment.

Generally, outdoor markets do not present too many technical difficulties so long as the weather is fine. However, in equatorial countries, where the sun is hot and rises quickly, people are plunged into deep shadow by the market awnings or roof. In these conditions photography becomes difficult because of the high contrast and dark shade. Rather than pack it in, you could try bringing your subject nearer to the edge of the shade where sunlight can reach them without shining directly on their face or body. With the background in deep shadow, their features will stand out even more in the frame. If you have a reflector, this could be used to reflect some light onto your subject's face or clothes.

Alternatively, a burst of fill-in flash can give added illumination where it's needed. It's best not to use flash at full power in this instance, instead try a series of exposures at half, third, quarter or even an eighth power so see which works best. If you're using a digital camera, you can check the results on the LCD monitor, although sometimes I think it best to leave decisions such as this to the bigger and more accurate rendition on a full-sized computer screen or an A4 inkjet print.

There is a greater need for flash when photographing festivals as many of these occur at night and streetlights or torches provide the only means of illumination.

If shooting with flash, make sure your subject is within the flash illumination distance. Built-in flash units are very limited and many people make the mistake of not getting close enough to their subject.

Most festivals are photography friendly with no shortage of performers, even from the spectators. The Venice Carnival and Mardi Gras in New Orleans, for example, are packed with exhibitionists more than willing to pose for your camera. As many festivals, particularly religious ones, are steeped in tradition, they will usually follow a set pattern of events, locations and timings, so do your homework and find out what to expect. If there is a procession or a parade, it helps to know the route so you can position yourself close to the action. Remember to take a lens that will allow you to pick out details and colour around you. A telephoto zoom lens is a must in these situations. Festivals draw vast crowds so you will be handholding your camera. In this case use a fast shutter speed to eliminate camera shake. Try other vantage points as well, look for a higher position so that you can look down on the action and convey the scale and size of the proceedings. And walk around the crowd for candids of your fellow spectators – they will be looking at what's going on in front of them, so they are less likely to pay attention to you and your camera.

Burmese girl in ceremony →

Timing and observation were the secret behind this delightful image of a girl checking her headdress as she takes part in a religious celebration in her village. Two local boys were starting to become monks, precipitating a parade of children in colourful costumes such as this. This girl was riding in a cart pulled by two mules and the photographer, Alan Chan, was looking at her through his viewfinder, attracted by her obvious beauty but disappointed by the lack of motion or expression. Suddenly, her headdress started to slip and as she raised her hands to prevent it from falling down, the picture was made, catching the change of gesture and expressive eyes. Metering was left to the camera's automatic exposure system.

Photographer: Alan Chan

Location: Mandalay, Myanmar

Time: 11am

Camera: Canon EOS 1

Lens: Canon 70–200mm f/4 L zoom

Film: Kodak Gold 100

Exposure: 1/250sec at f/5.6

Tripod: No

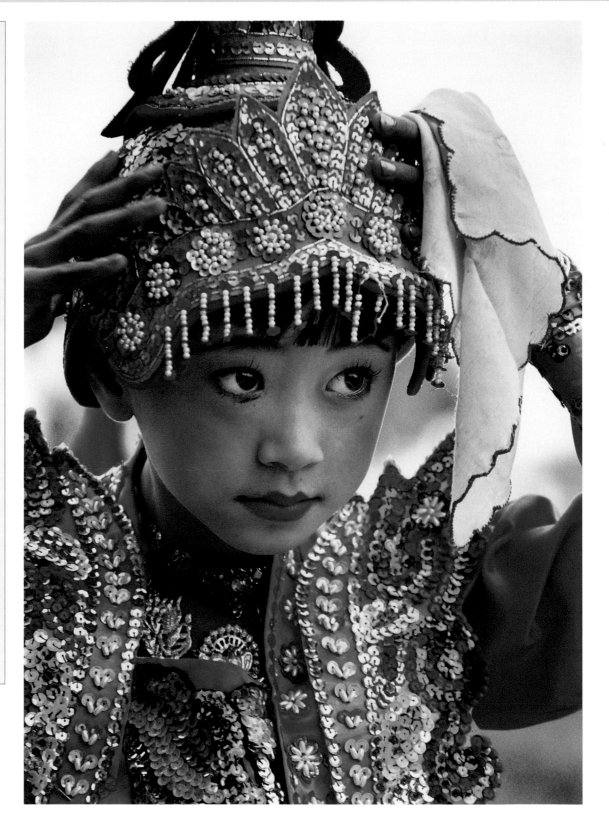

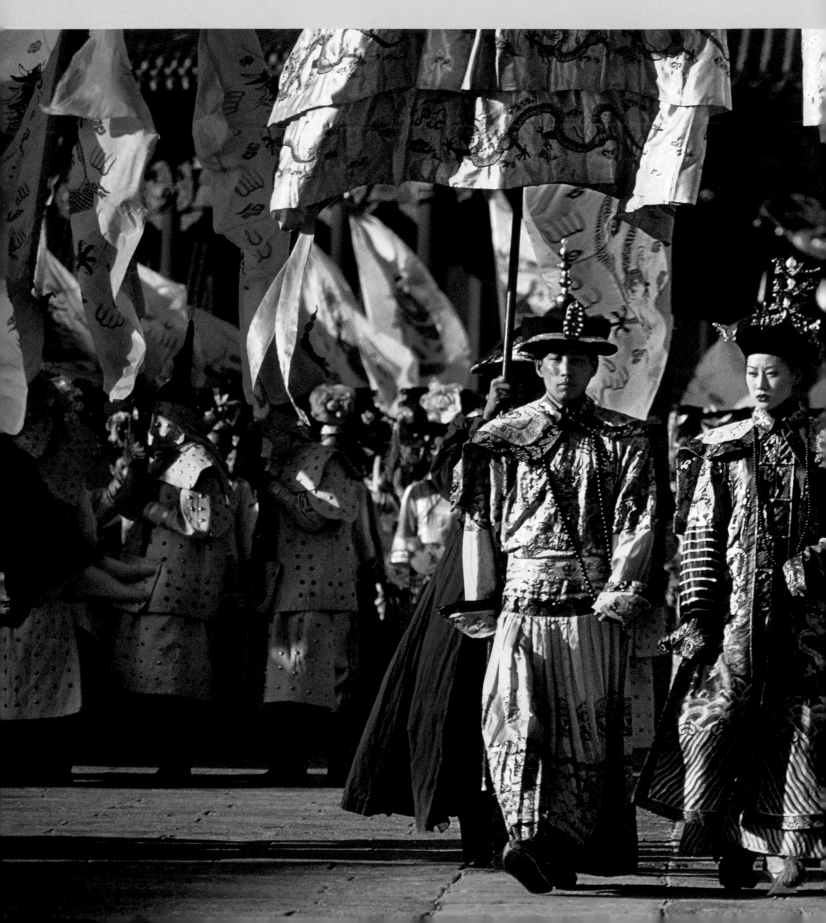

Technical tip

In a parade, try panning your camera by keeping your focus locked on one part of the action and use a medium slow shutter speed of say 1/8 to 1/30sec while following the action with your camera. The result will show a relatively sharp subject against a streaked background.

Markets & festivals

- Markets start early – get there when they are still being set up.
- Don't get in the way of market traders doing their business.
- Festivals and parades have procession routes – find out what the route is and the time it starts and study a map to find the best viewing position.
- At festivals use a telephoto or long zoom lens to get good close-up shots of the participants.

Qing dynasty pageant ↖

There are times in travel photography when you won't be able to move from your position, even if you want to. For example, this spectacular display of pageantry and colour was photographed from a fixed position in a public stand. It shows a parade featuring the richly decorated costumes and banners of one of China's former ruling imperial houses, the Qing dynasty, in Shenyang, northeast China. Although the sun was high in the sky and pretty harsh, the use of a telephoto zoom enabled a tight crop with vividly lit colours filling the background. A spot meter reading was made from the figure in the middle of the advancing trio and a shutter speed of 1/250sec deployed to freeze their step in mid-stride.

Photographer: Jon Bower

Location: Shenyang, China

Time: 11am

Camera: Olympus OM4 Ti

Lens: Zuiko 65–200mm f/4 zoom

Film: Fuji Provia 100F

Exposure: 1/250sec at f/4

Tripod: No; photographer used a monopod instead

Homage to Diego Riviera ↗

Cuetzalan is a typical Mexican town with a Sunday market that attracts people from nearby villages to buy, sell and trade their goods. While visiting the market, the photographer's intention was to make a picture that would project the atmosphere of the place. He soon settled on watching this flower seller and was reminded of the paintings of Mexican artist Diego Rivera. The woman sat under the translucent white tent of another salesman, creating a diffuse pool of light that was ideal for photographing people. The metering was completely automatic, using the camera's built-in system.

Photographer: Mauricio Alcarez

Location: Cuetzalan, Puebla, Mexico

Time: 3pm, mid-March

Camera: Minolta Maxxum 7

Lens: Tokina 80–200mm f/2.8 AT-X Pro AF zoom

Film: Fuji Velvia 50

Exposure: Not recorded

Tripod: Yes

Girls from desert festival ↙

Rajasthan is India's driest state with a landscape of deserts and very little natural colour. Perhaps it is the lack of colour in their environment that motivates the women to wear some of the most colourful saris and jewellery in all India. It is this vibrant display of colour that makes this image from Jaisalmer's annual desert festival so eye-catching. The joyful expression on the main girl's face, sharply focused, leaves us in no doubt as to the focal point of the picture.

Photographer: Piotr Zaporowski

Location: Jaisalmer, Rajasthan, India

Time: 2pm

Camera: Canon EOS 1

Lens: Canon 70–200mm f/4 L zoom

Film: Fuji Superia 100

Exposure: Not recorded

Tripod: No

Landmarks

When visiting a country for the first time people naturally are drawn to a well-known landmark because it is this image they associate with that destination. Most landmarks are manmade; great feats of architecture like the Sydney Opera House, the Taj Mahal or the Golden Gate Bridge.

We've all seen the pictures, but that doesn't stop us from taking a photograph just like that on the postcards for sale at the nearby kiosk. As photographers, we need to spend a little more time looking at the other photographic possibilities, to use our imagination to make an image that is fresh and different.

For example, the Taj Mahal is one of the most symmetrically pleasing buildings in the world and the best known image reflects this in its composition – the front view looking straight down the ornamental water feature with the four minarets placed equally from the centrally positioned dome. As a result one half of the Taj Mahal is a perfect mirror reflection of the other. Despite this faultless symmetry, it is an image that has become a cliché through overexposure.

And yet the Taj Mahal offers many more possibilities: close-up details of the exquisite marble inlay with thousands of semi-precious stones; low angle views from the marble forecourt; the use of wideangle lenses to exaggerate the converging verticals of the minarets. With most landmarks, water is never far away. In the case of the Taj Mahal, the Yamuna River runs close by, but at the rear of the building, so most visitors don't pay it much attention. They're missing something. Along the riverbank, Indian village life continues in a normal vein: men fish, women wash clothes, children play – all oblivious to the tour buses and camera-toting tourists nearby. With the unmistakable form of theTaj Mahal in the background, these sorts of reportage picture provide context to the building that 'tourist-type' images are lacking.

Water can also mean mist, particularly at sunrise, so imagine the type of landscape photograph you could get if you took an early morning taxi ride to capture the Taj Mahal at sunrise while the mist rises from the Yamuna River. Another continent, another landmark: the Sydney Opera House. All over the world millions of people are familiar with the image of the Opera House against a background of the equally famous Sydney Harbour Bridge. This composition is taken from a beauty spot called Mrs Macquarie's Chair, a small, rocky head of land sticking into the Harbour on the eastern side of Farm Cove. So popular is this spot that several professional photographers have their cameras on tripods in a fixed position in front of small tiered stands to arrange the tour groups that arrive by the coachload during the day.

If you arrive early enough, you will not only beat the tour groups, you will also get the best of the light. Sydney Harbour lies east to west, so the morning light soon after sunrise casts a warm glow on the white sails that is hard to resist. This east–west axis can also be exploited at the day's end if you want to get a closer view of the Opera House without the Harbour Bridge in the frame. Simply walk along the west side of Circular Quay towards The Rocks, pick your spot and frame the Opera House the way you want and watch how it glows with the low directional lighting of the setting sun.

Finally, for the best view catch one of the cross-harbour ferries from Circular Quay to photograph the Opera House from the harbour, but use a shutter speed of at least 1/500sec if you want to avoid blurred images while on the water.

Churchill and Big Ben ↳

Big Ben is one of London's most photographed landmarks. And while views from Parliament Square, which include the statue of Sir Winston Churchill, aren't new, this picture is not as straightforward as it looks. It was taken just before sunset, with the west face of the famous tower directly lit by the warm light and the stooping shape of the statue cast into silhouette. It is only in the early autumn that the sun sets absolutely square-on to the west face of the clock tower. To make the most of the perfect lighting conditions, a circular polarising filter was used to deepen the blue of the sky. By exposing for the brightest point of the clock tower (the photographer made a spot meter reading), the dark grey statue of Churchill was rendered a dense silhouette.

Photographer: Jon Bower

Location: Parliament Square, London, England

Time: 6.40pm

Camera: Canon EOS 3

Lens: Canon 24–70mm f/2.8L zoom

Film: Fuji Velvia 50

Exposure: 1/100sec at f/5.6

Tripod: No

Landmarks

Louvre pyramid ↗

Paris is packed with architectural landmarks and the glass pyramid at the Louvre is no exception, so producing an entirely different result makes a refreshing change. The unusual perspective of shooting through iron railings complements the geometrical power of the pyramid. By adding a coloured graduate filter, the sky has been transformed into a vivid background which further accentuates the geometric lines.

Photographer: Piotr Kowalik

Location: The Louvre, Paris, France

Time: Midday

Camera: Canon EOS 50E

Lens: Canon 70–200mm f/4 zoom

Film: Fuji Velvia 50

Exposure: 1sec; aperture not recorded

Tripod: Yes

Sydney icons →

On a small headland east of the Sydney Opera House is an exposed outcrop of sandstone called Mrs Macquarie's Chair. The wife of an early 19th century governor of Sydney, she often came to this viewpoint to admire the harbour. Today, it remains a popular spot for enjoying the sight of the Opera House sails against the backdrop of the equally famous Sydney Harbour Bridge. With the harbour aligned east–west, this is a perfect location to photograph both these famous landmarks against a sunset sky.

Photographer: Steve Day

Location: Mrs Macquarie's Chair, Sydney, Australia

Time: 6.30pm, September

Camera: Canon EOS 50E

Lens: Canon 70–200mm f/2.8L zoom

Film: Fuji Velvia 50

Exposure: 1/8sec at f/11

Tripod: Yes

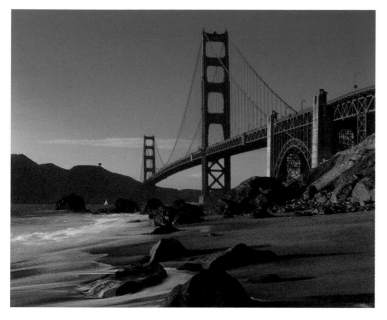

Golden Gate at sunset ↰

In many pictures of San Francisco's greatest landmark, the bridge doesn't look golden at all, but in this view from Baker Beach the late afternoon light has brought out the details of the bridge and reflected the warm glow from the beach. Filters played a part too – a combination of circular polariser and blue/yellow polariser has enhanced the colours and warm light while still maintaining the wonderful blue of the sky. Because of the slow shutter speed the waves have registered as a soft, blurred form on the shore.

Photographer: Kenneth Kwan

Location: Baker Beach, San Francisco, USA

Time: 6pm

Camera: Canon EOS Elan 7e

Lens: Canon 28–105mm f/3.5–4.5 zoom

Film: Fuji Sensia 100

Exposure: 1/2sec at f/16

Tripod: Yes

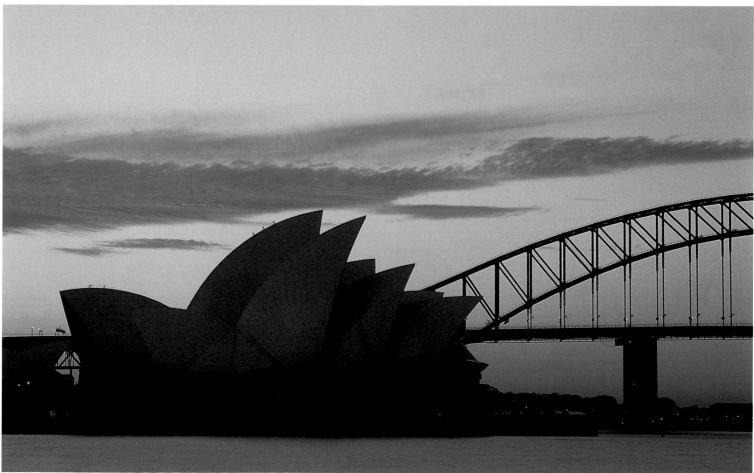

Landmarks

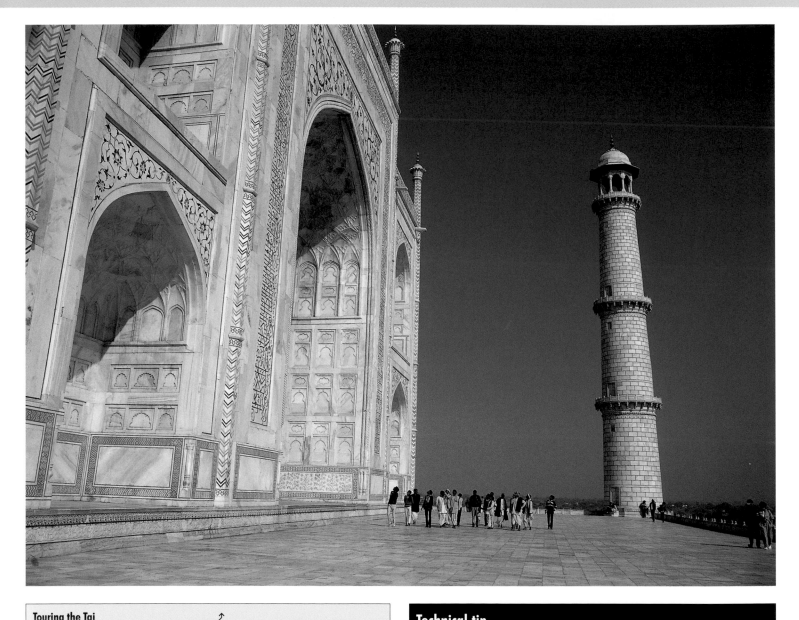

Touring the Taj ↗

When photographing a site as famous as the Taj Mahal, the challenge is to make a composition that is different and something more than just a straight record shot. Here, high bright sunshine lights up the marvellous details in the marble and the line of visitors provides the scale to convey the impressive dimensions of the building. A wideangle lens has deliberately exaggerated the converging verticals of the minaret and Moghul archways, while a polariser reduces reflective glare from the brilliant marble surfaces.

Photographer: Nigel Hicks	**Lens:** Pentax 45mm f/4 wideangle
Location: Taj Mahal, Agra, India	**Film:** Fuji Velvia 50
Time: 11.30am	**Exposure:** 1/125sec at f/8
Camera: Pentax 67II	**Tripod:** Yes

Technical tip

Don't always try to get the whole structure within the frame. Use telephoto lenses to focus on interesting details or graphic sections. Instead of trying to avoid or lessen the impact of converging verticals, why not make them a feature of the image – emphasising the compositional vanishing point in the sky.

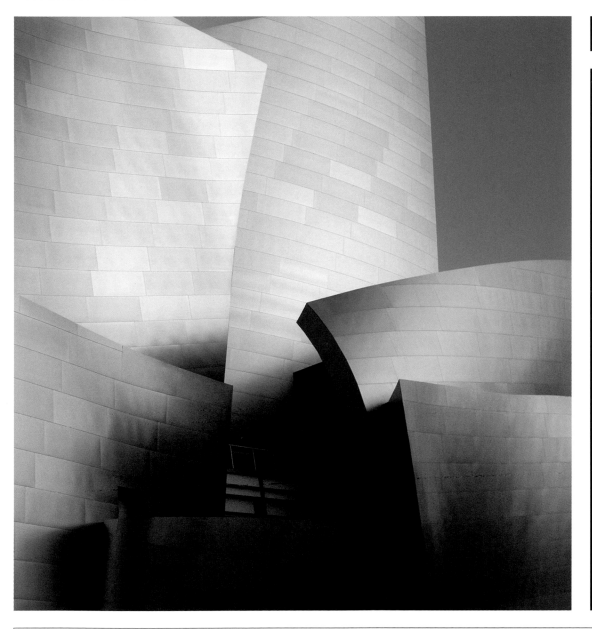

- When visiting a landmark for the first time, don't immediately take a picture – have a walk around instead and observe.
- Find out where the sun rises and sets in relation to the subject and return just before sunrise or sunset to get the warmest light.
- Take a polarising filter – this will reduce any glare from reflective surfaces and emphasise clouds.
- Use the landmark as background to other images, thereby showing it in relation to the rest of the environment.

Dusk approaches ↗

Construction of the Disney Concert Hall was almost complete when Brad Kim paid an evening visit in August. It was approaching sunset and shadows were lengthening. Kim noticed that the sunlit part of the metal exterior was taking on a warm cast, while areas in shadow were turning cool. He composed carefully, so that the lines of the walls were evenly balanced on both sides of the frame. He used a circular polariser, set the camera's white balance to automatic and made a partial meter reading from the bottom half of the picture. After downloading the image onto his PC, he cropped the image some more to exclude any peripheral distractions from the scene.

Photographer: Brad Kim

Time: 7pm, August

Lens: Canon EF 20mm f/2.8 USM wideangle

Exposure: 1/60sec at f/5.6; ISO 100

Location: Disney Concert Hall, Los Angeles, USA

Camera: Canon EOS 10D

File type: JPEG

Tripod: Yes

Skyscrapers & towers

When Gustave Eiffel designed and built his tower for the Paris Exposition of 1889, little did he know the effect his 300m (986ft) high edifice would have on architecture and photography. It was the world's tallest structure when completed and was meant to be temporary. Nearly 120 years later, it still draws crowds of visitors to its base who, with craned necks, marvel at its lofty form and frown with disappointment at the inability of their cameras to include the whole tower from top to bottom in the viewfinder.

In most cities skyscrapers are surrounded by other tall buildings – and are best shown as part of an overall view of a city. But even then, in the canyons of New York City, isolating individual skyscrapers is impossible. In this instance, photographing the skyline of Manhattan is more easily done from the water on the Staten Island Ferry or looking back from the other side of the Brooklyn Bridge. Similarly in Sydney, its tall city buildings are at their most impressive when photographed from a ferry on the harbour.

In Paris, the Eiffel Tower stands out because there are no other surrounding buildings that can challenge it for height or attention. And, unlike an office building, its architectural form isn't repeated in the next city block. Standing at the base of the Eiffel Tower, you can use your camera lens to make a subject of the marvellous symmetry of the sweeping iron spans linking the four platforms supporting the tower. Wideangle lenses come to the fore here to enable you to distort the spans and arrange the curves so that your composition becomes a study of lead-in lines and converging verticals. Alternatively, telephoto lenses can help you crop closely on precise geometric designs within the ironwork.

Of course, people are drawn to the Eiffel Tower, as with any skyscraper, for the promise of the view from the top. Here, you can get that spectacular sweeping vista of a city that we all love – providing the weather's good! If you know the forecast is promising for the day ahead, it's best to get to look-out points as early or as late as possible, because angled sunlight of morning or afternoon will pick out more details and cast a warmer light on the buildings below.

Try not to shoot into the sun, but if it is unavoidable, use a lens hood to reduce the chance of flare. If the sky is cloudless, don't include too much in the viewfinder as it will cause your camera's light meter to select a faster shutter speed, leading to underexposure. Also, a plain blue sky conveys no depth in a picture and detracts from the real centre of interest, which is the city buildings and streets below. For your view from the top, it's worth finding something prominent in the foreground or to the side, such as a nearby tall building or structure, that can serve as a focal point and a measure of scale to the scene, thereby giving your photograph depth.

Modern city architecture is becoming more adventurous with some unusual shapes and structures rising through our skylines. The London Eye is a very good example. At around 400ft high, this huge revolving observation wheel resembles a giant bicycle wheel from a distance, but its white exterior, curious observation pods and perfect circle makes it a very recognisable part of London's skyline. Rather than photographing it from close proximity on the South Bank, far more interesting images can be made by showing part of it peeping between concrete office blocks or from one of the nearby bridges on the Thames: Waterloo, Hungerford and Westminster.

The lesson here is that if the skyscraper or tower is of recognisable design, shape or height, then you can build up a set of photographs taken from various quarters of the city in order to show how its size and form relates to the rest of its urban environment. Don't always go for the obvious.

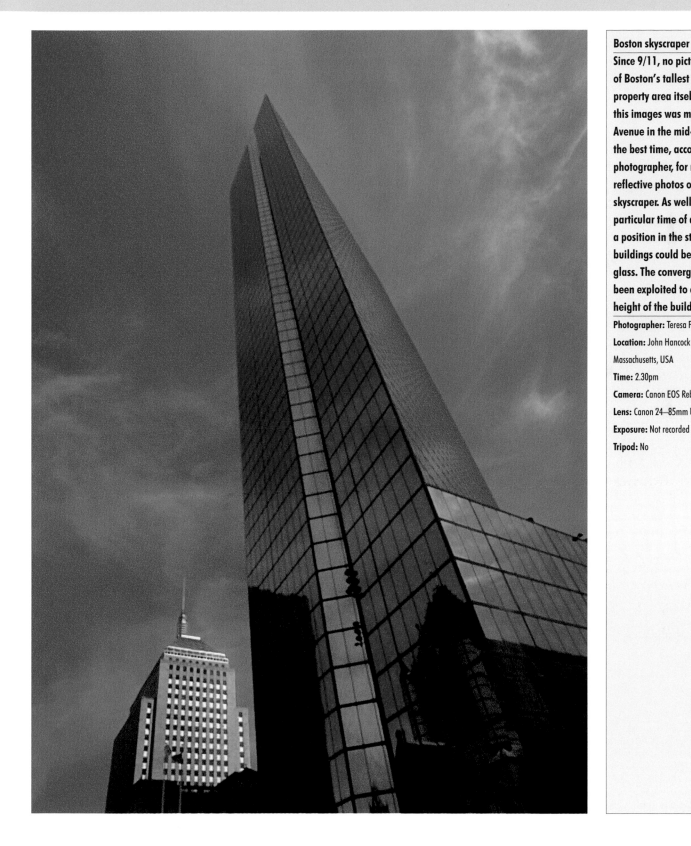

Boston skyscraper

Since 9/11, no pictures are allowed of Boston's tallest building from the property area itself. Consequently, this images was made from St James Avenue in the mid-afternoon – the best time, according to the photographer, for making good reflective photos of this 60-storey skyscraper. As well as choosing a particular time of day, she also chose a position in the street at which four buildings could be reflected in the glass. The converging vertical has been exploited to exaggerate the height of the building.

Photographer: Teresa Forrest

Location: John Hancock Tower, Boston, Massachusetts, USA

Time: 2.30pm

Camera: Canon EOS Rebel 2000

Lens: Canon 24–85mm USM zoom

Exposure: Not recorded

Tripod: No

Skyscrapers & towers

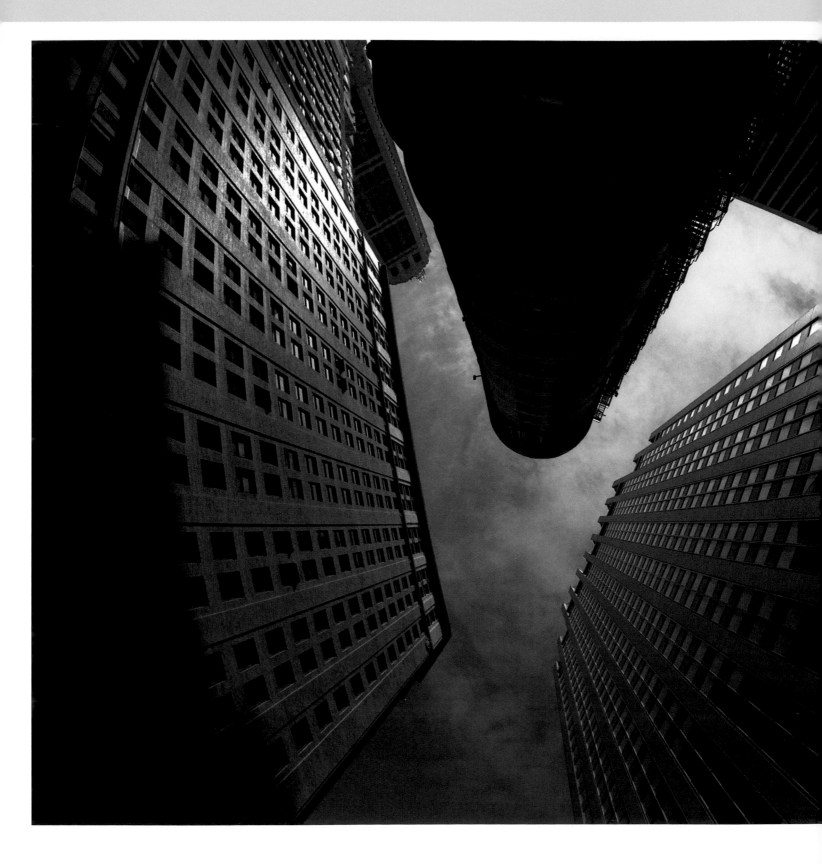

Skyscrapers & towers

- Tall buildings look most impressive from a distance, shown in the context of their surroundings.
- Choose a time and position when a part of the building is lit by the warm low light of early morning or late afternoon.
- Prominent architectural features or details can be picked out using a telephoto lens – the greater magnification means there is a greater risk of camera shake, so use a fast shutter speed if you can't use a tripod.
- If the sky is plain blue, don't include too much in the frame. Cloudy skies are far more interesting.

Technical tip

A superzoom lens gives plenty of flexibility for photographing skyscrapers and towers from a variety of positions and distances. Zoom throughout the range before deciding on your final composition, remembering to emphasise any lead-in or diagonal lines.

Hanover Street ↖

Fisheye lenses produce highly recognisable effects. In this example, the camera and lens have been pointed straight up from a street of tall buildings in the heart of New York's financial district. With buildings surrounding the centre of the frame, there is an almost claustrophobic sense of being stuck in the bottom of a well. Making an accurate light reading was the greatest difficulty as the area of sky was much brighter than the skyscraper walls in the rest of the frame. The photographer bracketed his exposures by 1 stop either side of the 'correct' reading.

Photographer: John Pollak

Location: : Lower Manhattan financial district, New York, USA

Time: 2–3pm, mid-summer

Camera: Pentax 67II

Lens: Pentax 35mm fisheye

Film: Kodak Tri-X; ISO 400

Exposure: 1/500sec at f/8

Tripod: No

Skyscrapers & towers

Empire State ↳

To convey the true height of the tallest skyscrapers in relation to their surroundings, it is necessary to photograph them square on from an elevated position. That way, the distortion of converging verticals caused by tilting the camera skywards when shooting from the ground can be avoided. For this colourful night view of New York's Empire State Building, Louis Greene went to the 32nd floor of a building on 32nd Street. He chose to shoot 20 minutes after sunset because of the colourful contrast between blue sky, fading sunset and the building's lights. Meter readings were made from the horizon and the top of the building and the resulting exposure bracketed by 1/2 a stop.

Photographer: Louis Greene

Location: New York City, USA

Time: 20 minutes after sunset

Camera: Mamiya 645M

Lens: Mamiya 80mm

Film: Fuji Velvia 50

Exposure: Approx 4sec; aperture not recorded

Tripod: Yes

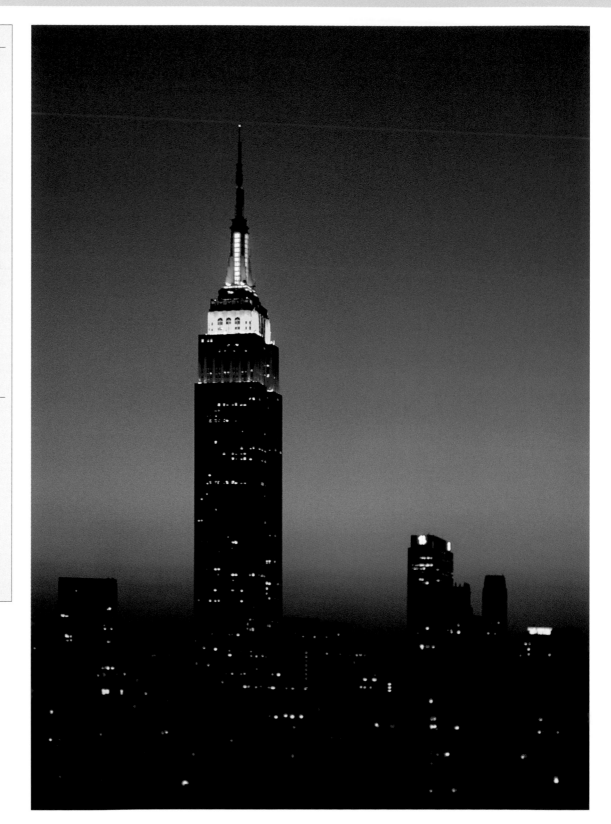

The mighty Petronas Towers →

For any visitor to Malaysia's capital city, the twin skyscrapers of the Petronas Towers are one of the highlights. The world's tallest buildings, they dominate the Kuala Lumpur skyline and represent a major pictorial challenge to any photographer trying to convey their size and stature. In this image, Daniel Bayer has chosen to photograph at night, when the buildings are brilliantly lit, to depict their physical presence in a graphically defined way. The distortion of the 17mm wideangle focal length gives the buildings a more stately look and the towers have been perfectly framed, to create an effect of almost perfect symmetry.

Photographer: Daniel Bayer

Location: Kuala Lumpur, Malaysia

Time: 7pm

Camera: Nikon F100

Lens: Nikkor 17–35mm f/2.8 AF-S zoom at 17mm setting

Film: Fuji Provia 100F

Exposure: 30sec at f/8

Tripod: Yes

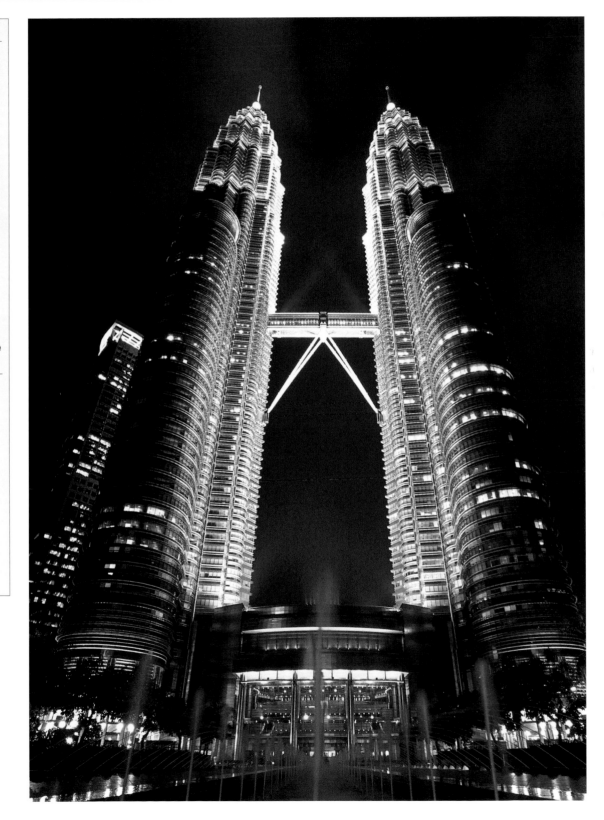

Skyscrapers & towers

Religious buildings

To my mind, churches, mosques, temples, monasteries and other places of worship have more photographic potential than any other type of architecture. Also, travellers can gain more insight into a country's culture and society from these places than from skyscrapers or even museums. Generally, there isn't a problem with photographing a cathedral or temple from the outside, but don't be surprised if there are restrictions on photography indoors. It's important to remember that these are places of worship and you should always be mindful of those who are visiting to practise their faith.

From the outside, a large cathedral or temple will present the same difficulties as any tall building when photographed from the ground. Converging verticals will be impossible to avoid unless you are able to shoot from an elevated position or use a specialist perspective control (PC) lens. These lenses are expensive and only available for a few makes of camera, so seeking out an elevated position is your more likely option. The 'barrel' distortion of wideangle lenses exaggerates the leaning effect, so it's best to use a longer lens focal length, ideally a short telephoto of around 90mm to 135mm in 35mm format.

I think it is best to photograph a major church or mosque from a distance so you can see it in relation to its surroundings. Mosques, with their distinctive minarets and central domes, are particularly eye-catching from a distance. For example, the roof and exterior of Istanbul's Blue Mosque is as representative of that city as the ceramic sails of the Opera House is to Sydney. Don't forget the details: the gnarled and monstrous features of church gargoyles have great impact in close-up, while the exquisite stone carved figures of saints and bishops can only be truly appreciated when viewed in isolation through a telephoto zoom.

Inside, stained glass windows and richly painted ceilings are worth a closer inspection with your lens. Of course, any interior photography should only be made after obtaining permission. Even then, don't be surprised if there's a small fee or a ban on flash use. A tripod is highly advisable for interiors because flash (even if it is allowed) is next to useless given the vast space and high ceilings of a church.

If neither flash nor tripod is allowed inside, digital camera users can get around the issue of low light by increasing their ISO setting. The higher the number you choose the faster the resulting exposure, but there will be extra image 'noise' too. Film users can also increase their ISO setting, but you can't adjust it frame by frame as with a digital camera, because when it comes to processing the film, there can be only one development time for the whole roll. So, if you're shooting film and choose to uprate the ISO from the nominal setting, then keep it at that setting until the end of the roll and give it extra development time to compensate for the underexposure.

In so many ways, Buddhist temples and monasteries are the most photographically rewarding. This is helped by a more open design, with shrines in temple forecourts for worshippers to light incense, spin prayer wheels and ring bells or beat drums. The smoke from burning incense adds to the atmosphere, particularly when making candid or portrait studies.

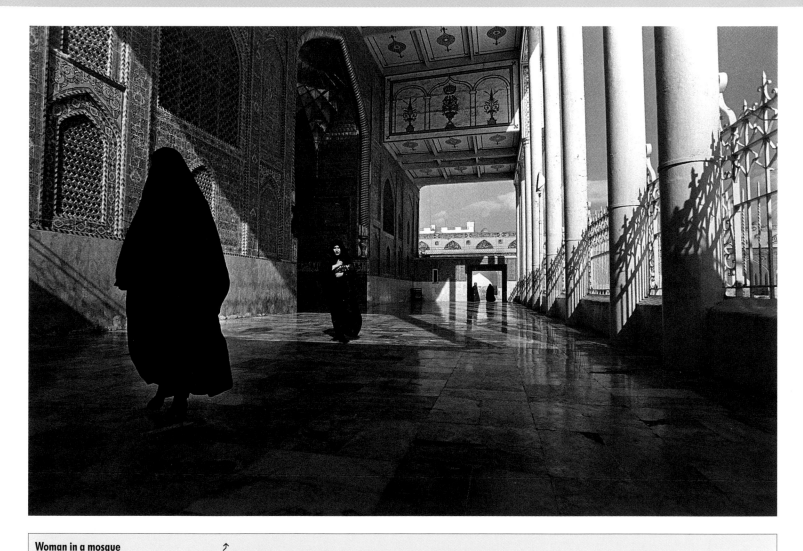

Woman in a mosque　　　　　　　　　　↗

In regions with a history of political unrest, travel photography can also become an important medium for documenting life in more peaceful times. Piotr Zaporowski visited Iraq just before war broke out in that country in March 2003, to document daily life. This image of a burka-clad woman at a mosque in Samarra presents a scene of calm far removed from the destruction and turmoil in news pictures published since the war. Normally, a black & white composition of an old and well-preserved location such as this mosque could be deemed 'timeless', but in this case the turbulent nature of the present times for Iraq means this picture is clearly from another era.

Photographer: Piotr Zaporowski	**Time:** Around noon, March	**Lens:** Canon EF 20–35mm f/2.8 wideangle zoom	**Exposure:** Not recorded
Location: Samarra, Iraq	**Camera:** Canon EOS 1	**Film:** Ilford 400	**Tripod:** No

Religious buildings

Enlightenment ↑

By adopting a low viewpoint and using the wide end of a zoom lens, it becomes hard to gauge the true height of this statue of the Buddha. Such framing also creates strong diagonal lines, which gives the image thrust. To avoid underexposure caused by the sun's inclusion in the frame, a meter reading was made from the statue and this value overridden by 1/2 a stop when taking the picture. A polarising filter was used to reduce glare and reflections.

Photographer: Alec Ee

Location: Singapore

Time: 2.30pm

Camera: Sony DSC F-505V

Lens: Built-in Carl Zeiss 7.1–35.5mm zoom

File type: JPEG

Exposure: 1/250sec at f/8; ISO 100

Tripod: No

San Geronimo church →

The whitewashed churches and chapels of New Mexico are graphic features of the local landscape. With their propensity of crosses and right angles, they make a simple, yet striking study in the desert light. By composing the scene so that the crosses and bell towers are set against a background of blue sky and soft white cloud, the similarity with churches in Greece is all too apparent.

Photographer: Geraint Smith

Location: Taos Pueblo, New Mexico, USA

Time: Early afternoon

Camera: Nikon F3

Lens: Nikkor 105mm

Film: Kodachrome 64

Exposure: 1/250sec at f/11

Tripod: No

Technical tip

Whether shooting digitally or on film you can compensate for the lack of light indoors by uprating your ISO setting. By doing this film users will have to tell the processing lab the new rating so that increased development time is given. Digital users should be aware that the faster the ISO rating the greater the amount of image noise.

Religious buildings

- Find out first if there are any photographic restrictions – tripods and flash are often prohibited and photography during services is rarely permitted.
- Do not intrude on anyone's prayers or meditation – remember these are places of worship.
- Famous religious buildings such as the Blue Mosque of Istanbul or the Golden Temple of Amritsar have been well photographed before – have a good look round for a different angle.
- Photograph candids of people (not tourists) around the temple precincts.

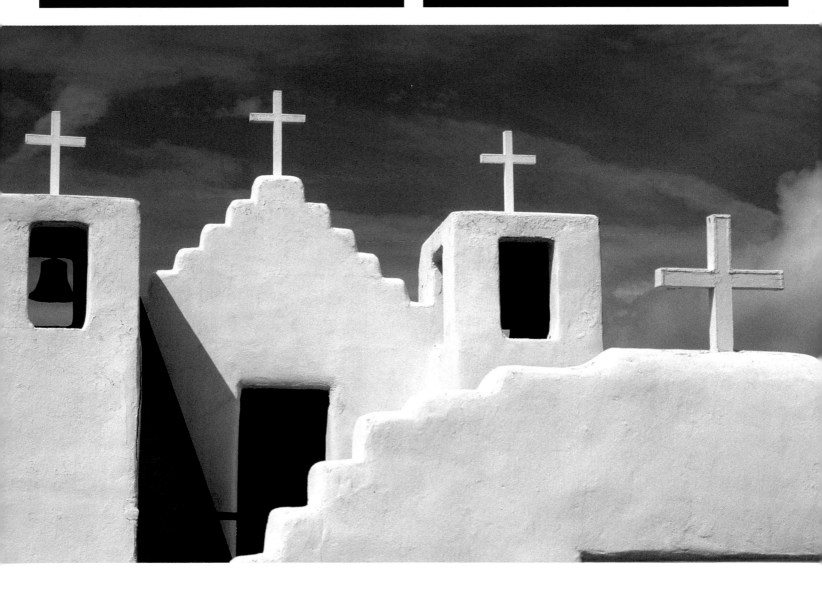

Castles & palaces

Historically, castles are imposing structures, built as much as a statement of their rulers' intent and power as for their defensive capabilities. They also were built to last and it is this sense of permanence and survival through centuries of upheaval that adds to their popularity as visitor attractions.

Because they were built in areas of strategic importance, a castle's position and surrounding geography can provide wonderful picture possibilities. Water is a great natural defence and many castles were built on the water's edge for this reason. Photographically, water provides a variety of changing foreground interest – boats at anchor, rising mist, colourful reflections of floodlit ramparts at night. Where water doesn't occur naturally, you will often find a moat dug around the castle perimeter. Moats provide a perfect mirror reflection and many photographers use this to compose an image that is a study in symmetry.

Because of the geographical factors that determine a castle's position, it is not surprising that many castles occupy dramatic settings. As a result, it makes sense to photograph a castle as a focal point in a larger, overall landscape. Indeed, many of the greatest vistas in the Scottish Highlands feature a castle against a dramatic backdrop of mountains or lochs. Eilean Donan and Castle Urquart are prime examples. Such a setting needs to be approached in the same way as any natural landscape. Find out the direction and times for sunrise and sunset and establish which part of the castle will be lit at these times. Use a wideangle lens to show the castle in context with its landscape and be careful not to let too much sky or reflected highlights in the water fool your camera meter into underexposing. It's best to meter off a well-lit area of the castle wall and use this exposure value for your photograph.

Of course, you can also focus more closely on the castle with longer lenses in order to highlight the architectural qualities. Gates, ramparts, portcullis, window slits and stone steps are features of most castles and worthy of more prominent consideration in your photographs. This approach involves filling most, if not all, of the frame with the surrounding stonework. As it's of a neutral and consistent tone, making an accurate meter reading is practically guaranteed.

Some of Britain's best known castles also serve as royal palaces – Windsor is the world's largest inhabited castle – but most other palaces around the world were built for their splendour and luxury and look remarkably different as a result. In France the Palace of Versailles is a vast statement of French 17th century opulence, and Thailand's Grand Palace is one of the most colourful and richly decorated buildings to be found in the Far East.

Because of their size, array of colours and intricate artistic details, palaces such as these are impossible to photograph in their entirety, unless you are fortunate enough to be flying overhead in a hot air balloon or helicopter! Assuming the aerial view is not an option, it is best to concentrate on sections that typify the art and architecture of the palace. Where colour is a prominent feature, particularly gold, choose an area that is well-lit, showing off the brilliance of the gilded detail. Metering needs care as the high reflectance of gold and highly polished surfaces will lead to a fast exposure reading. Take several spot readings from the surrounding area in your viewfinder to determine the exposure variance and then settle on an average reading. Either lock your exposure at this setting or switch to manual and select your preferred aperture and shutter speed combination. Even then it pays to bracket around your 'correct' exposure, in order to have a selection of images.

Prima Torre, San Marino ↙

Medieval castles were built in prominent positions overlooking valleys, a fact underlined by the composition in this image of Prima Torre. The castle has been placed off-centre in the frame in order to provide a good sense of depth to the background of modern city lights.

Photographer: Kenneth Kwan	**Time:** 8pm	**Lens:** Canon EF 100–300mm f/5.6 L zoom	**Exposure:** 2sec at f/8
Location: Republic of San Marino	**Camera:** Canon EOS Elan 7e	**Film:** Kodak Elitechrome 100 EC	**Tripod:** Yes

Castles & palaces

Castle Stalker ↙

The Scottish Highlands are famous for their ancient stone castles, beautifully situated by lochs where the reflection of mountains and fortress add to the overall sense of impregnability. For this dawn view in winter, photographer Rod Edwards was using a Wista, a field camera that uses sheet film to make a 4x5in negative or transparency. He used a polarising filter to control reflections, an 81a filter to add warmth to the castle stone and a grey graduated filter across the sky to even out the exposure variance across the frame. All this filtration resulted in a slow exposure of 1/2sec. Later Edwards cropped out some of the foreground to make this panoramic image.

Photographer: Rod Edwards

Location: Loch Linnhe, near Fort William, Scotland

Time: 8am, February

Camera: Wista 45DX Rosewood field camera

Lens: 120mm

Film: Velvia 50 rated at ISO 40

Exposure: 1/2sec at f/22

Tripod: Yes

Neuschwanstein in winter ↗

Europe's most famous castle, Neuschwanstein, enjoys a setting that fulfils most childrens' vision of a fairytale palace. With a dusting of snow over the turrets and pine forest, this stereotypical and familiar image nevertheless couldn't fail to impress photographer Louis Greene. The light wasn't anything special, overcast and grey, so he minimised its inclusion. Metering off the sky and foreground, a 0.3 ND graduated filter was added over the lens to balance the exposure variance, creating a picture that can only enhance the reputation of this Bavarian royal folly.

Photographer: Louis Greene

Location: Bavaria, Germany

Time: Late morning

Camera: Canon EOS Elan 2

Lens: Tamron 28–200mm f/3.5 zoom

Film: Fuji Velvia 50

Exposure: Not recorded

Tripod: Yes

Technical tip

Before you start exploring a palace or chateau, have a look at any postcards in order to see how other photographers have interpreted the scene and to get an idea of what there is to see. Note the quality of the light and try to guess what time of day the picture was taken.

Castles & palaces

- Castles are usually built of local stone and the degree of warmth reflected by the rising or setting sun varies according to the colour and coarseness of the rock.
- Use a wideangle lens to show the castle or palace in context with its landscape.
- Many castles are built beside water, so look for a spot that provides an uninterrupted reflection.
- Palaces tend to be more lavish than castles — look for rich decorative features that would make a colourful study photographed on their own.

Interiors

It would be a rare thing, having taken a series of photographs of a building's exterior, not to then venture indoors and photograph what lies within. However, don't expect it to be easy. Not all places permit photography indoors, tripods are deemed obstructive and flash commonly is not allowed. So let's assume all these factors apply, which they so often do, and rise to the challenge.

Time of year and time of day can determine the level of success when photographing interiors that are lit mostly by available daylight. Given that many places of interest aren't open before 9am and remain closed during the winter months (Britain's National Trust properties come to mind here), there will be little in the way of direct sunlight shining through any windows, doors, arches and other openings. This isn't all bad news as diffused, non-direct ambient light means less contrast and more even tones.

Church interiors are popular but tricky subjects. During the day some churches are lit only by candles or the light shining through stained glass windows. Even a bright day outside will mean fairly low light indoors, so taking pictures without a tripod will mean having to use your fastest possible shutter speed to avoid camera shake. This means using a wide aperture and/or uprating your ISO setting in order to achieve a shutter speed of at least 1/60sec. Film users should load with fast film, say ISO 400 or 800, when shooting indoors without flash. Of course, you can still uprate the ISO speed beyond this, but remember to inform the processing lab to take this into account so they can give the film more development time to compensate for the underexposure.

Shooting digitally offers tremendous advantages indoors as you can adjust the ISO rating and white balance (WB) setting for each frame and then immediately check the result on the LCD panel. Most digital photographers set the WB to automatic, but for interiors where lighting can be a mixture of window light, tungsten lamps or fluorescent tubes, it is advisable to make more precise adjustments using your manual settings. Some digital cameras have more white balance settings than others and it's worthwhile knowing exactly what type of lighting they relate to. Like most film, digital camera sensors are daylight balanced. As film users well know photographs taken in the light of normal tungsten household lamps will produce a warm, orange cast, while fluorescent light gives off a green colour cast. Adjusting the WB to the appropriate settings will ensure that with these light sources your images will still appear as if lit by daylight.

In the absence of a tripod, monopod or other means of support, you may have to improvise to get a sharp result. Look around for flat stable surfaces that can support your camera and use the self-timer delay to make your exposure. Windowsills, seats, church pews, tables are some of the possibilities. I've even heard of a photographer who, instead of tilting his head right back to photograph the interior of the dome of St Paul's Cathedral in London, simply set his camera's self-timer on 10sec delay and then placed the camera on the floor with the lens pointing straight up! Simple, but effective.

Window light is also a favourite with portrait photographers as it creates an atmosphere that is more documentary in style than a perfectly lit studio portrait. Interior shots of bars, cafés, pubs and restaurants aren't complete without people, so use your camera's spot meter to take separate readings of the lit window space and the areas in shadow and then choose the average as your exposure. Check this average exposure with the reading from your subject's face. Even then it may be best to open up a bit more as a large well-illuminated window can have a huge influence on a camera's meter reading.

The variable lighting conditions of many interiors demands that you bracket your exposures – in many cases, more extensively than you probably would with other types of photography.

Starlite Diner ↗

Although this classic American diner was open 24 hours, the photographer still expected it to be empty at 1am. It wasn't. His intention was to compose the picture so that the pattern of the floor led to a vanishing point in the centre of the picture, bisecting the line of stools and benches on either side of the frame. A shutter speed of 10sec was long enough to capture the red lights of the ceiling reflecting off other surfaces while revealing the outline of customers who remained still enough during the exposure. No filters were used.

Photographer: Jean-Luc Benazet	**Time:** 1am	**Lens:** Minolta 35–70mm f/3.5–4.5 zoom	**Exposure:** 10sec at f/22
Location: Fort Lauderdale, Florida, USA	**Camera:** Minolta X300	**Film:** Kodak Gold 200	**Tripod:** Yes

Interiors

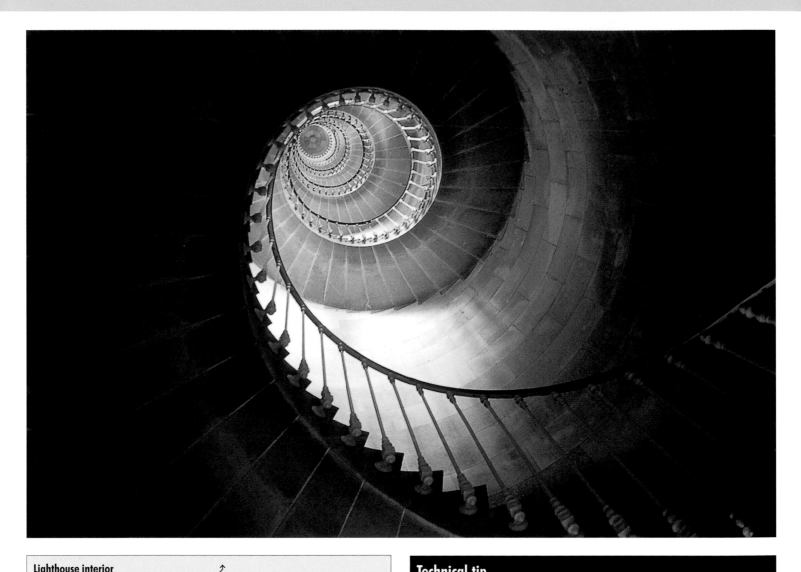

Lighthouse interior ↗

Without using a tripod, the photographer was at the very limits of exposure for obtaining a sharp, blur-free result handheld. The only lighting was from the lighthouse windows and fortunately the sun was still high enough to illuminate the interior stonework, even in the shadows. Rather than position the very top of the spiral staircase in the centre of the frame, the photographer's main concern was to line up a single point of contact for the different circles. The chosen exposure was taken from the reading made by the camera's automatic metering system, with no compensation or override.

Photographer: Josep Lluis Grau

Location: Phare des Baleines, St Clément-des-Baleines, Ile de Ré, France

Time: 4pm

Camera: Nikon F100

Lens: Nikkor 24–85mm f/2.8–4 zoom

Film: Fuji Velvia 50

Exposure: 1/30sec at f/2.8

Tripod: No

Technical tip

The warm cast produced by household tungsten lights and candles looks very atmospheric on daylight balanced film. To record the same effect digitally, set your white balance setting to daylight and then check the result on the LCD monitor.

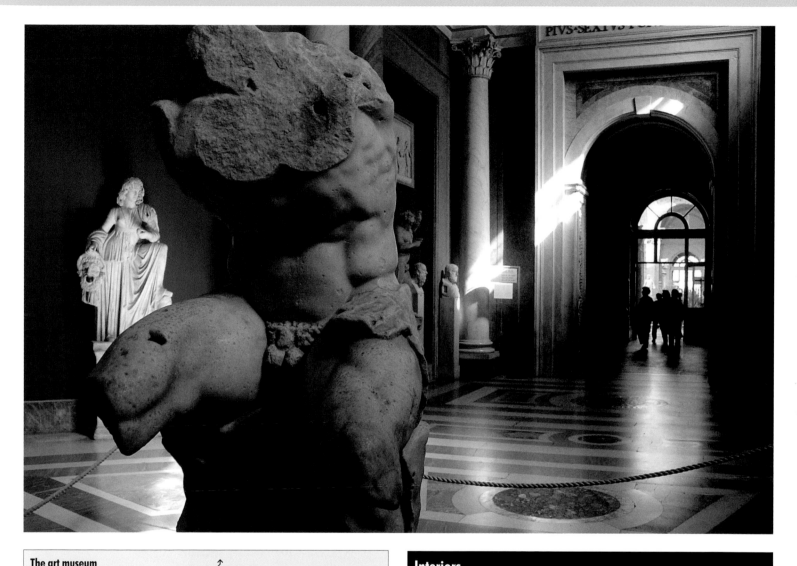

The art museum ↗

The Vatican Art Museum is one of the most historic museums in the world with a priceless collection of art and antiquities. It is the museum's contents rather than the building itself that is the focus of attention. However, in this wideangle study, we see more of the museum space as a work of beauty in itself while the main attraction – the well-lit marble statue against a dark red wall – is reduced in scale and prominence.

Photographer: Charo Diez

Location: The Vatican Museum, Rome, Italy

Time: 2pm

Camera: Sony V1

Lens: Built-in Carl Zeiss 7–28mm zoom

File type: JPEG

Exposure: Not recorded

Tripod: No

Interiors

- Use available light rather than flash as the result will be a lot more atmospheric.
- If a tripod isn't allowed inside you could place your camera on a seat, step, windowsill or table and use the self-timer to trigger the shutter.
- Make portraits of people sitting by windows, remembering to take several spot readings to determine the exposure, and then bracket around your chosen reading.

Coastlines & beaches

At some point we have all found ourselves entranced as we gaze upon a great expanse of ocean from a coastal cliff top or beach. The draw of the ocean as waves roll in to the shore has a powerful effect on our senses and imagination. Photographically, there is an enormous range of possibilities wherever land meets the sea, mostly to do with the local geology. But there are some other important factors to consider before you set up your tripod.

First, pinpoint your location on a local map and find out the precise direction your stretch of coastline is facing. This may not seem so obvious at first but a coastline can be sprinkled with inlets, coves and jagged promontories, all facing different directions. For example, the west coasts of Norway, Scotland, Brittany and Galacia are so ragged and broken that from different parts you can look out to sea in a north, south, west, even an easterly direction. For this reason a large scale, local map can give you the detail you need.

Determining the best time of day for the light will depend largely on the direction you're facing, but the time of year will have a greater bearing on this judgement the further you are away from the equator (see Sunrise & sunset times, p.48).

Another factor that plays a large part in choosing your time and place – and one that is unique to coastal landscapes – is the tide. Local

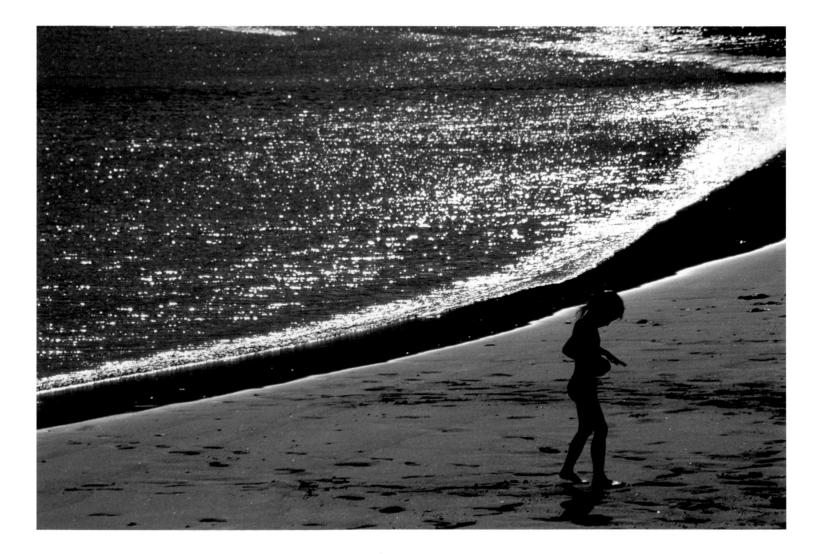

tide-tables give a day-by-day list of high and low tide times throughout the year. Obtaining a copy of these will prove extremely useful to your planning as high and low water marks can vary substantially in a 24-hour period. Low tide gives you the opportunity to access a shore that is otherwise submerged, thereby giving you a different vantage point or revealing a focal point such as a large rock that can provide foreground interest to a scene.

Finally, there is the weather forecast. Unsurprisingly, coastal climates are incredibly fickle and can be totally different to the weather experienced a few miles inland. Wind is always a factor and even on a day when the sea is like a millpond, a new weather front making landfall from the sea is very often preceded by blustery winds and gathering clouds.

Taking all these factors into account, the ideal conditions for a coastal landscape are a day when low tide coincides with the warm, low-angled light of dawn or dusk, shining directly onto your chosen coastal view, at a time of year that this occurs. (And that's assuming dry clear weather!) Obviously, an element of luck is needed, but with the right planning, local knowledge and a good forecast you could find a stretch of coast in the vicinity you're visiting that gives the best chance for these factors to combine. It can be done because we've all seen the pictures to prove it. If you're visiting a coast for the first time, it pays to study local maps for any information about the geology and topography of the coast. This can give clues to the colour and nature of the shore. For example, chalk cliffs are mostly brilliant white with large white boulders at their base; sandstones are soft, orange and red/brown; granite produces a multitude of colours with large stones and rockpools packed with marine life; and river and creek estuaries are home to dark, impassable mudflats. While many people long for the gentle, white sandy beaches backing onto rainforests, for my mind the coastal landscapes with the greatest photographic appeal are those where cliffs or mountains plunge into the seas, such as the fjords of Norway and New Zealand's South Island. These are not places to sunbathe in. Instead, the drama of the landscape and the fast changing light brought by unpredictable weather makes these shorelines ideal for the camera.

Look out for compositional elements to add interest to the coastal landscape, such as small fishing harbours and seawalls or lighthouses standing steadfast above the crashing waves. The placement and construction of these features convey much about the nature of a coastline, providing you don't zoom in too closely for your photograph – far better to use a wider angle of view to show the lighthouse in context with the shore it's protecting shipping from. Some features such as sea stacks or natural arches provide an obvious focal point for a coastal landscape. Again, it pays to use a local map to locate these features and find out where the best vantage point would be for photography. Because water is highly reflective, filters are often needed to control the light levels of your scene. Polarisers reduce the glare and bright sunbursts reflected on a cusp of a wave. Neutral density (ND) filters are handy for extending the shutter speed of your camera to several seconds or longer, if you wish to record the incoming sea as a misty froth on the shoreline. This is a technique best attempted just before sunset or after sunrise, when light levels are low and a tripod is needed.

On sunny days sandy beaches are as reflective as water so it makes sense to avoid photography in the middle of the day when the light is intense. In such conditions shadows are inky black and without detail and contrast very high. You will need to stop right down in order to achieve a workable shutter speed and while depth of field will be extensive, obtaining an exposure that's accurate right across the frame will be extremely difficult, particularly if you're shooting on slide film. Far better to go for a swim or have lunch instead!

Late on the beach ↰

Instead of trying to overcome the harsh overhead light of early summer on a beach, it is easier to look for situations where it might work to your advantage. Charo Diez decided to make a feature of the glare and reflections on the seawater and split the frame between sea and sand using the curve of the shoreline. She metered for the girl and closed down the aperture by 2 to 3 stops to render her as a silhouette, then waited for her to walk wholly into the sandy half of the frame. A circular polariser controlled the effects of glare from the water.

Photographer: Charo Diez	**Time:** A couple of hours before sunset, May	**Lens:** Sigma 28–200mm f/3.5–5.6 Aspherical zoom	**Exposure:** Not recorded
Location: Gomera Island, Canaries, Spain	**Camera:** Nikon F80	**Film:** Fuji Sensia 100	**Tripod:** No

Coastlines & beaches

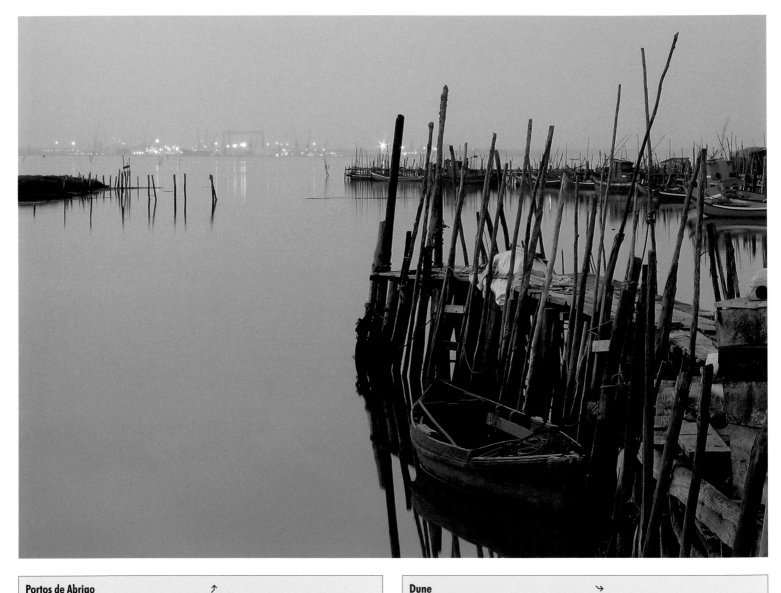

Portos de Abrigo ↑

Taken just after sunset on the River Sado estuary, the soft blue tones and very still water evokes a sense of calm that the photographer felt when witnessing this view. He stopped right down to maximise depth of field and relied purely on the camera's automatic metering system. The lights provide the only contrast to a totally blue image, as well as adding depth and interest to the view. No filters were used.

Photographer: Jorge Coimbra

Location: Carrasqueira, Portugual

Time: 7.30pm

Camera: Canon PowerShot G3

Lens: Built-in Canon 7.2–28.8mm zoom

File format: JPEG

Exposure: 6sec at f/8; ISO 50

Tripod: Yes

Dune ↘

A whole day spent wandering around the beaches and dunes of this remote stretch of Scottish coast culminated in a lovely evening of warm light that enhanced the texture of the sand. Olivier Demé climbed a steep slop to use the vertical face of sand as both foreground and lead-in line towards the bay. She used a 81b warm-up filter and a grey graduate to compensate for the difference in brightness between the sand and sky. The filter was placed diagonally to follow the edge of the sandy area from the bottom right to the top left of the frame.

Photographer: Olivier Demé

Location: Balnakeil Bay, Durness, Scotland

Time: 6pm in October

Camera: Nikon F5

Lens: Nikkor 28–80mm zoom

Film: Fuji Velvia 50

Exposure: f/22; shutter speed not recorded

Tripod: Yes

Technical tip

The two filters to aid you most while photographing a stretch of coast are a polariser and a neutral density (ND) grad. Both filters can reduce the amount of light through the lens substantially, so remember to take a tripod with you and get into the habit of using it.

Coastlines & beaches

- Use a large scale, well detailed map to work out the exact position and facing direction of the part of coast you wish to photograph.
- Buy a set of local tide-tables to see the best times to explore the shore.
- Avoid taking photographs in the middle of the day, particularly on bright days.

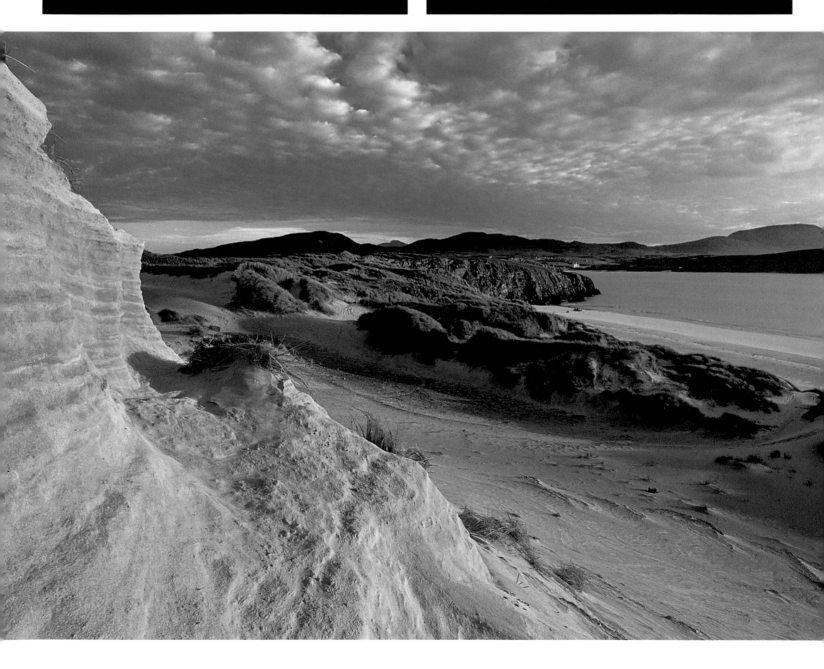

Coastlines & beaches

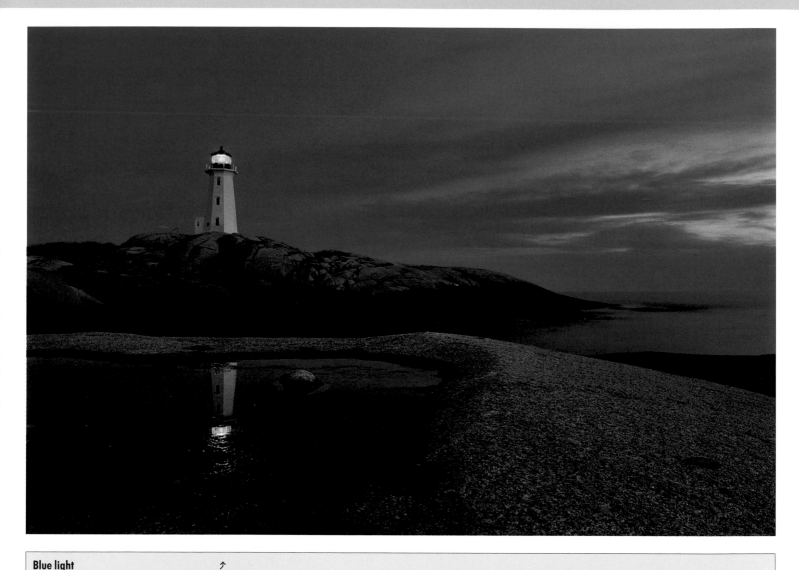

Blue light ↗

A 30sec exposure has captured the subtle tonal variations of the soft blue light after sunset, but what delivers the composition added balance and depth is the green light of the lighthouse reflected in the still pool of water. No filters were used and the camera set to aperture priority, using an exposure time taken from the camera's automatic meter reading.

Photographer: Kenneth Kwan

Location: Peggy's Cove, Nova Scotia, Canada

Time: 9.30pm

Camera: Canon EOS Elan 7e

Lens: Canon 35mm f/2 wideangle

Film: Fuji Velvia 50

Exposure: 30sec at f/13

Tripod: Yes

Porcos Bay

Mid-afternoon was the ideal time for this location as the sea was strongly illuminated and the beach falls into shadow later in the day. A polariser has defined the clouds and reduced surface glare on the water. The photographer also used a soft edge 0.6 ND graduated filter, placed above the horizon to reduce the exposure variance between sea and sky. A spot meter reading was made from the sea using the camera's built-in meter.

Photographer: Marcio Cabral

Location: Fernando de Noronha Island, Brazil

Time: 3pm

Camera: Nikon F90s

Lens: Nikkor 17–35mm zoom at 17mm setting

Film: Fuji Velvia 100F

Exposure: f/8, shutter speed not recorded

Tripod: No

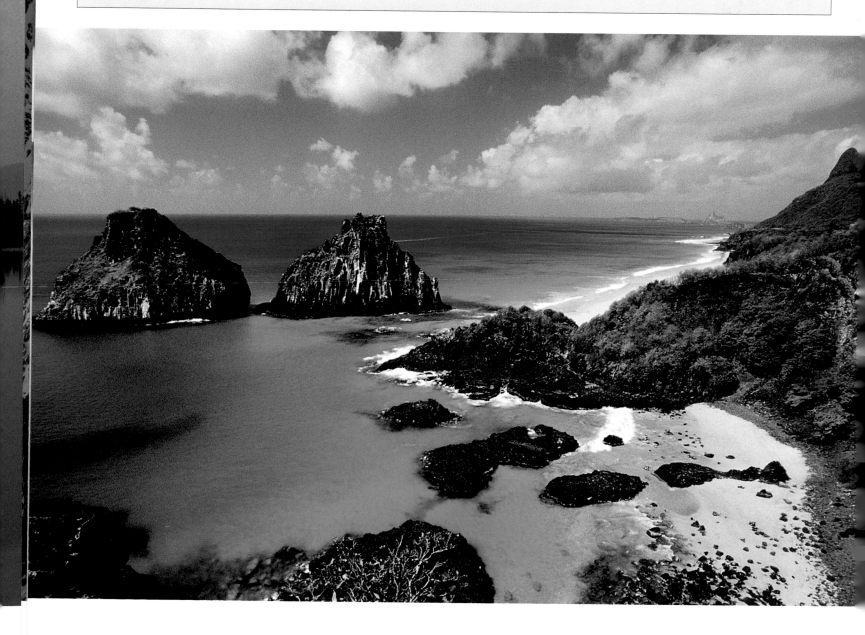

Natural landmarks

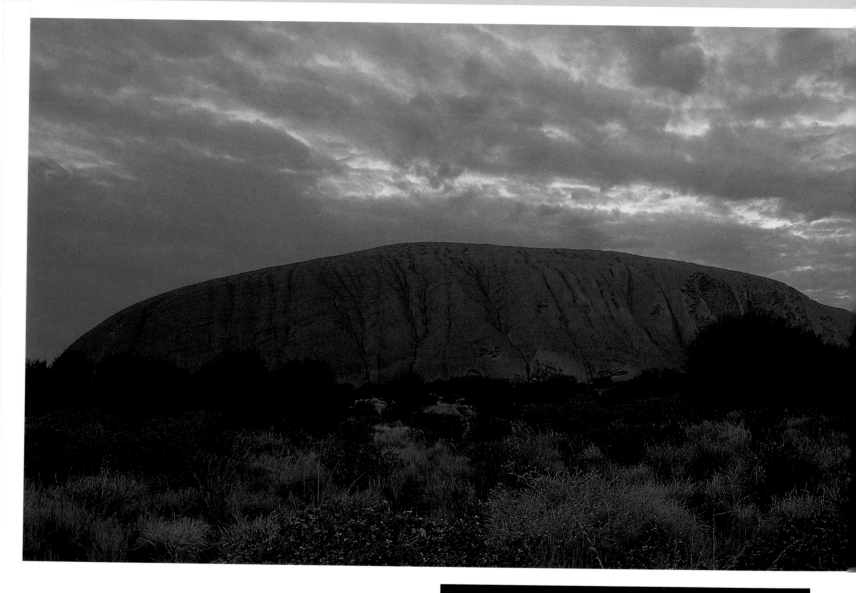

Technical tip

Look at postcards of well-known places and landmarks and go to the spot where the view was made, then move around and try a different angle, lower down or higher up, looking for other elements or foreground interest to include. Try the view through different lens focal lengths.

Natural landmarks are more of a challenge than manmade creations because nature's scale is far grander than any human feats of engineering. The vastness of the Grand Canyon or the sheer size of Uluru (Ayers Rock) is difficult, if not impossible, to define in a single photograph. Plenty of photographers have already grappled with these challenges and the results of their efforts can be seen in the postcard views or travel brochure images that are familiar to most of us. But, as with any manmade landmark, there are plenty of other possibilities to explore, depending on the time of day and your angle of approach.

For both these examples, it can be easier and far more stimulating to photograph a view of the landmark that you haven't seen before. So distinctive is the colour and geology of Uluru and the erosion patterns of the Grand Canyon that including just a small part of these features will be enough for the viewer to know where your image was made. With this approach your photographs can become more studies of composition and colour, texture and tone, mood and spirit, than just another snap of a well-trodden destination. Telephoto zoom lenses are ideal for making well-cropped studies of these sorts of detail and, because you're working with a narrower angle of view, variances in lighting levels (contrast) are likely to be less, making correct exposure easier to achieve.

Alternatively, such well-known landmarks also make wonderful backdrops, a fact that advertising photographers have exploited for decades, to the point where Monument Valley in Arizona is synonymous for a particular brand of cigarette. This is an extreme example, but the point is that a recognisable location or landmark needn't be the primary subject for your camera. Just a suggestion of its inclusion can be enough for you to use it as the 'scene setter' for a photograph that tells something more about the place from an original perspective – *your* perspective.

Using a wideangle lens is almost mandatory for such imagery, giving you the width to bring some local flavour into the scene: people, vehicles, distinctive signs, an empty road, horses or wildlife. Just think about what else you can include in the image that is as much part of this environment as the famous landmark everyone has come to see. By thinking this way you are more likely to take an original and memorable photograph instead of 'just another tourist snap'.

Uluru sunset

The world's largest monolith, Uluru (Ayers Rock), is renowned for its changing colours during the course of the day. At sunset there is a rapid change of colours but it is this burning, glowing orange reflecting the direct light of the sun that so entrances spectators. Composition is key here, including enough foreground to show the rock in the context of its surroundings and enough sky to counterbalance the foreground. In essence, this picture is a series of three layers – sky, rock, scrub.

Photographer: Steve Day
Location: Uluru & Kata Tjuta National Park, Northern Territory, Australia
Time: Sunset
Camera: Canon EOS 50E
Lens: Canon 28–135mm f/3.5–4.5 USM zoom
Film: Fuji Velvia 50
Exposure: Not recorded
Tripod: Yes

Mobius Arch　　　　　　　**Overleaf**

To achieve his desired result Inge Johnsson needed to photograph Mobius Arch in dawn light during the winter. He wanted the Sierra Nevada mountain range visible through the arch and winter was the time to go because the mountains would be clearly visible, covered in snow. At 7am in January, the arch had a distinct orange cast in the dawn light and the relatively low contrast meant the snow did not end up being overexposed or 'burnt out'. The only filter used was a warming polariser.

Photographer: Inge Johnsson
Location: Alabama Hills, California, USA
Time: 7am, January
Camera: Canon EOS 3
Lens: Canon TS-E 24mm f/3.5 L tilt and shift
Film: Fuji Velvia 50
Exposure: Not recorded
Tripod: Yes

Lakes, rivers & waterfalls

Storm over Blackfriars Bridge ↑

The South Bank of the Thames provides a constantly changing vista for photography and while walking towards Blackfriars Bridge I was struck by the black clouds looming over St Paul's Cathedral. The sun was dropping right down, bathing the bridge in brilliant light. Such contrast was an opportunity too good to miss. I placed my faith in a spot meter reading from the dome of St Paul's and took several frames when I heard the sound of this police boat speeding down river. I got two frames with the boat – this was the best. No filters were used.

Photographer: Keith Wilson

Location: Blackfriars Bridge, London, England

Time: 5pm

Camera: Canon EOS 1

Lens: Canon EF 28–135mm f/3.5–4.5 USM zoom

Film: Kodak E100VS

Exposure: Not recorded

Tripod: No

Castle Rock over Oak Creek ↘

Obviously, capturing the warm light of the setting sun on the craggy edifice of Castle Rock was the main reason for this image, but the warm, silky depiction of the water has provided balance to the composition as well as another focal point. Key to this result was the use of a small aperture – f/22 – and the lens' depth of field scales to focus on the part of scene that would ensure sharpness throughout the image. A warm polarising filter has nullified any blue cast in the water.

Photographer: Leping Zha

Location: Sedona, Arizona, USA

Time: Near sunset, April

Camera: Pentax 67II

Lens: Pentax SMC 55mm f/4 wideangle

Film: Fuji Velvia 50

Exposure: 1/2sec at f/22

Tripod: Yes

Lakes, rivers & waterfalls

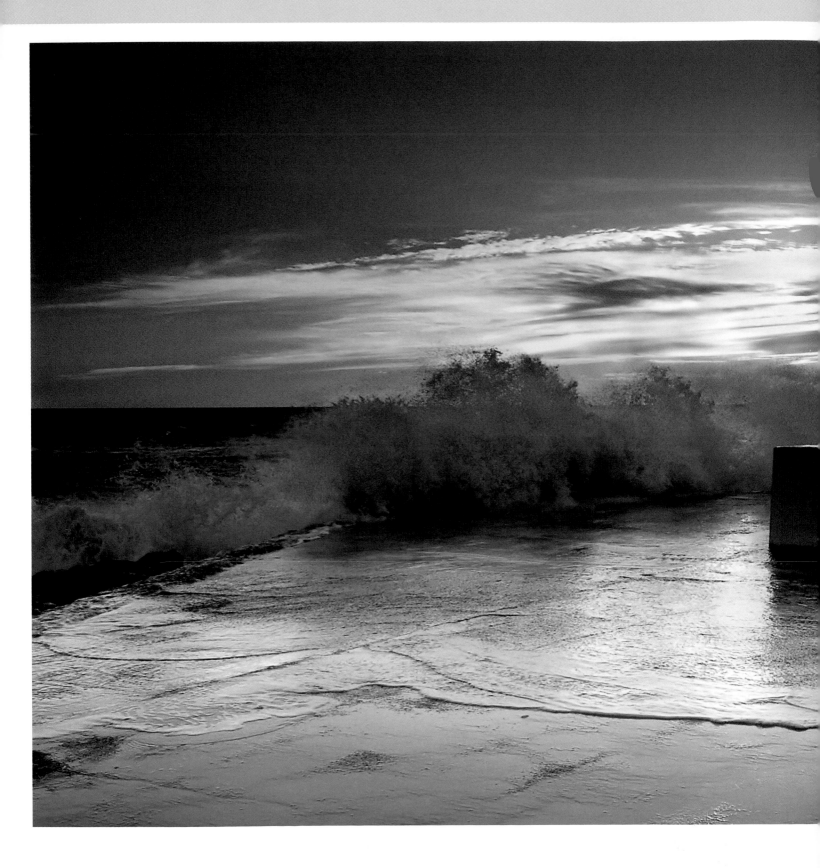

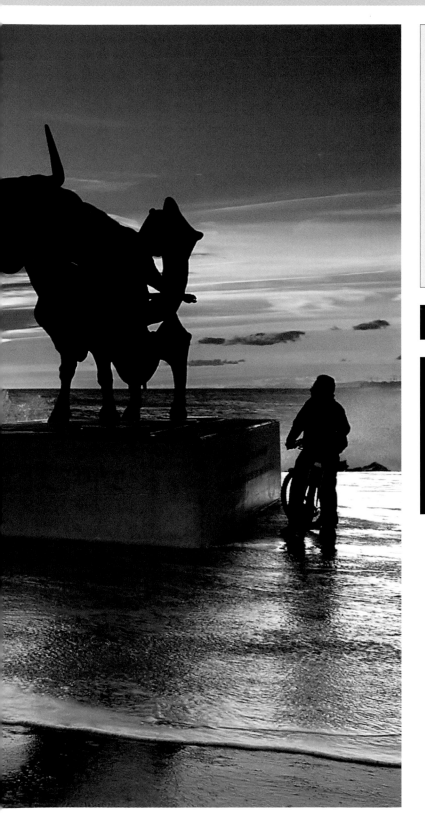

Toro ↖

It's not often you find a statue near an exposed stretch of coast, particularly one with a westerly aspect for the sunset. But it is this unusual statue of a bull that has provided the main focal point in what would otherwise have been just another ordinary sunset. It had been a windy afternoon and the waves crashing over the sea wall added another dramatic element to the scene. Including the figure of the man with a bike at the edge of the frame has given a human touch and scale to the image. The exposure was taken from the camera's automatic exposure reading and the only filter was a neutral density (ND) graduate positioned over the sky.

Photographer: Fernando Pegueroles

Location: Vilanova I la Geltru, Barcelona, Spain

Time: 6pm, December

Camera: Minolta Dimage 7i

Lens: Built-in Minolta 7.2–50.8mm zoom

File type: JPEG

Exposure: 1/180sec at f/5.6; ISO 100

Tripod: No

Technical tip

Use a zoom lens to try different compositions – a longer focal setting will make the sun bigger and more dramatic in the frame and a wider angle will include more of the sky with its cloud patterns and changing colours.

Sunrise & sunset

In equatorial countries, the sun rises and sets in the same direction and at virtually the same times all year round. But in more distant parts of the northern and southern hemispheres there is a huge variation in the sun's position and the number of daylight hours from one season to the next.

As people living in northern Europe and Canada know too well, the position and intensity of the sun varies dramatically throughout the year. For example, take the Scottish city of Glasgow, latitude 55° 50' N; on the shortest day of the year, 21 December, sunrise and sunset times are 8.45am and 3.44pm, making only seven hours of daylight. On the longest day, 21 June, these times become 3.31am and 9.06pm respectively – nearly an 18 hour day. These differences become more marked the closer you travel to the poles, to the point where the sun can disappear for weeks at a time during the winter and never set during the summer.

Sunset has long been a favourite time for travellers. It is a photo we usually all want to make no matter where we are in the world. But isn't one sunset like another, you may ask? Certainly, the subject is the same, but as any seasoned traveller will tell you the intensity and scale of a sunset can vary enormously. The height and density of cloud cover, air temperature and the purity of the atmosphere all play a part in the way the colours are rendered. It is ironic that some of the most beautiful sunsets occur where there is a lot of pollution in the atmosphere or following the previous evening's firework display – smoke particles help scatter the red colours of the spectrum to even more spectacular effects.

Despite having to wake up in the early hours and darkness of dawn, many landscape and travel photographers prefer the light of sunrise to that of a sunset. Sunrises are generally cooler and the colours more subtle. Again, a lot depends on what the sky is like: if it has rained during the night and cleared, there will be fewer particles in the atmosphere to scatter the sun's rays. The air temperature at sunrise is cooler too and as the sun climbs above the horizon, the colours will recede instead of intensify, as with a sunset.

Photographing a sunrise or sunset is fairly straightforward. I always use a tripod and remote release (or self-timer) and set up the camera well in advance, framing the scene where I expect the sun to meet the horizon. It's important to have the horizon perfectly level, particularly if the sun is rising/setting over the sea. Whether you're using autofocus or focusing manually, the distance setting will be infinity (the sun's a long way off, after all!). Take your meter reading off the sky, being careful to keep the sun out of the frame, lock this value and then make a sequence of bracketed exposures around this reading of +-one stop and another at +-one half a stop. The reason for making so many exposure variances is simply to give you a series of images showing varying degrees of colour saturation. It's all a matter of taste as to which you prefer. Digital camera users will be able to delete the ones they don't wish to keep after viewing them on the camera monitor.

Anything else in the foreground is likely to be in silhouette, in which case a recognisable shape such as a line of palm trees, a lighthouse, sailing boat or fishing trawler will add interest to the scene. The same applies to sunsets and sunrises taken inland – try to avoid the foreground from being a large dark area of nothing by including an object that is catching some of the ambient light or a stretch of water reflecting the sky's changing palette above.

Snow-capped mountains take on a different guise at sunrise and sunset, reflecting colours from warm and vibrant pinks to liquid gold. Having a scene such as this to break up the horizon adds to the drama unfolding in the sky.

From a photographer's perspective the good thing about a sunrise or sunset is the certainty of its return – once you've found a good position, you can always return 24 hours later if the weather has been less than ideal at your first attempt.

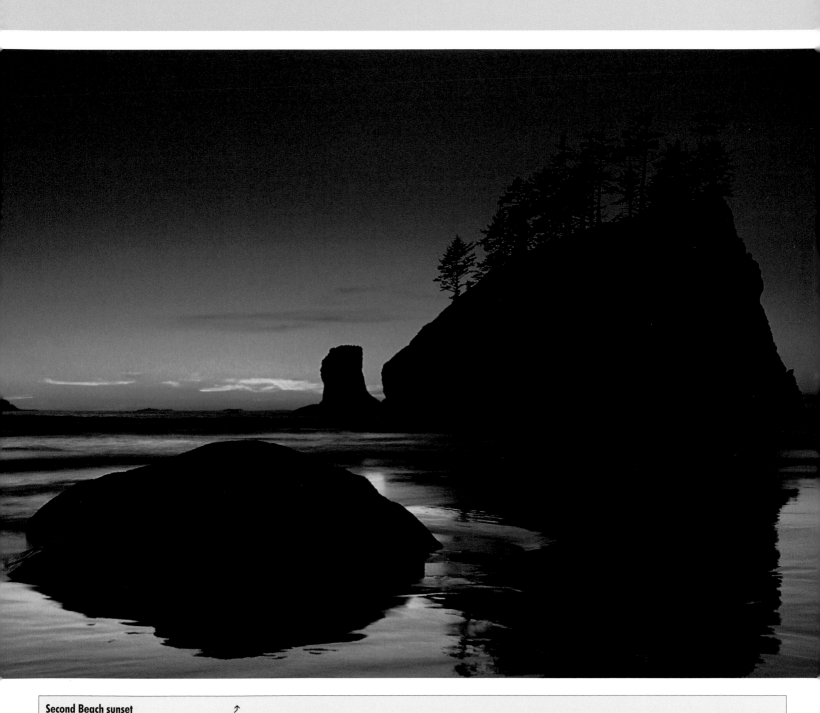

Second Beach sunset ↗

Sunset colours are at their most vivid when the sun has disappeared completely below the horizon. As well as the brilliant colour, a sunset image can be made more interesting by including a dramatic silhouette or foreground reflection. This image has both those qualities and the foreground elements help lend depth and scale to the image. Stephen Penland took a spot reading next to the brightest part of the sky and downrated his film by half a stop to give more exposure.

Photographer: Stephen Penland	**Time:** 9.30pm	**Lens:** Nikkor 24–85mm f/2.8–4 zoom	**Exposure:** 1sec at f/16
Location: Second Beach, Olympia Peninsula, Washington, USA	**Camera:** Nikon F100	**Film:** Fuji Velvia 50 rated at ISO 40	**Tripod:** Yes

Deserts

Not all deserts are an endless vista of giant sand dunes rolling away into the distance. Some are featureless and flat stony wastelands supporting a few lonely cacti. Others are well covered with thorny scrub and plants that have adapted to the extreme conditions. A desert is defined by its lack of rainfall, just a few inches a year on average, some years none at all. These are the driest and hottest places on earth. So what's the attraction for photographers?

With guaranteed sunshine and clear blue skies without a hint of air pollution, desert terrain provides some of the best natural light to be found anywhere in the world. Being able to work outdoors knowing that you are going to have the same clear and consistent light day in, day out immediately boosts your chances of creating some great pictures. As a result you can concentrate more on composition, moving around and trying different lenses and angles to arrange the graphic elements of the desert in the viewfinder.

Giant sand dunes are the most spectacular desert feature and in the Namib Desert of southern Africa, the western Sahara, or the Empty Quarter of the Arabian Peninsula, these reach great heights and are constantly shifting in the wind. It is a strange, uncluttered landscape where the only colour is the clean blue of the sky and sandy yellow of the dunes. Apart from a glimpse of the horizon, there are no straight lines and distances are hard to gauge.

The undulating dunes rolling into the distance make a pleasing study in form – there is something comfortable to the eye about their curving lines, which lead the eye across or into the frame. Such curves can be accentuated with the distortion of a wideangle lens, while patterns in the shifting sand, created by the wind blowing across the face of the dunes, makes an attractive foreground.

In a landscape reduced to rounded shapes, soft tones and with few details, it pays to look out for something that breaks this soft-lined uniformity. The bleached trunk of a dead tree, an exposed piece of rock, a group of palm trees or a well-worn trail vanishing in the distance can each add scale and depth to your composition, vital elements for any landscape.

Flatter, scrubbier deserts are less attractive unless there is an outstanding geological feature, outpost or landmark to break up the tyranny of distance. But even the most monotonous desert can be transformed by rain. Dry saltpans fill with water attracting hundreds of birds from nowhere and brilliantly coloured wildflowers provide a more welcoming sight.

A polarising filter is handy to reduce glare but full polarisation in bright sun may lead to an unnaturally dark sky. Instead, a warm-up filter (81a, 81b or 81c) is a better bet, particularly if you wish to enrich the golden tone of the sand, but ultimately the best light will be in those golden hours following sunrise and before sunset.

Death Valley landscape　　　　　　　　↳

Although this image was shot on colour slide film, Brad Kim could see its graphical potential if rendered as a black & white image. He used a circular polariser to boost the contrast between light and shade and then scanned the slide with his Canon scanner at home. The file was converted into black & white using Photoshop 7.0 and saved in Photoshop file format, creating a file size of 17.8 Mb. Actual image size was 4692x3976 pixels.

Photographer: Brad Kim	**Time:** Early morning, October	**Lens:** Canon EF 100–300mm f/5.6 L zoom	**Exposure:** f/22; shutter speed not recorded
Location: Mesquite Flat, Death Valley National Park, California, USA	**Camera:** Canon EOS Elan 7e	**Film:** Fuji Velvia 50	**Tripod:** Yes

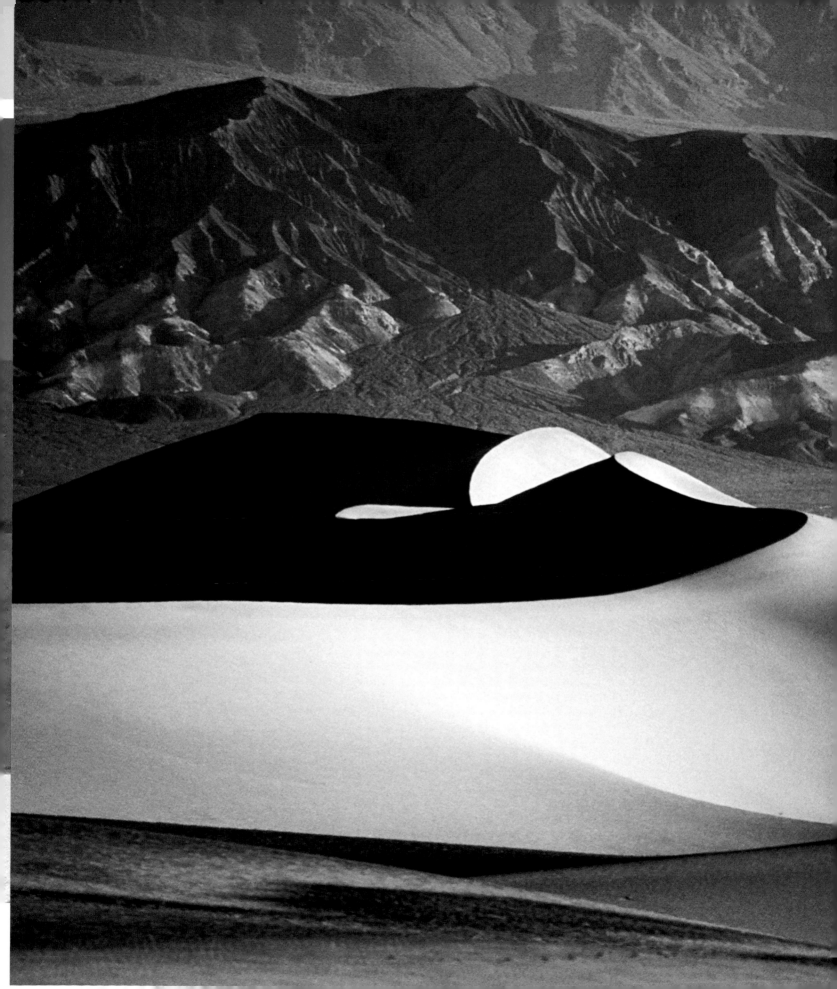

High altitude

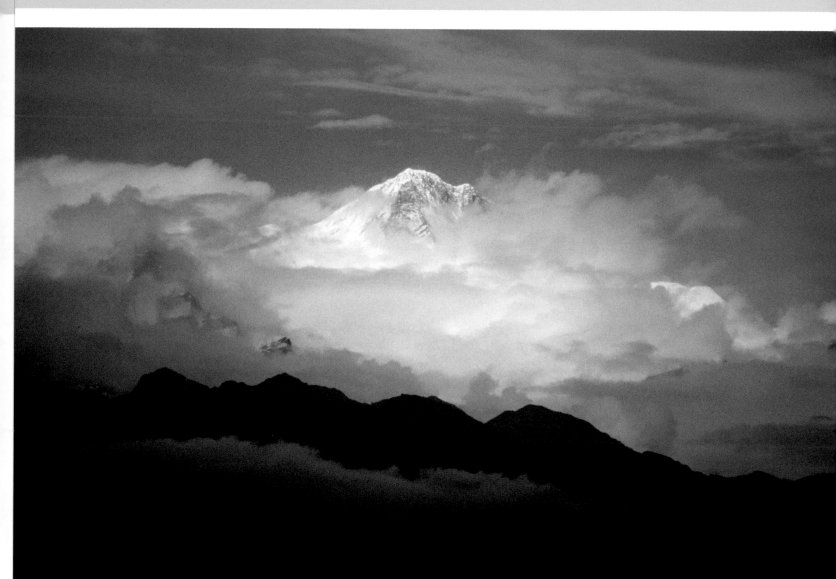

Annapurna shrouded in mist ↗

Often the best mountain scenery is that glimpsed after a period of stormy weather. That was the case with this view of Annapurna, one of the highest mountains in the Himalayas, photographed just after dawn. Jon Bower had been stuck in the town of Pokhara for several days when the monsoon rains came early. This was the only glimpse he got of the mountain but it was worth the wait.

Photographer: Jon Bower

Location: Near Pokhara, Nepal

Time: 8am

Camera: Olympus OM4 Ti

Lens: Zuilo 65–200mm f/4 zoom

Film: Kodachrome 64

Exposure: Not recorded

Tripod: No

The world's great mountain ranges such as the Andes and Himalayas are special because of the physical challenge they present to those who attempt to scale their peaks. The main lure is the promise of spectacular views, which are also breathtaking in the true and literal sense of the word. The higher you climb, the thinner the air and, at 10,000ft, there is a risk of altitude or mountain sickness afflicting the under prepared climber as air pressure and oxygen volumes recede.

At 15,000ft oxygen volumes are around half the levels found at sea level. To walk comfortably at these heights you need to have acclimatised by spending several days resting and letting your body adjust to this oxygen-depleted atmosphere. Even then, bigger breaths, more frequent stops and a slower walking pace are necessary to save yourself from exhaustion.

Many people cannot survive above 20,000ft without supplementary oxygen and those that do are generally young, very fit and well trained. At these heights, it is also extremely cold, with freezing winds and the threat of violent weather striking with little warning. But the scenery is awesome.

Because of the sheer enormity and height of these mountains, wideangle lenses are the most commonly used. However, a telephoto zoom is an ideal complement for filling the frame with those peaks that are out of reach. As with any landscape photography, the best light to exploit is during the early morning or late afternoon. But the geography of these regions means that the glacial valleys at the foot of these mountains will be in shadow when the peaks are lit by the first and last rays of the day. It's only when the sun is high that the full face of a mountain from peak to valley will be lit. Bracketing your exposures around a mid-tone reading from say a rock or patch of ground not covered by snow is the best way to ensure a good result. As with the clear light of the deserts and polar regions, distances can be hard to judge in high alpine regions with mountain peaks looking closer than they really are. Consequently, conveying depth in your images requires thought. Look for natural lead-in lines in the form of rivers, valleys, glaciers and ridges and foreground interest such as Buddhist mani stones or chortens, which are common in the high Himalayas. Huts, stone walls, tracks and terraces provide scale and further information about the local culture of the location.

I've always found people who live in high altitude areas to be friendly and mostly co-operative for the camera, so make a point of trying to engage with them, always being respectful and polite. There's bound to be communication gaps as far as the language goes, but showing them pictures on your digital camera monitor is bound to break the ice. And if you do photograph someone, make sure you show him/her the result on the screen immediately afterwards.

Technical tip

At high altitudes, there is more ultraviolet light in the atmosphere and this can make your images look quite blue and cool. An ultraviolet (UV) filter will cut out much of this light while a 81a, 81b or 81c warm-up filter will also help to counter this cast.

High altitude

— Wideangle lenses and zooms will give you the width you need to capture the vastness of the terrain at high altitudes.
— Contrast levels are high due to valleys being in darkness when mountain tops are lit by morning or setting sun. Use a neutral density (ND) graduated filter to reduce this contrast.
— Look for natural lead-in lines or foreground features to show depth in the scene.

Planes, trains & rickshaws

Planes, trains & rickshaws

Technical tip

Before using slow sync or fill-in flash, check the range of your flash and remember the inverse square law which states that as the distance from a light source is doubled, the amount of light reaching the subject is quartered. Flash falls off quickly, so make sure you're not too far away from your subject.

Planes, trains & rickshaws

- A low angle of view helps create an impression of dynamism, particularly when viewed through a wideangle lens.
- A general view of main roads and city streets in major Asian cities can reveal all means of transport and provide a crowded tableau of life on the move.
- As well as photographing views from a boat or ferry as you come into port, get some shots of your fellow passengers on deck or include part of the boat in the overall scene, in the foreground.

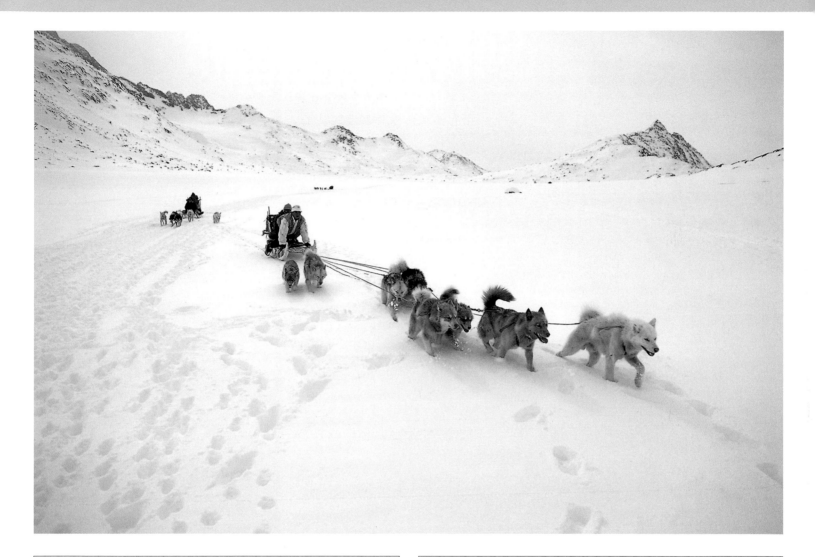

Angry look ←

A fleeting glance, and an angry look as a passenger makes eye contact with the camera. The man's stare is in marked contrast to the blank looks of the other passengers and without his expression the picture would have had no impact at all.

Photographer: Charo Diez	**Lens:** Sigma 28–200mm f/3.5–5.6 Aspherical
Location: Bangkok, Thailand	**Film:** Ilford XP2 Super
Time: 10am	**Exposure:** 1/60sec; aperture not recorded
Camera: Nikon F80	**Tripod:** No

Homeward bound ↗

In Arctic locations such as Greenland, the traditional dog sledge remains the most reliable means of getting around. This team of huskies was one of several in a convoy that was returning from an overnight trip near Ammassalik Island. A 20mm lens has captured the line of sharply focused sledges as they make their way across a thick carpet of snow towards home. In these brilliant white conditions it was necessary to overexpose the metered reading by 1.5 to 2stops, to avoid underexposure and the snow looking too blue. No filters were used.

Photographer: Keith Wilson	**Lens:** Canon 20mm f/2.8 wideangle
Location: East Greenland	**Film:** Kodachrome 64
Time: Mid-afternoon in April	**Exposure:** 1/250sec at f/8
Camera: Canon T90	**Tripod:** No

Moving subjects

When confronted with a moving subject, you need to first decide whether to 'stop' the action with a fast enough shutter speed or emphasise the movement through panning and/or long exposures. In the previous pages the combination of panning and slow sync flash was suggested for photographing some of the more exotic means of transport in Asia's urban jungle. With or without flash, panning is best executed when the camera locks focus on the subject and follows its path in a steady sweep, even after the shutter has fired. The camera's AF needs to be in continuous (predictive) mode and the shutter speed slow enough (1/30sec or slower) to render the background as a streaky blur while the moving subject stays comparatively sharp. Moving cars, trains, rickshaws and buses are obvious subjects but there are wonderful sporting and festive occasions where such a technique can result in exciting images. Some examples are the running of the bulls at Pamplona, Spain, the Monaco Grand Prix, a lone giraffe making a loping run across the Serengeti or the fevered action of the New Orleans Mardi Gras. A streaky, blurred background conveys movement and helps the subject stand out. It also helps if your subject is brightly coloured or of distinctive appearance – a red Ferrari accelerating out of one of Monaco's famous hairpins would be perfect, providing you can keep up with it!

This may seem contradictory, but stopping the action can also produce dramatic 'moving pictures'. It's a case of choosing the right subject. For instance, the power and speed of water cascading hundreds of metres at Victoria Falls in Zimbabwe or Iguaçu on the Brazil/Argentina border, requires a shutter speed of at least 1/1000sec to 'freeze' the action. For more typical situations such as children running from the surf, more sedate speeds will do, say 1/250sec. Photographing action is also about timing and when to press that shutter button. It's worth firing off a burst of frames too, so select continuous AF and switch your camera's drive to continuous as well. Most cameras feature a built-in motordrive with a typical speed of three frames per second (fps). At major sporting events like Wimbledon, the World Cup, ski jumping or Olympic track and field events, you'll need a fast shutter speed and a continuous burst of frames to capture that split second when ball meets racquet or football hits back of net. It can be more by luck than judgement, but at least with a digital camera you can view your result on the LCD monitor to see if you still need to keep shooting.

Gannet in flight ↰

When focusing for moving subjects such as this northern gannet, try to release the shutter at the point of least movement. This gannet has been caught at the instant its flight slows before landing. A burst of fill-in flash took care of any shadows while a slow shutter speed of 1/15sec captured enough ambient light to register any small amount of movement as blur. The clear blue sky makes an excellent background and the other birds and sea in the distance provide the viewer with location context.

Photographer: Kenneth Kwan

Location: Bonaventure Island, Quebec, Canada

Time: 11am

Camera: Canon EOS Elan 7e

Lens: Canon 28–105mm f/3.5–4.5 zoom

Film: Kodak EBX 100

Exposure: 1/15sec with fill-in flash, aperture not recorded

Tripod: No

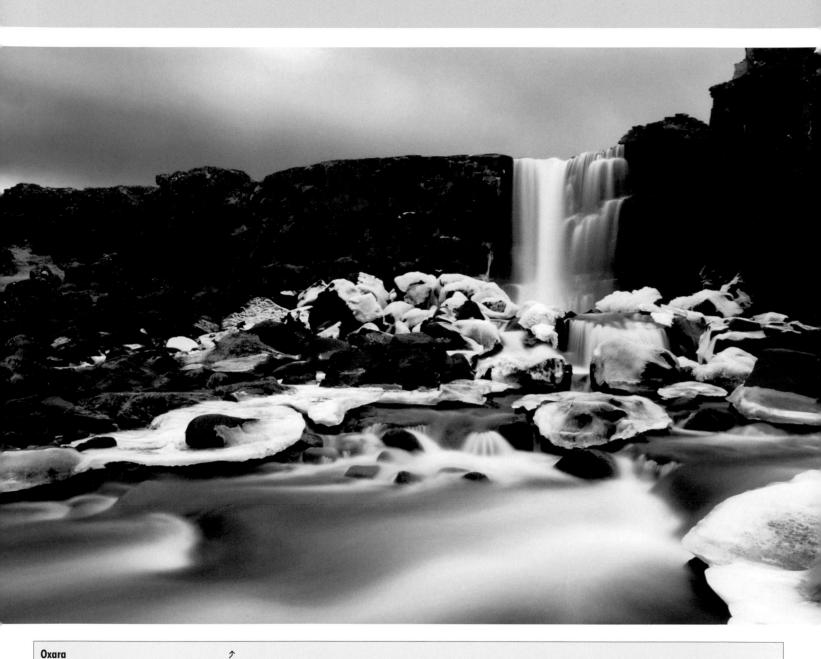

Oxara ↑

It was almost dark on an overcast day when Palmi Einarsson went to this beauty spot to make long exposures of the waterfall. There was no snow on the ground but the air and water temperature was cold enough to have formed large lumps of ice on the riverbank. No filters were used and Einarsson relied on the camera's automatic metering system for his exposure value. The camera's white balance was set to cloudy.

Photographer: Palmi Einarsson	**Time:** 5pm	**Lens:** Nikkor 50mm f/1.4 D lens	**Exposure:** 10sec at f/10; ISO 125
Location: Iceland	**Camera:** Nikon D1X	**File type:** JPEG	**Tripod:** Yes

Moving subjects

Mexican dance ↙

When these dancers started to perform at a midday party for tourists, the photographer noticed that the background was too distracting. He continued shooting anyway and decided to make a closer crop and remove the background later using Photoshop. With the image on the computer screen, he also added a Radial Blur for an extra sense of movement.

Photographer: Mauricio Alcaraz

Location: Amatitan, Jalisco, Mexico

Time: Around 2pm, July

Camera: Minolta Maxxum 7

Lens: Sigma 28–200mm f/3.5–5.6 Aspherical zoom

Film: Fuji Provia 100

Exposure: Not recorded

Tripod: No

Freeway lights ↗

Geraint Smith came up with a novel means of recording a light trail to show 'the craziness of LA traffic'. While cycling home one evening he noticed the railings of an overpass above and decided to return to make this shot from there, holding the camera rigid for most of the exposure. Then for the last couple of seconds he moved the camera to make some of the light trails zigzag across the frame.

Photographer: Geraint Smith

Location: Pasadena, California, USA

Time: Evening rush hour in winter

Camera: Nikon F3

Lens: Nikkor 35mm f/2.8 wideangle

Film: Kodachrome 64

Exposure: 8sec at f/5.6

Tripod: No

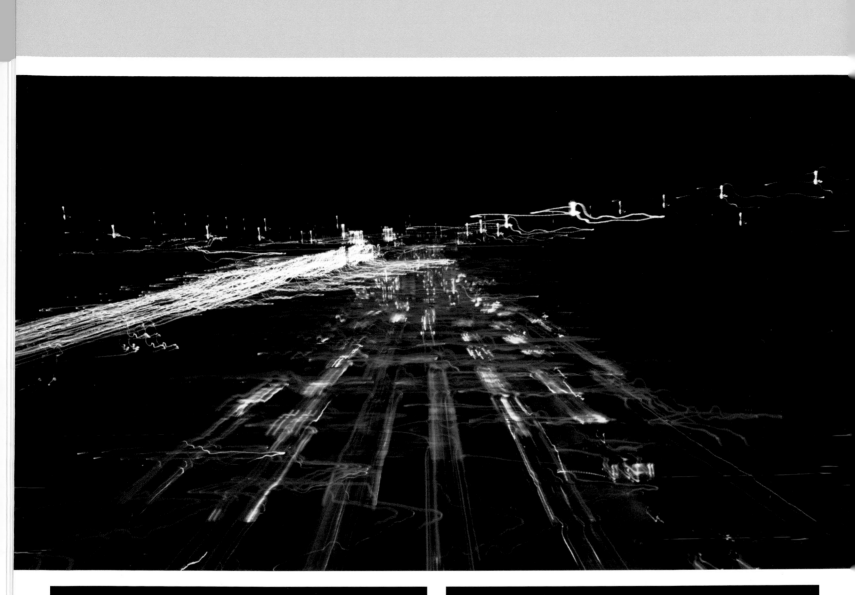

Technical tip

In many crowded situations a monopod is more useful than a tripod for keeping your camera steady while panning a moving subject. It won't get in anyone's way and still give you the support you need to keep the panning movement as level as possible.

Moving subjects

- First decide if you wish to 'freeze' the action or emphasise it by deliberately blurring the subject or background.
- Switch your camera's autofocus mode to 'continuous'. On this setting the AF will keep the subject in focus even when it's moving towards you, away from you or across your path.
- If you're panning, keep the camera moving evenly before, during and after firing the shutter.

Moving subjects

Keith Wilson

Glossary

Acknowledgements

It may be my name on the front cover but there are many others who have contributed their dogged labour and unsung skill to the making of this book.

First of these is Brian Morris at AVA who picked up the phone and commissioned me in the first place. Many thanks Brian for your trust and faith.

A big thank you also to my editor Laura Owen, who was always available, helpful and patient, and to Caroline Walmsley for helping me to clear the final hurdle.

Picture Editor Sarah Jameson worked like a Trojan supplying a huge variety of pictures that have made this book what it is – a pictorial triumph, enhanced by the sympathetic eye of designer Gavin Ambrose.

I remain profoundly touched by the support of Ailsa McWhinnie, Tracy Hallett, Liz Roberts, Jo Chapman and Samantha Cadwallader, my talented colleagues on the world's two finest photo magazines – *Outdoor Photography* and *Black & White Photography*.

Finally, the biggest debt of thanks goes to my family: Pamela, Elizabeth and Olivia, for putting up with the stranger with the laptop who stole their evenings and weekends.
I owe you so much.

Keith Wilson
London
August 2004

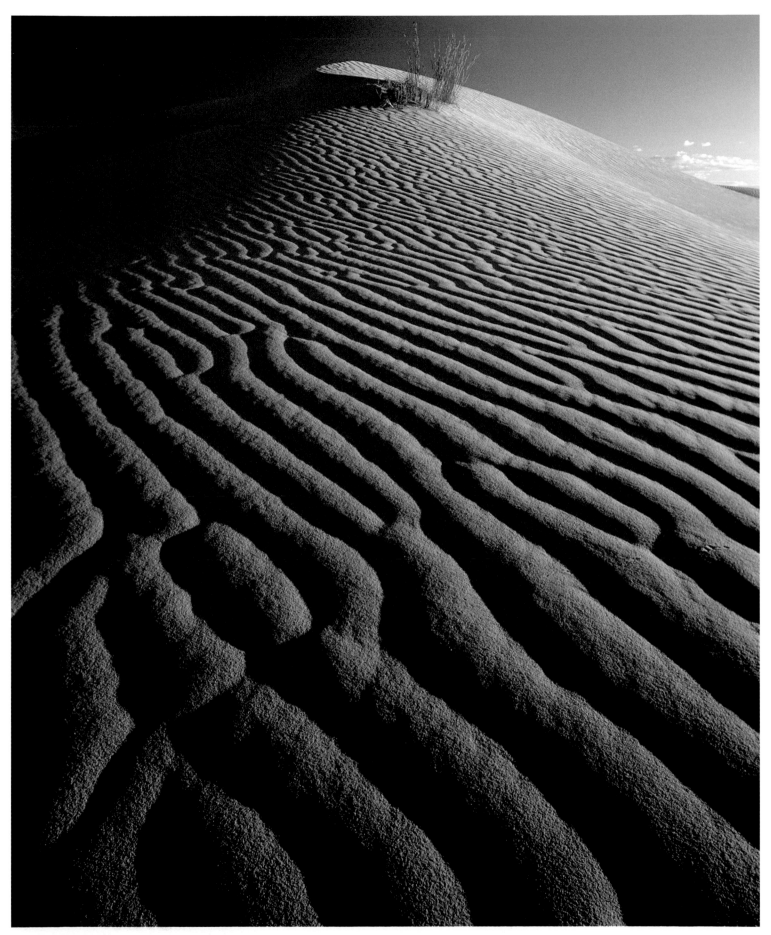

Inge Johnsson (see page 39)

Inge Johnsson (see pages 146–147)